Storyville to Harlem

You want to feel the smell—the color—the great "OH MY" feeling of the Jazzmen, and stomp around in the smoke and musk of the joints and find all them faces that play it right and listen good; then you just go and locate yourself some of the drawings and paintings of this cat Steve Longstreet and steal you a few."

Louis Armstrong (1971)

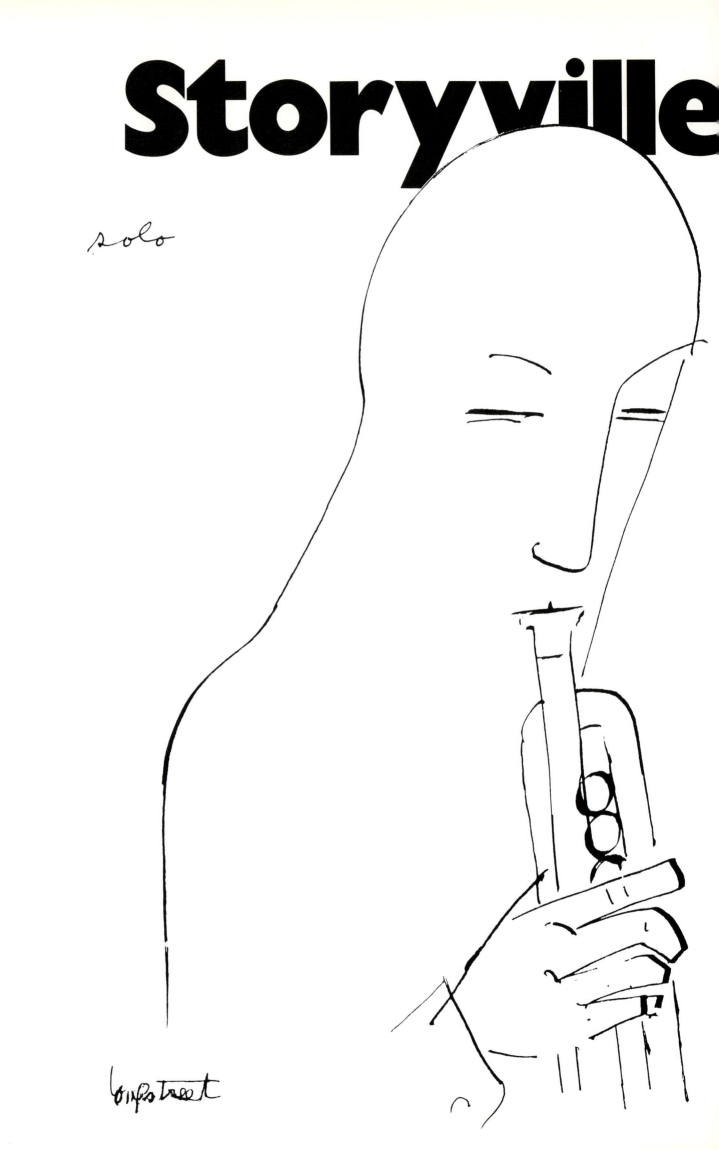

to Harlem

Fifty Years in the Jazz Scene

Stephen Longstreet

Rutgers University Press *New Brunswick and London*

Library of Congress Cataloging-in-Publication Data

Longstreet, Stephen, 1907–
 Storyville to Harlem.

 Bibliography: p.
 I. Jazz music—Pictorial works. 2. Jazz musicians—
Portraits. I. Title.
ML87.L66 1986 785.42'09 85–30315
ISBN 0–8135–1174–7
British Cataloging-in-Publication Information Available.

To Jimmy Welton
who was there from the start
and all jazz folk
who didn't make it into the
history books

Thanks are due to these collectors and collections for permission to reproduce certain drawings:

The Tanney Collection, Boris Godoff Estate, Erdelac Americana Collection, the Baroness Elena Guzzardi, Henrietta Steinman, Dr. and Mrs. Eric Wolfe, Mr. and Mrs. Jacob Gimpel, Harry Godwin, Mr. and Mrs. Robert Weiss, Mr. and Mrs. Owen Crump, Mr. and Mrs. Don Weir, Shirley Burden, Howard Gotlieb, the Freemantle Estate (England), Renee and Harry Longstreet, Sid F. Graves, Shirley Burke, Mr. and Mrs. Brian Fletcher, Librairie Grand (Paris), Camiel van Breeden (Holland), Charles Grayson, Avrom Thomi, Mr. and Mrs. Arthur Gamerel, Irwin Blacker, Mr. and Mrs. Robert Schabacker, Lawrence Lariar, Mr. and Mrs. David Marcus, the James Welton Estate, Richard Hyland Estate, Leon Lance Estate.

Certain of the drawings are connected with suites of drawings now in the Library of Congress, Yale, Mugar Memorial Library (Boston), the Oakland Museum, Huntsville Museum of Art, New Orleans Jazz Museum, Stanford University Special Collections, Dix Collection (Mexico), Delta Blues Museum, Academy of Motion Picture Arts and Sciences, and the limited editions of drawings sponsored by the Los Angeles Art Association.

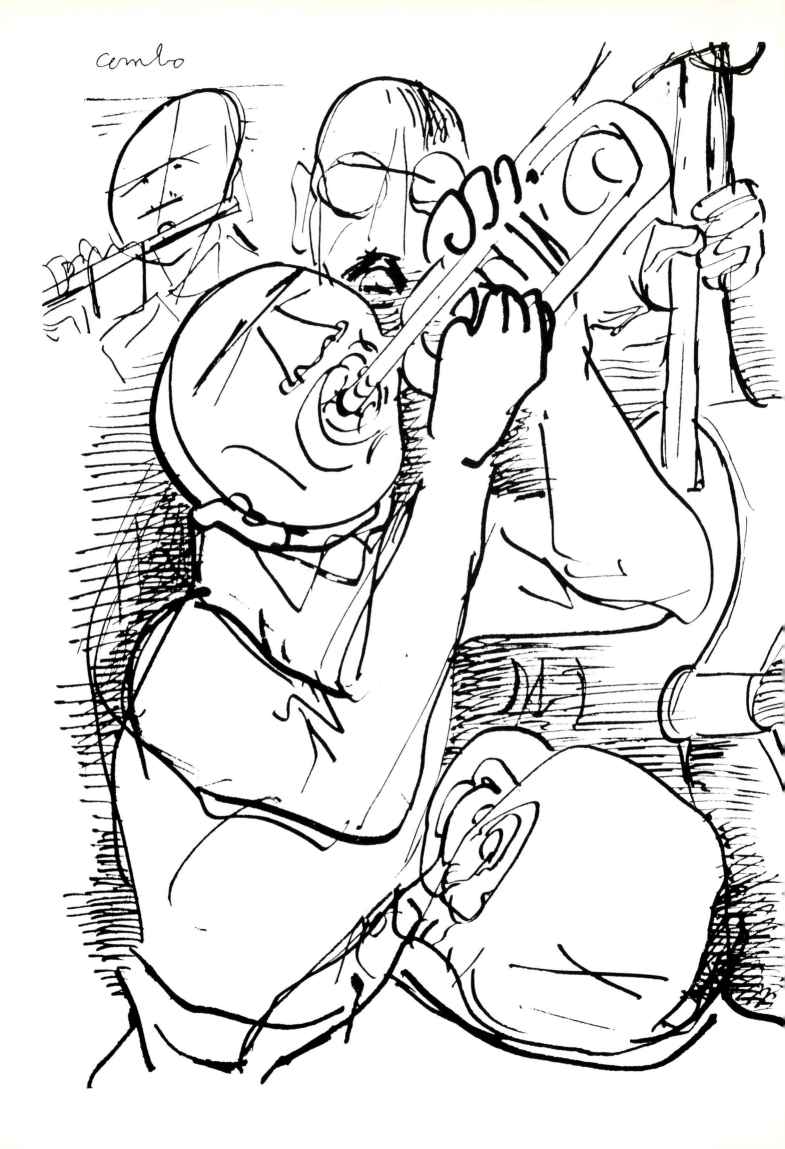

Introduction

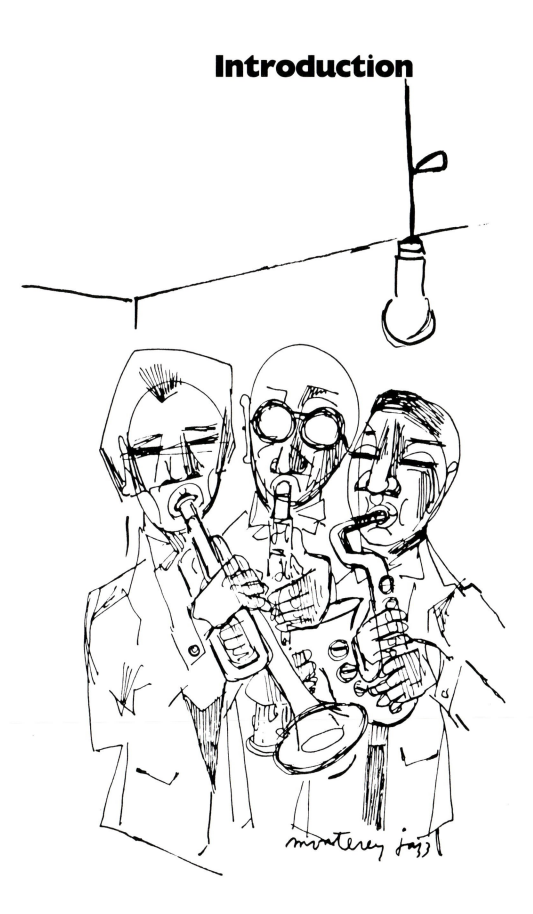

boogie piano

Monterey
1933

being a small boy who had never heard Negro music (the term "Black" was not in use—the polite form was "Colored"), I was fascinated by hearing a football player, Paul Robeson, sing Negro Spirituals after practice at the Rutgers training field. I was too young to see they had something called "soul." I grew friendly with Paul. He told me he was taking a beating from his own players during practice. Through him I met some of the people in the depressed section of New Brunswick, New Jersey, called "Nigger Heaven," also the "uppity colored" on Railroad Avenue in the shadow of the tracks of the Pennsy Lines. The Pullman porters and train chefs lived here, and they owned race records of Ma Rainey and others, music not sold in the white music shops. There were also some scratchy jazz recordings. I suppose I was listening to King Oliver, Dixieland Jazz and Jelly Roll Morton, the New Orleans Rhythm Kings. But at the time, it was just the new razzmatazz sounds that delighted me.

I tried to explain it to Mr. Wilmot who taught us music once a week by

having us read notes from slips of paper (he once politely told me, "you are a listener."). As for "the Colored Music," I once heard him explain to an uncle of mine, "it's whorehouse music, that's all it is, the sounds of the depraved Southern white man lusting for the flesh of the nigrahs." I was never forbidden from going to visit the homes where there were early jazz records—because I never told anyone.

As a teenage art student in New York City, I began to discover by 1925 that certain people were talking about the new music: in Greenwich Village, in the uptown speakeasies, at the Vanity Fair and New Yorker magazine parties. They insisted the jazz sound was more than whorehouse music. I was making nine dollars a drawing from the New Yorker—it was then all fresh and frisky—and Carl Van Vechten, John O'Hara, Ralph Barton and I were enjoying visits to Harlem. That Harlem wasn't the one of misery and poverty, of racial conflict. The Harlem of the 1920s I first saw was the world of the Cotton Club, shows like Black Birds of 1928, joints where whites only were served by blacks, the speakeasies where college boys down from Harvard and up from Princeton in Stutz Bearcats came to seek drink and sex and see black girls shimmy, mooche, belly roll.

Also around this time, I met the great James P. Johnson and found he had

come from my New Jersey town and been an accompanist to Bessie Smith. He was to become a great expert on the stride piano. We used to "cut up touches," talking of the narrow-minded tone deaf New Jersey burgs in which we both had lived.

I soon began to devote much of my time filling sketch books of Harlem scenes, its people and the jazz world, when I should have been in art school drawing a female model in the life class. A few of those early jazz sketches are in this book—some in recent years acquired by museums, the Library of Congress, Yale's Black Arts collection—but at the time, I was only a very young man with a head full of strange and wonderful sounds and with a great interest in black and white life, the music makers and their looser, more extended values. All a bit overexhilarating for someone cutting loose from what Kid Ory told me was "white bread livin', tippin' your hat to the same wife all your life, sayin' 'yes sir' to the shitheads."

Harlem to me was the Stroll, the Lafayette Theatre, the black dudes and con artists, sellers of goofer dust, Big John root; horn men looking for a gig standing by the Trees of Liberty. Talking big, talking sad, bragging of kip time, and scoring with the band canary, or working the girls turning tricks; talk of recording hopes, the hard winter coming up.

I was young and not wise, but I was attentive and curious. Soon I saw that behind the glitter of a black

speakeasy and night club there was the cold-water flat, the gas turned off and a father who did not live at home, and all the women who early each morning would be moving toward the subway and the street cars, to the day work and housework, coming back weary with bits of broken food in a tote bag, a fistful of cigarettes, a discarded dress or shoes, and a couple of silver dollars or slim bills for a day of toil.

Still, there was often a get-together, a wedding, a birthday, later a rent party. So the music could begin sad with a spiritual, go to the blues and on to the work songs, the field holler learned in the cotton fields, on the river docks, jail songs. The brass would end up with good improvised jazz, oiled by gin and a Brunswick stew, sometimes ribs, and fried golden catfish (nobody then called it "soul food"). The old folks sat along the wall, kids ran underfoot and the young danced or horsed around. I don't recall just when the shaking became the Charleston, then the jiving the Black Bottom. "It keeps the spirit up," Ethel Waters said, and Louie Armstrong, his dial of a face shiny and damp, would tell us how it was when he was an orphan in New Orleans, and got a charity horn and stole coal sacks. How he got a girl and went to Chicago to join King Oliver. "Oh, that was some big city I tell you, to a 'cullud' boy from the Delta." He would get out the handkerchief and play "Lively Stable Blues."

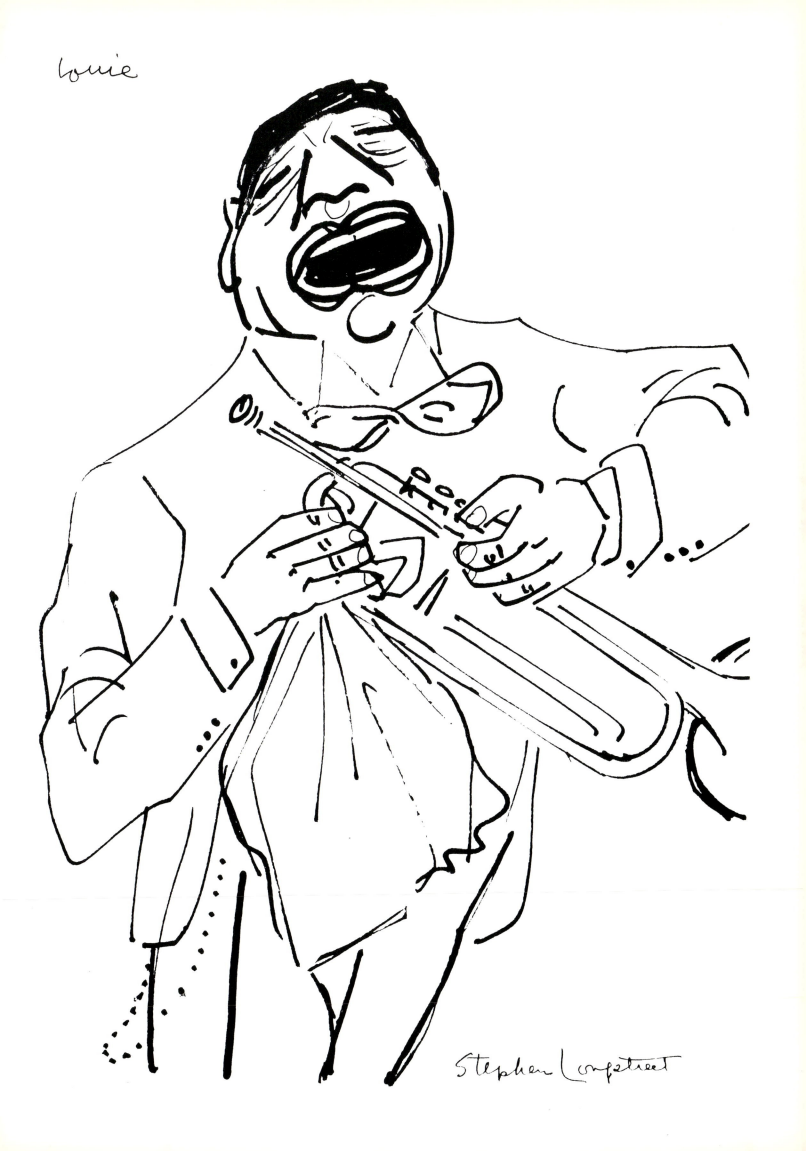

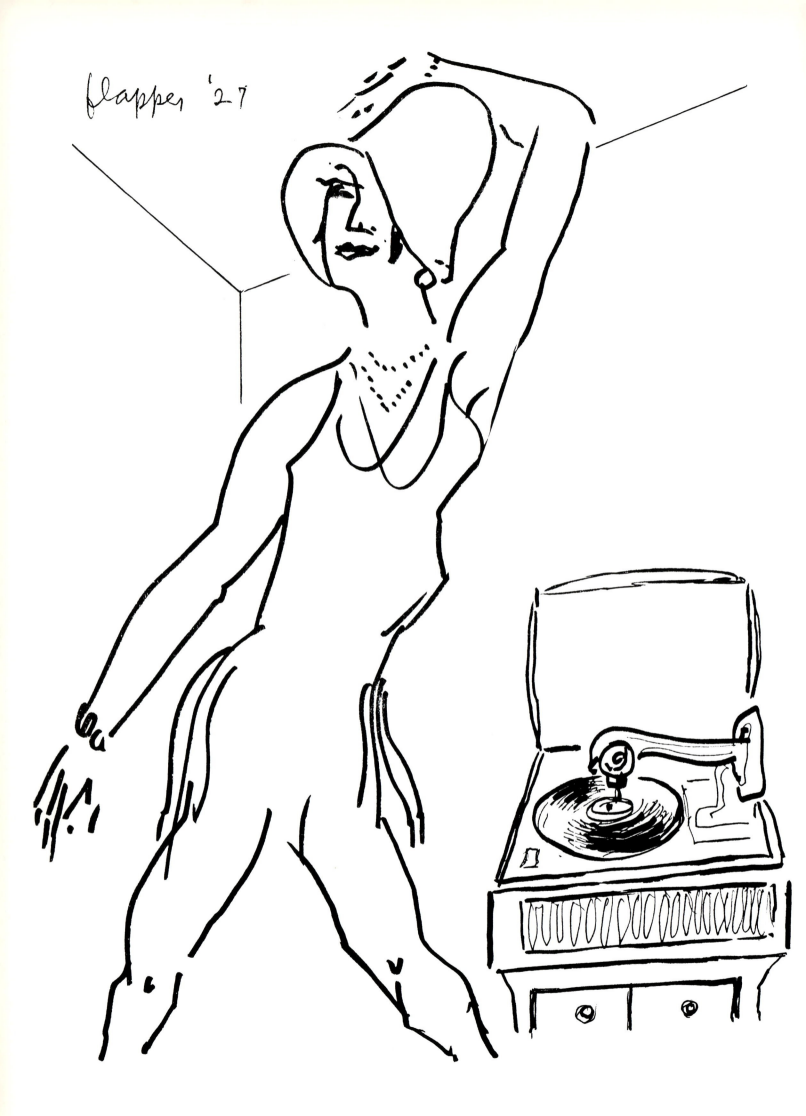

When I left the scene to go to Paris, I had no idea I was one of Gertrude Stein's "Lost Generation" or Hemingway's "Sun Also Rises" set. I just wanted to get close enough to what Picasso, Braque, Bonnard and Soutine were doing, to smell the paint and get the scene on canvas. I found that a black bandleader, Jim Europe, who worked army bands, had made jazz sounds in Europe, and later there was Bricktop's nightclub where the sound was right. There were some jazzmen in Paris, escaping from Judge Lynch and the back of the bus to live in Europe and make their music for the growing jazz cult.

When I came back from Europe after the Great Bull Market of 1929 had dropped as dead as one of the bulls in Ernesto's stories, the jazz combos and bands were in misery. Some of the roadhouses set up by Al Capone and his boys where they hired the new music had been closed by the Feds. The night club tables, as the depression spread, had plenty of empty chairs. The torch singers sang sadder songs to empty space. And your family's mattress, chairs and table, a few pots and pans stood at the curb when the landlord dispossessed you. No work, no welfare, just a few bread lines and thin soup. ("Do you have change from a toothpick?") Some of the bandsmen took to tooting in store-front churches on Sundays while a black Jesus looked down from the wall.

With galleries shutting their doors, my drawings and paintings of the jazz world were not selling. I went down to Florida where perhaps the living might be cheaper. In New Orleans I saw fear and hunger, and the jazz sound was sadder. Broken-shoed duos and trios playing down by the river, for coffee and doughnuts. Jackson Square benches became bedrooms, and in

7

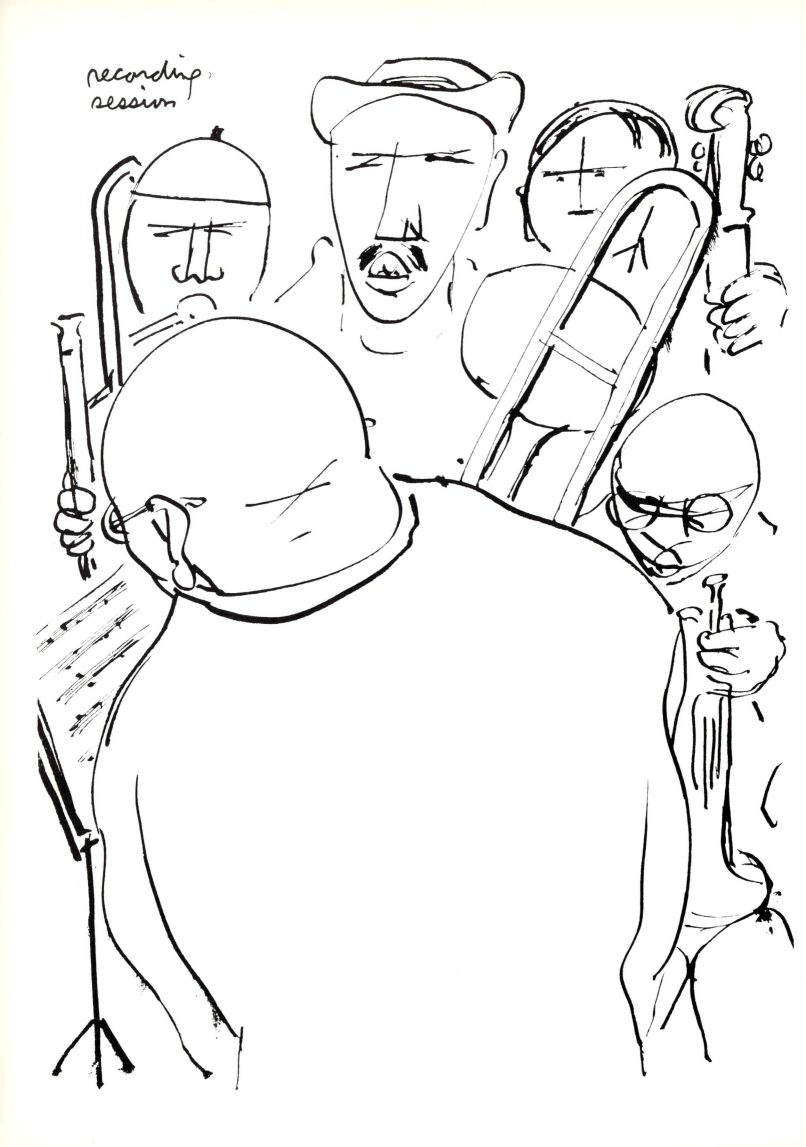

Storyville to Harlem

funky, dimly lit bars some old men sat on platforms and played the original style jazz; you could stay and listen for the cost of a beer. Some talked of the old sporting house days when Storyville music was stomping good, and they recalled fabulous madames: Kitty Jackson, Kate Townsend and a Mr. and Mrs. Hiawatha. One old jazz man told me to go find a Miss Nell, who once ruled the best sporting house in the south on Basin Street. "Had herself some of the damndest, finest good jazz anybody ever played in Storyville."

She called herself Nell Kimball at the time I at last discovered where she had retired to. Old, but still alert and intelligent about her years in the sporting house world, she gave me her memoirs to read ("got no publisher"). I read her manuscript and told her when she spoke, her story was grand and alert, but in writing it down got too literary. Times being slack, I worked with her, rewriting her book. She knew a great deal of the early jazz history first hand; Buddy Bolden, early street parading, the roots of jazz and the turning of its style when it came around to playing in the sporting houses. As for her book, while publishers admired her lively life, her wit and intellect, no one dared to publish it during her lifetime, and not until 1970 was the version I had edited in print (Nell Kimball, Her LIfe as an American Madam). It remains the best eyewitness account of jazz during its Storyville period.

After the Depression, as times eased up a bit, the cats playing jazz were more sure of their power and their sound, and the new young blowers and drummers and bass-slappers were mostly able to read music, talk of Ravel and Debussy, and before long I heard terms like Free Jazz, Cool Jazz, Hard Jazz, and New Music Quartets "playing polyphonically against each other." Electric circuits brought in tricks and tape recording; stereo, multi-channels; jazz was hunting the elusive. Today watching Ornette Coleman make a tape is like being in the belly of a space ship with glowing control panels blinking, in computer-dominated control rooms, with floor crews, sound tables, banks of transistors, blending of tapes on tapes. It was no more the early years of jazz or of listening to a pickup combo doing record cutting in a Jersey City warehouse loft where the drummer, Big Toots, is telling me during a recording of "Royal Garden Blues": "Everybody talking of this new way of recording, Electric Recording. Well, we got it too." I said I didn't see it, and Big Toots pointed to one lonely electric light bulb hanging from a rafter. "There man, there."

No matter what you called it or where you heard it, jazz was still—as John Coltrane told it to some of us— "the only original American art created here in this republic, and it didn't come from any other place, like opera or the classic concert stuff, abstract painting or the forms that made poems."

I claim no great vision, but as a genre historian and graphic artist for over half a century, I have played a very small part in the recording of jazz history. In 1947, I was asked to write the screenplay for the motion picture The Jolson Story, in which I tried to show the difference between the real jazz and Jolson's Tin Pan Alley-created kind of schmaltzy "Mammy" sentimentality. But somehow, the jazz part was nearly all cut from the film. I then did a film version of Young Man with a Horn, a novel loosely based on the life of Bix Beiderbecke. One of the studio production heads told me there was too much black jazz in the script and "not enough rootin' for the white boy." When I didn't make changes, another version, not mine, became the final film. I worked on The Helen Morgan Story, in which I tried to insert the values of what was the 1920s image called "The Jazz Age." But I felt the director's final version false and feeble.

I still had hopes of helping bring true jazz to the screen. The last time I met Louie Armstrong was on the set of Hello Dolly, in which he had a musical segment. He was in his prime as we slapped palms, and we talked of doing a motion picture feature of his life. But no studio showed any interest in the idea when it was presented to them.

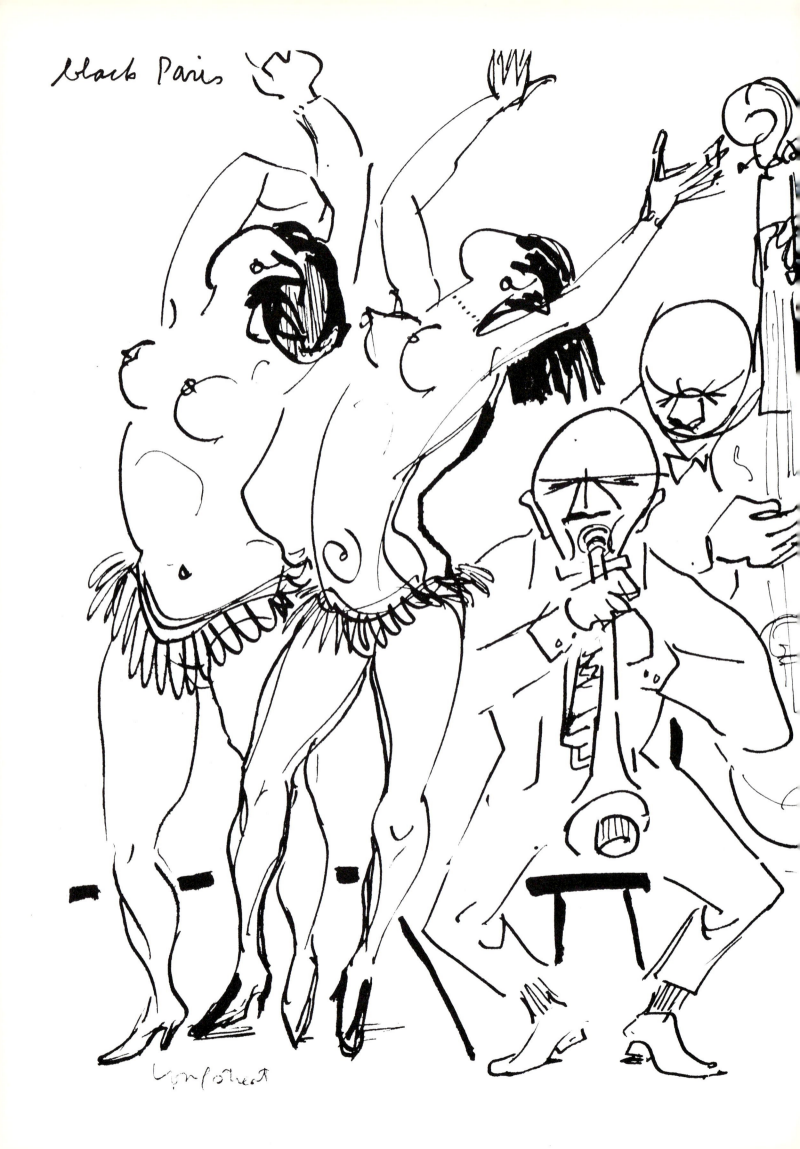

Chicago 3AM

In 1947 I did write a play set in the New Brunswick of 1913 involving the changeover from ragtime to early jazz as seen through the eyes of an ordinary family (my own) and featuring some of the Rutgers football team. I originally wanted to use actual ragtime music and true early jazz, but when the play got into production, the excellent composer and witty lyric writer had to conform to the producers' demand for popular music. One of the hit songs from High Button Shoes was "Nobody Ever Died For Dear Old Rutgers." It ran three years on Broadway and has been played all over the world ever since. I had planned to do a play on the life of Buddy Bolden, but the producers were never able to raise the money for the production. It seemed that everything I had to say about the jazz world would be in the form of graphic art and books.

I do not claim to be a jazz critic, nor an expert on the technical aspects of the music. My interest has been to hear and enjoy, to record in line and color its scenes and performers; to set out in texts my impressions and intimacy with some of the men and women who were jazz, are jazz, how they sounded, what shadows they cast, what they said and felt; to capture in other visual and verbal mediums, the color, smell, sound, atmosphere, and the human condition of the music and its joys and miseries. To sum up what I feel about jazz, there is a line from Kafka. "What does it all matter, as long as the wounds fit the arrows . . . "

11

The other books on jazz I have published (The Real Jazz Old and New, Du Jazz *and* Sporting House) were texts with some illustrations; this one is a graphic presentation of drawings going back to 1925. The text for the picture was often taken from notes made on the back of the drawing.

I was fortunate to be there when most of the pioneers were still alive and I knew and was friendly with many of them. They are nearly all gone now— both the famous and the nearly forgotten. While this is a personal record, it salvages some of what might have been lost both as graphic images and texts created directly in their

periods—periods that can be clearly identified by the changing styles of an artist as he moved in over fifty years through time to this once-new beat.

Stephen Longstreet
Miradero Road
California – 1986

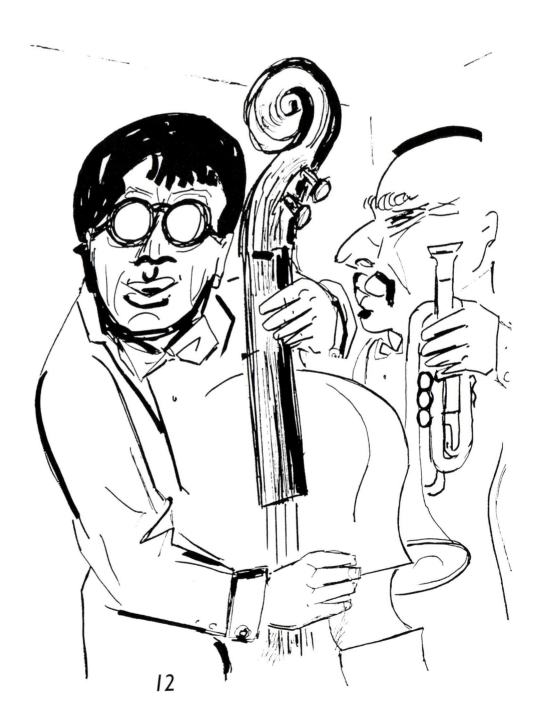

12

former jazz trio

New Orleans

new Orleans is in southeastern Louisiana, on the Mississippi River, 40 miles north of the Gulf of Mexico. The original settlement was founded by Sieur de Bienville, named for the Duke of Orleans. In 1762, against the wishes of French inhabitants, New Orleans was ceded to Spain. In 1803 it was given back to France and days later ceded to the United States under the terms of the Louisiana Purchase. The city was twice subjected to military assault. In 1815 General Andrew Jackson successfully defended it against a British attack at the Battle of New Orleans—the final engagement of the War of 1812. In 1862 the city, a Confederate stronghold, was captured and occupied by Union forces. New Orleans is the chief cotton market of the United States. Also jazz music, an original American art form, was created here.

—*From an old guide book*

15

The Big Muddy

arly on the Mississippi became a highway that moved, and the first boats gave way to better ones. The first, called the New Orleans, *left Pittsburgh for a trip down the Ohio and Mississippi rivers to New Orleans, January, 1812. Top speed upstream, two miles an hour, better than keelboat. Other river boats were* Comet, Vesuvius *and* Enterprise.

By 1834, 230 steamboats in the Mississippi river trade soon increased to 450, with black music makers in the grand salon every night. Between New Orleans and Louisville, the Enterprise *made the trip in just under twenty-six days. The* Diana *got the five hundred dollars in gold the Post Office offered to the first boat running New Orleans to Louisville in less than six days. In 1858, the* A. L. Shotwell *made it in four days, nine hours and nineteen minutes, and the band played loudly.*

Mark Twain and the show biz productions of Show Boat *—and you can add "Ol' Man River"—have an American legend about the river: the Mississippi that begins way up north and ends at New Orleans. On the return trip it carried jazz, the men and some women who acted as the Daniel Boones of the music. An old horn player remembers, "Got my start as a kid, playing jazz on deck, and folks throwing coins into my cap at my feet. Alus learn not to shoot crap with the boiler crew."*

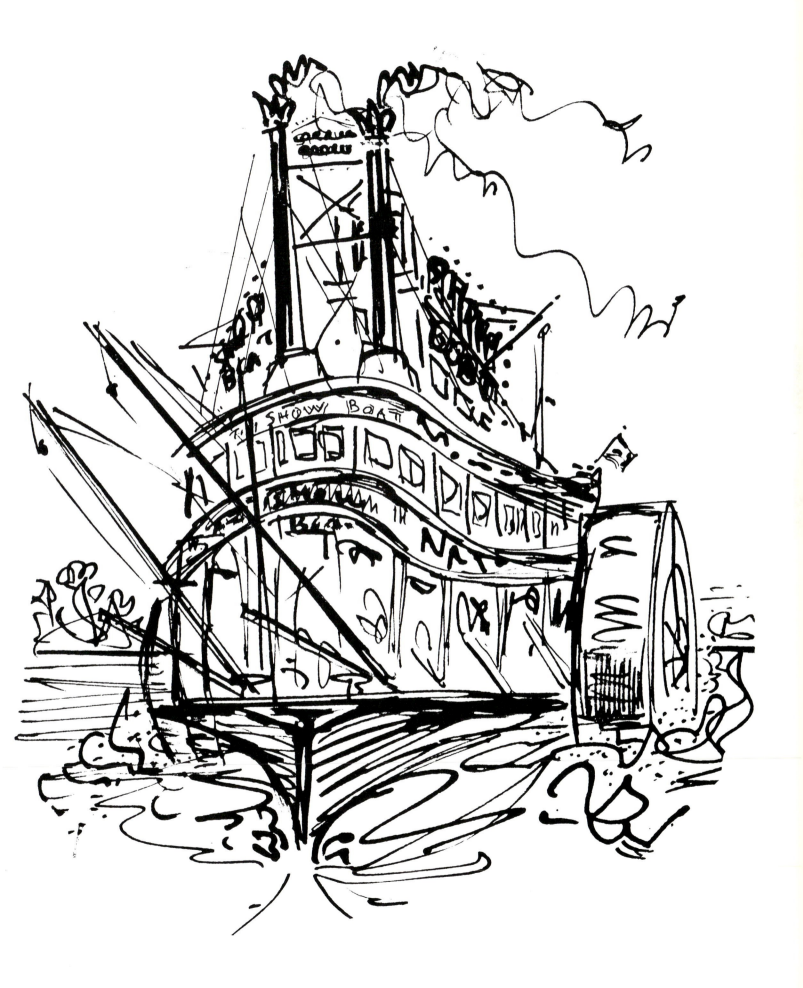

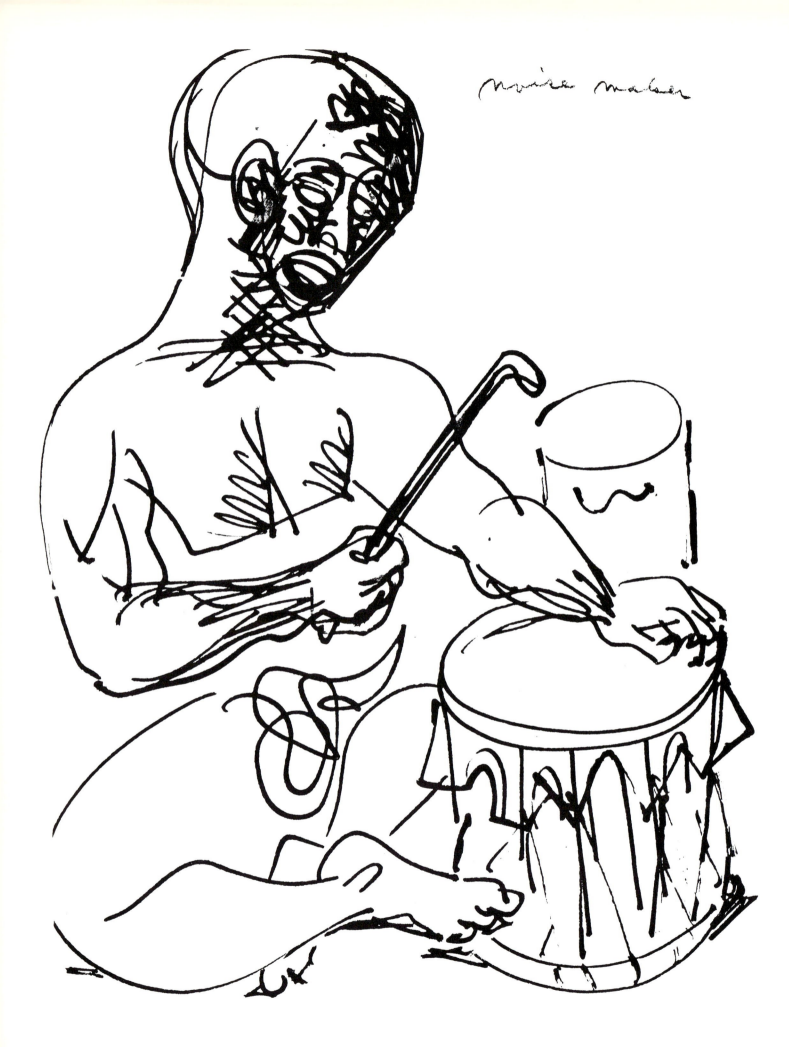

Utter Abandon

ear the end of the 19th century, you saw the not yet finalized forms of jazz beginning to draw together.

But study the report of one early observer. "We have never observed in any of the dance houses of Gallatin or Barracks Street, or the ballrooms of the demi-monde further downtown, the utter abandon which has characterized these places. A hall would be filled with some two or three hundred scowling, blackbearded, redshirted visitors coming from every port, prison and lazarhouse, and presenting such a motley throng as Lafitte or any of the pirates of the Gulf might have gathered for their crews. With a piano and two or three trombones for an orchestra, and with dances so abandoned and reckless that the cancan in comparison seemed maidenly and respectable, one can form an idea of what the scene was."

19

Legal Sin

f course there was debate. The police and the political grafters had to be reassured there would still be an income from regulating and seeing that certain rules were enforced. By July of 1897, an ordinance was remodeled to provide for two segregated districts, one in the French Quarter and the other above Canal Street. So it came to pass, legal sporting houses could even have music.

Be It Ordained, by the Common Council of the City of New Orleans, That Section 1, of Ordinance 13,032 C.S. . . . is hereby amended as follows: From and after the first of October, 1897, it shall be unlawful for any prostitute or woman notoriously abandoned to lewdness, to occupy, inhabit, live or sleep in any house, room or closet, situated without the following limits, viz: From the South side of Customhouse Street to the North side of St. Louis Street, and from the lower or wood side of North Basin Street to the lower or wood side of Robertson Street: 2nd: And from the upper side of Perdido Street to the lower side of Gravier Street, and from the river side of Franklin Street to the lower or wood side of Locust Street, provided that nothing herein shall be so construed as to authorize any lewd woman to occupy a house, room or closet in any portion of the city. It shall be unlawful to open, operate or carry on any cabaret, concert-saloon or place where can can, clodoche or similar female dancing or sensational performances are shown, without the following limits, viz: from the lower side of N. Basin Street to the lower side of N. Robertson Street, and from the south side of Customhouse Street to the north side of St. Louis Street.

interior
sporting house

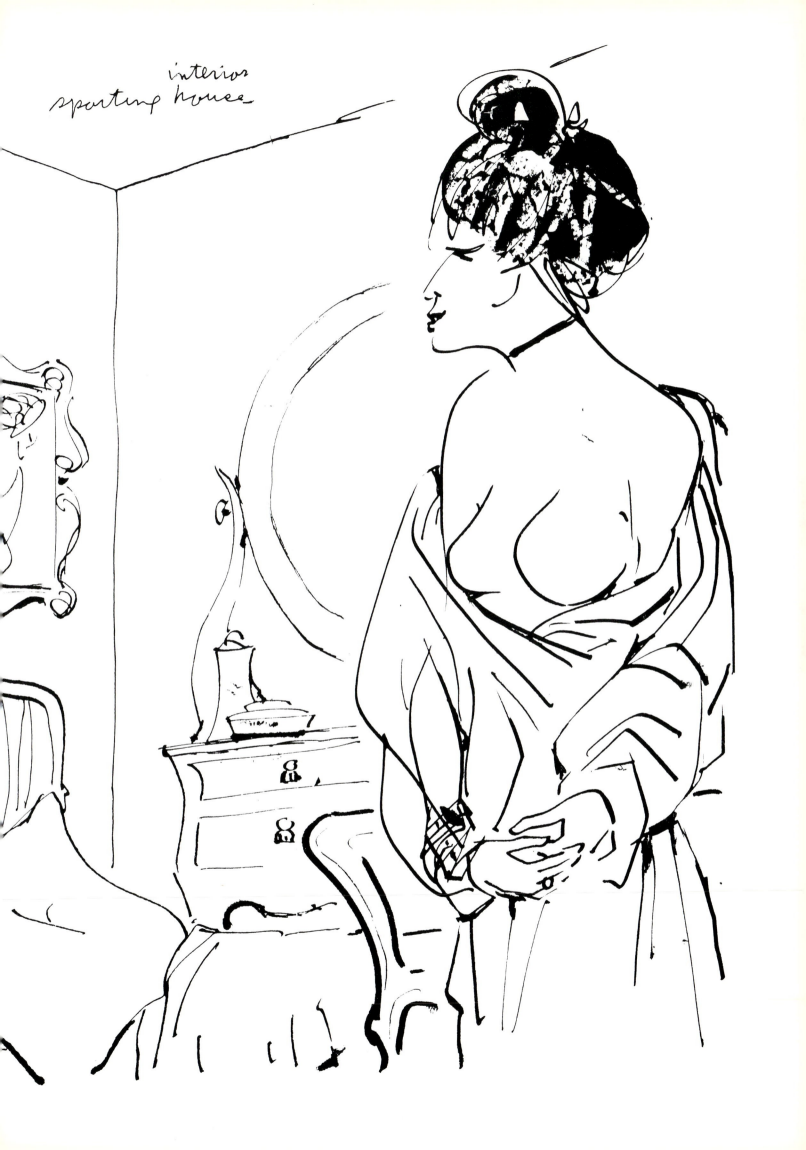

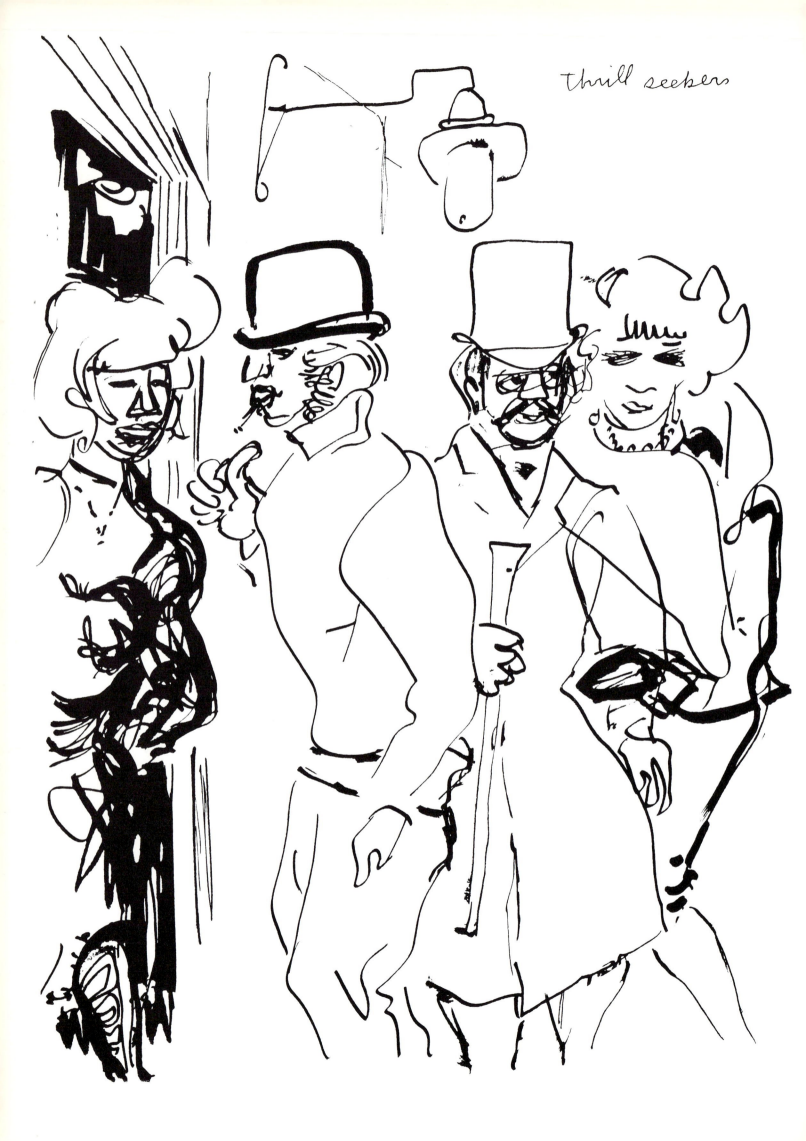

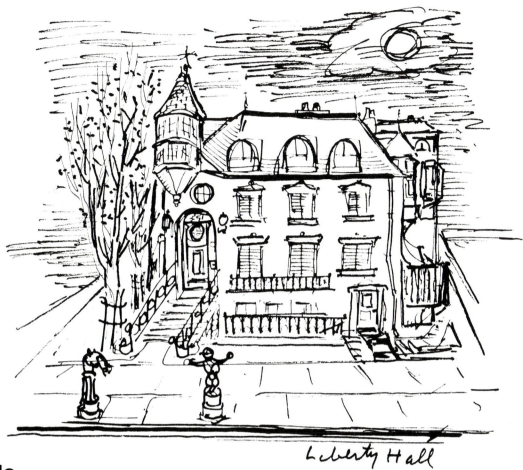

Liberty Hall

Storyville

arly jazz got a rough start. Storyville was created because harlotry, crime, and the importing of whores and their fancy men and protectors were getting out of hand in New Orleans. By the middle of the 1880s the queen of the sporting houses was Gertie Livingston in the old Peed House on Burgundy Street, run, as she put it, for "a nice class of trade." Her girls were feisty and given to the use of fingernails and fists and any weapon at hand including the boîte a l'ordure. One of her girls bit off another girl's finger in a fight and was tossed out into the street, the madame holding her trunk because it contained four dozen towels. As one paper put it: "Helen does not think Gertie has any right to withhold the trunk, as the towels come under the act that provides that a workman's tools cannot be retained." The same was to apply to jazz instruments.

Often after some private party or convention meeting, some of the men would "go down the line" and visit some sporting houses, sometimes just to add a few drinks, listen to the jazz trio, jolly the girls, but not to go upstairs. Jelly Roll Morton recalled a New Year's night when one guest brought a lady friend to hear Jelly Roll play. Nell Kimball said: "Ladies came—it could happen at times, but it was rare."

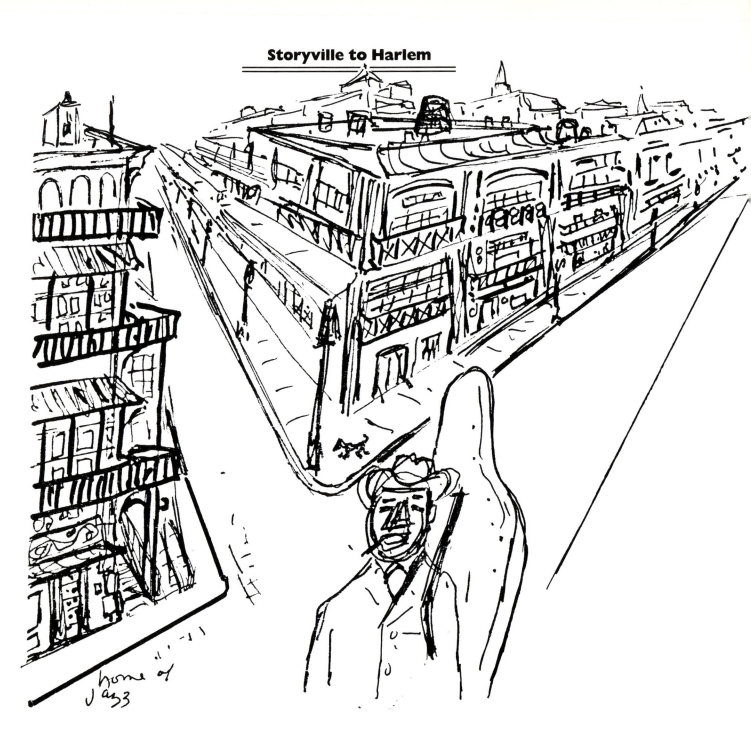

The Start

After Robert E. Lee threw in the towel, many Confederate army bands dumped their instruments in New Orleans pawn shops. Blacks bought the music tools cheaply, began to play with no knowledge of reading music or the proper way to handle slides or valves, so they played the popular ragtime their own way. The sounds in the night over the howls of whores and drunken sailors were the first wha-wha sounds of jazz. Then from here to the houses where a jazzman could play his music in surroundings fairly free of the fear of being killed in a street or bar brawl.

As one later told me: "Kept us out of the rain or them street parades and riverside picnic celebrations. Four walls and a hatful of sportin' house silver dollars for us black boys: 'pianner', horn and tail gate trombone."

24

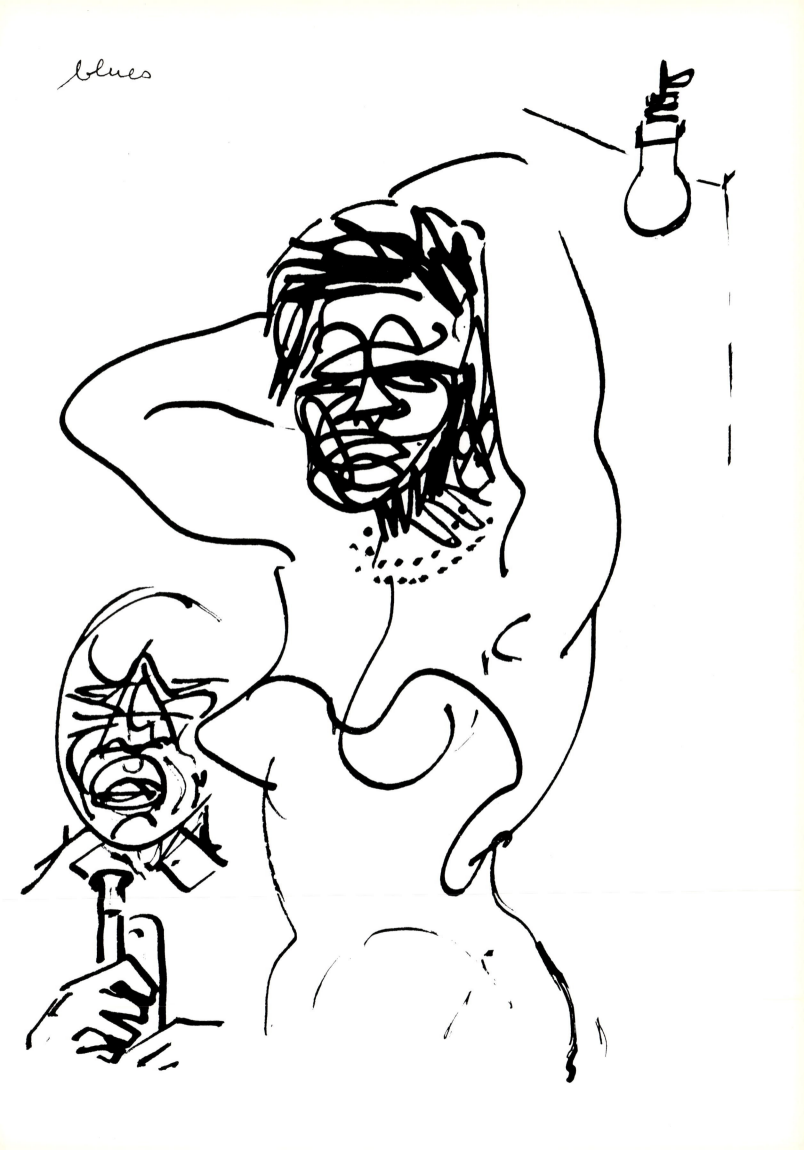

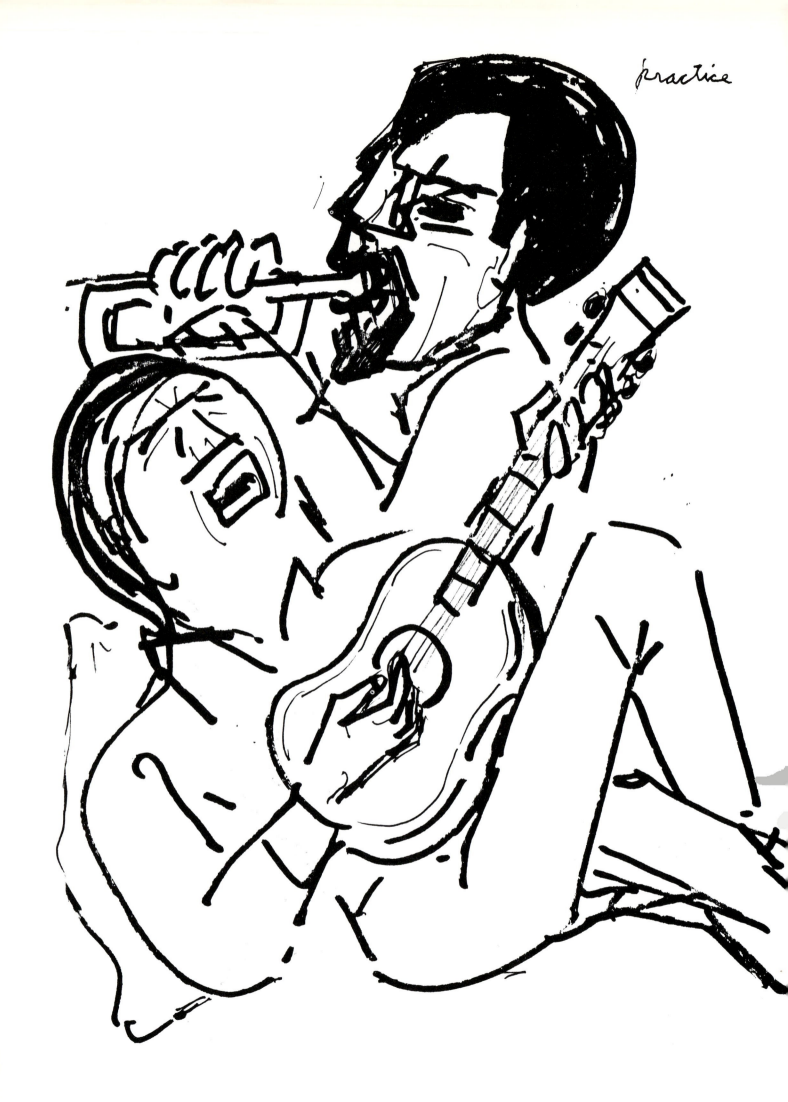

It's a Poor Living

ou just felt good to be playing the music, but it wasn't you that made the big jack, the crisp green sawbucks and C-notes. They went into the hands of the madams and the club bosses. For the average Joe, it was coffee and cake, red beans and rice, a free drink for the piano player and a pint jug of white mule in the banjo case for the band.

Storyville was Liberty Hall for Whitey, and the visitor came out of the Southern Railroad Station on Canal Street, looking for a hack or the early taxis, a hotel room and then for a night on the town. White or black poontang. And many tried the colored joints first.

> Gimme a pigfoot
> An' a bottle of beer.
> Send me gate. I don't care
> Gimme a reefer
> An' a gang of gin.

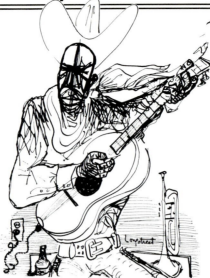

Congo Square

the right people ("the quality") always struggled—not too strongly—against the idea that they got rich making tainted money from their real estate leased for whorehouses, their businesses supply- ing the wines, gourmet items and bourbon, linens, crystal hangings for the pleasures of sinners. But they bravely fought off their doubts. An early guide book points out one of the sights that visitors should not miss: "Circus public square is very noted on account of its being the place where the Congo and other Negroes dance, carouse and debauch on the Sabbath, to the great injury of the morals of the rising generation; it is a foolish custom, that elicits the ridicule of most respectable persons who visit the city; but if it is not considered good policy to abolish the practice entirely, surely they could be ordered to assemble at some place more distant from the houses, by which means the evil would be measurably remedied."

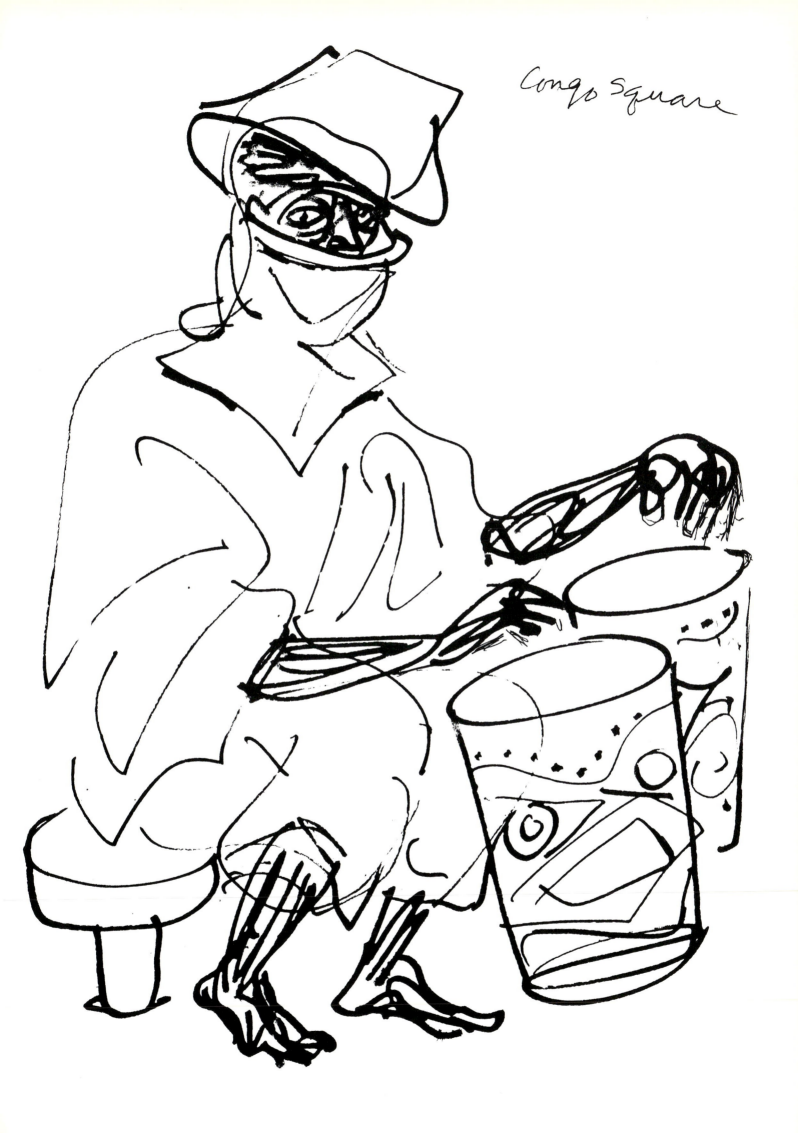

Congo Square

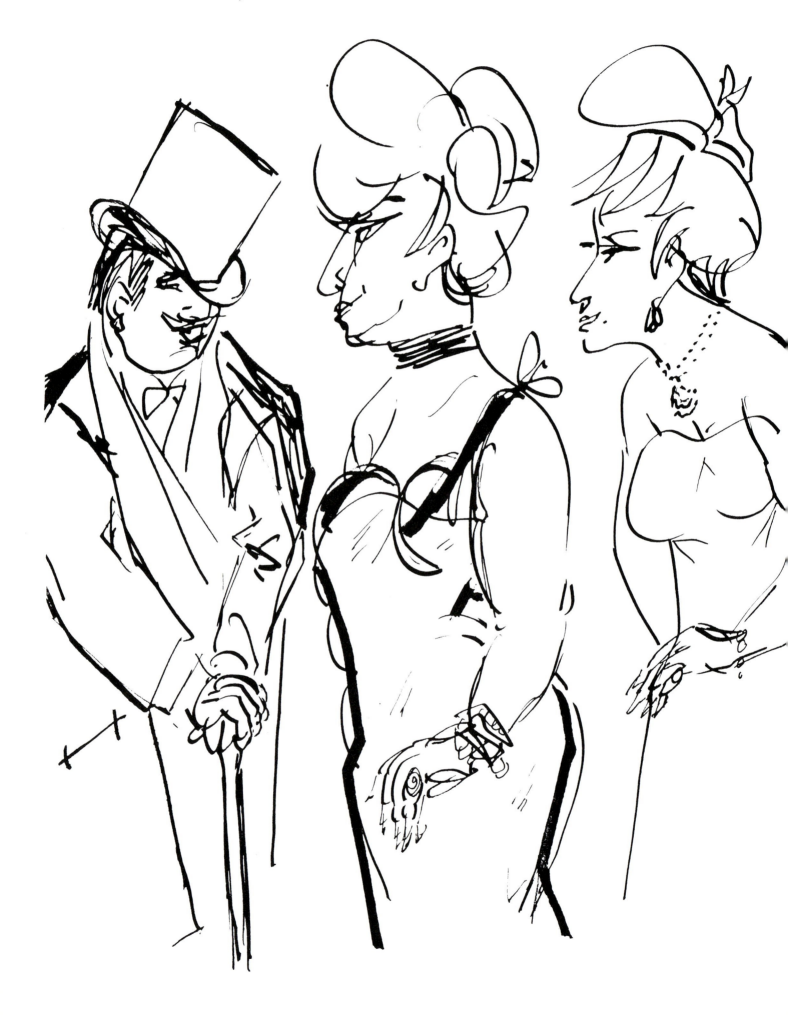

The End of Storyville

"The end of something," Big Toots said, "is that you see it coming and you find it done after it ends. But the end is on you, too, sudden, and over fast like a snap of a finger. And you look back and man, you say it sure happened all of a sudden . . . it sure did."

So Storyville, after fear and trembling, after hard talk and rumor, came to its end. According to Nell Kimball, the navy and the Federal Government had decreed that "good Christian boys keep their flies buttoned and their bowels open." The idea was that young men in the vigor of their youth could be satisfied with magazines, songs and free doughnuts.

By midnight of November 12, 1917, it was unlawful to operate a brothel or assignation or sporting house in New Orleans. Some felt the brothels would be given protection and would be reopened. Fire insurance companies had cancelled policies in Storyville. The state fire marshal investigated rumors to burn the whole district. The respectable people who owned the properties demanded protection.

"Cowboy Blues"

The Spasm Band

f you're black and the going hard, no papa around, and mama scufflin' for a living, you live in the streets and you get street wise. You see where you can make a bit selling papers, sweeping up or liberating something: hub caps, stray bikes. Then comes music: it can bring a few coins to buy a hero sandwich or a pack of smokes. So you are one of a group of musicians who play in the streets and saloons for coins and drinks. Some from twelve to fifteen years old called themselves The Spasm Band. These Spasm boys had what might be termed the original jazz band. One organizer, Harry Gregson, sang through a piece of gas pipe; couldn't afford a megaphone. The boys screamed "hi-de-hi" and "ho-de-ho," expressions used in river songs.

The Spasm Band first appeared in New Orleans long ago, playing in front of theatres and in saloons and brothels. Even had a few engagements at the West End Grand Opera House. The Haymarket Dance Hall on Customhouse Street had musicians called the Razy Dazy Spasm Band—until the original Spasm Band made hard protest with stones and bricks and the title was changed to Razy Dazy Jazzy Band.

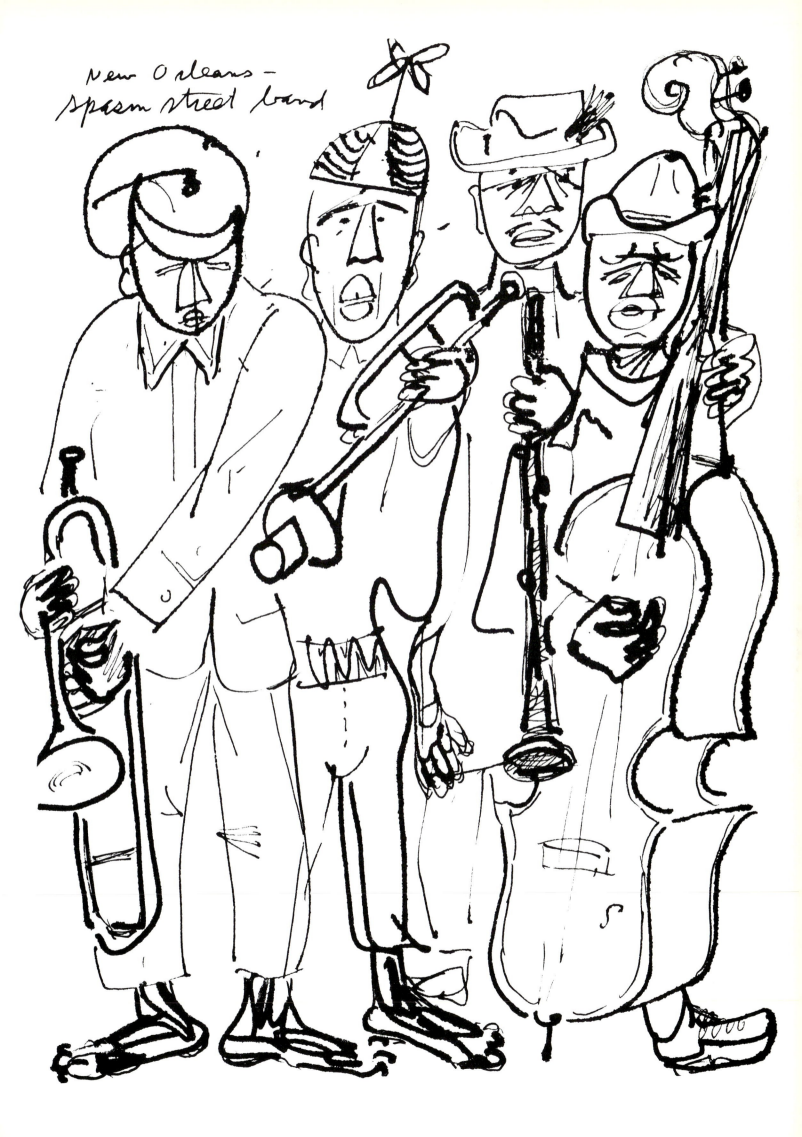

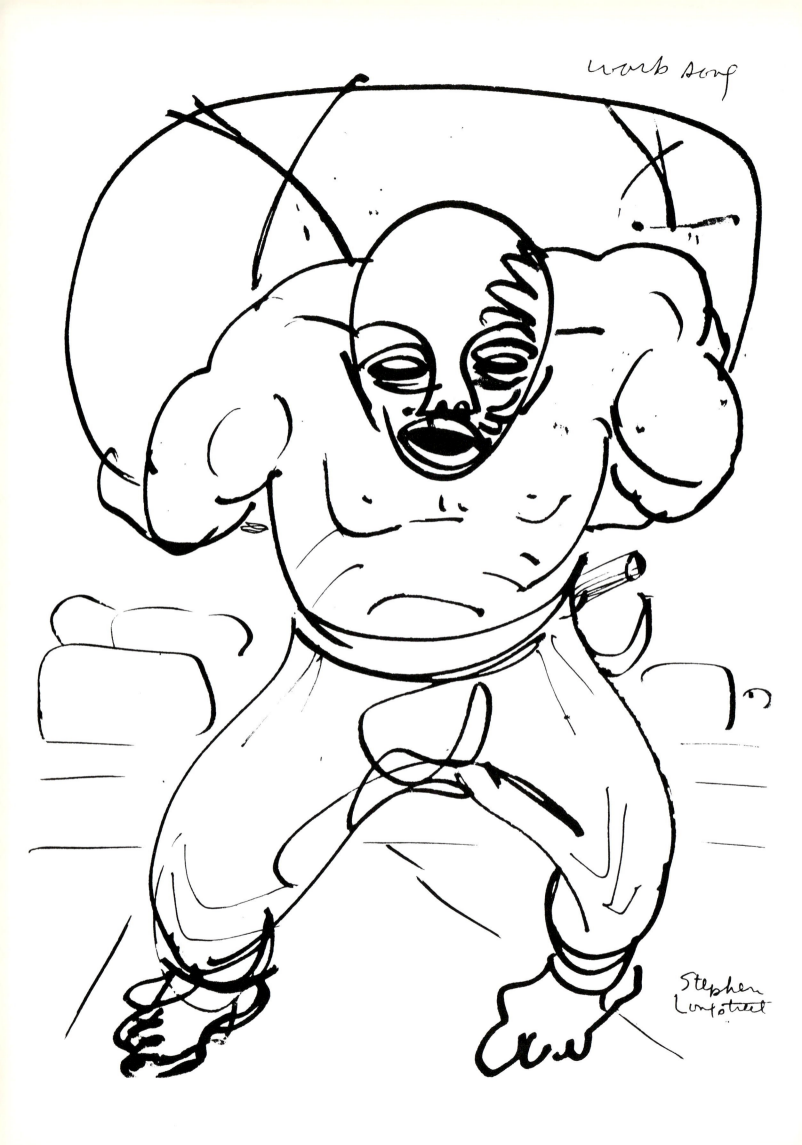

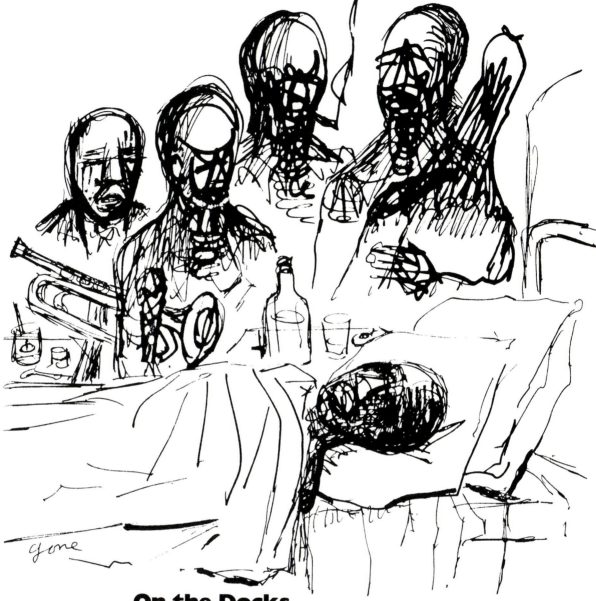

On the Docks

jimmy Welton, an old jazz musician, used to object to the movie scenes: "All those chorus groups of grinning darkies, backed by a twenty piece off-stage band, all the jigging and fancy dancing. But if you ever saw the real docks and piers with big load carriers and accidents, you found the singing was sad ass and nothing about which to prance. 'Dog Tired' was the only tune I ever remember hearing."

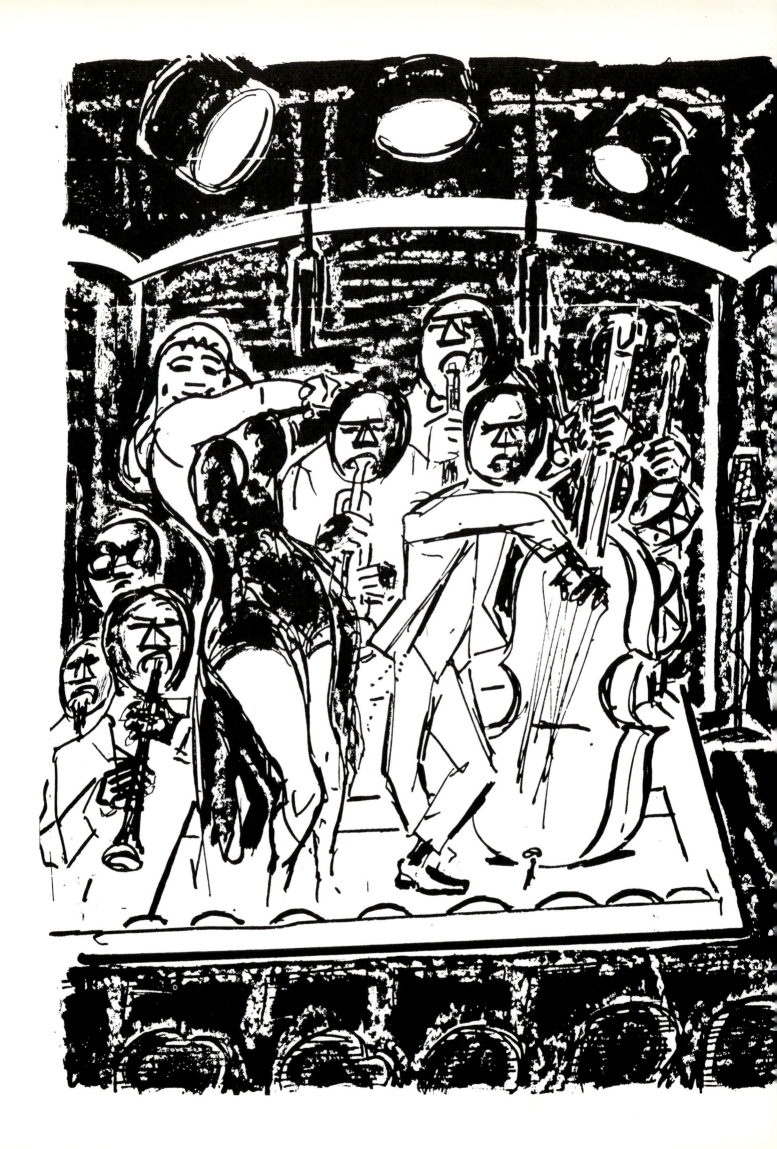

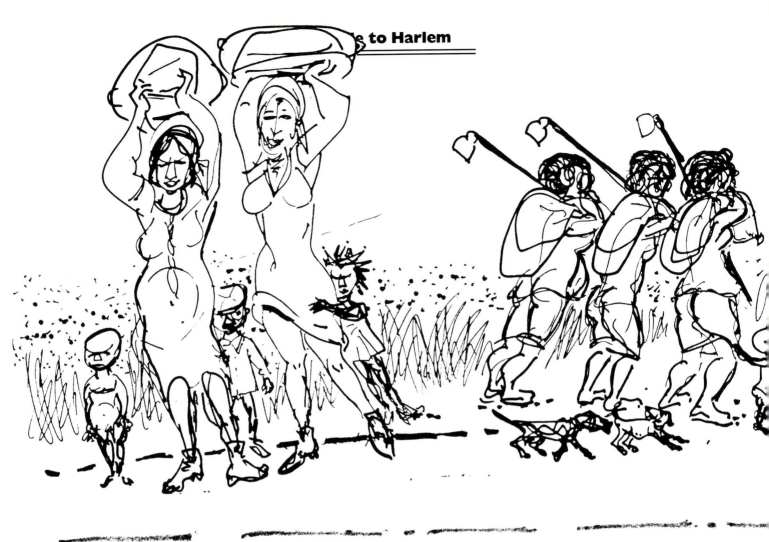

Work Songs

Work songs are usually sung by men. But I've heard unrecorded songs by women on market days in Richmond and Lake Charles; "Short Hours and Long Days" and "Liftin' and Carryin'." There were also some kind of grunting songs for lifting loads, which may have come before scat singing: Um-um ah-ah, yeah-yeah, um-um.

38

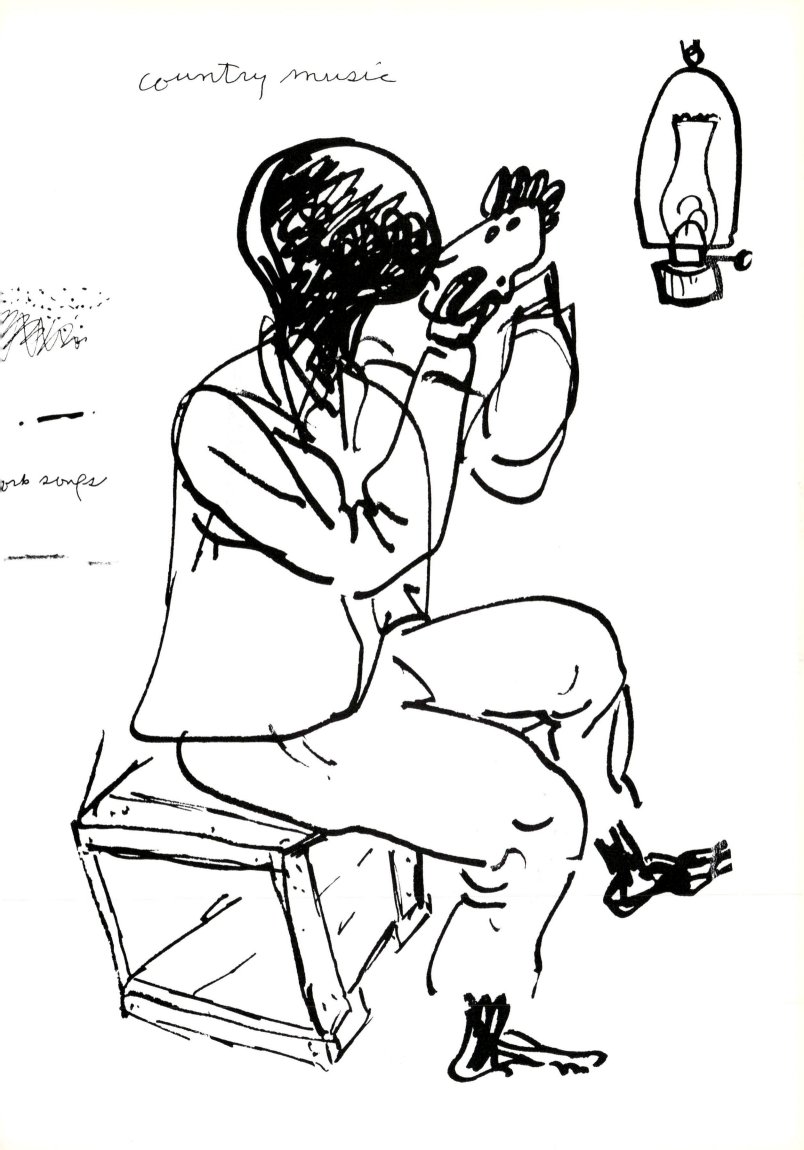

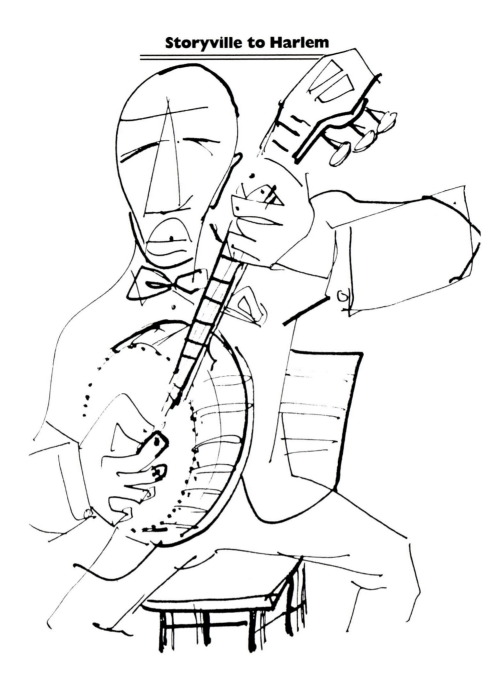

Mule Music

I n the turpentine camps, logging tracts, the banjo was popular. Some called it "mule music" as a jackass would often raise his own voice on hearing the picking on the strings of "Pine Top Blues."

40

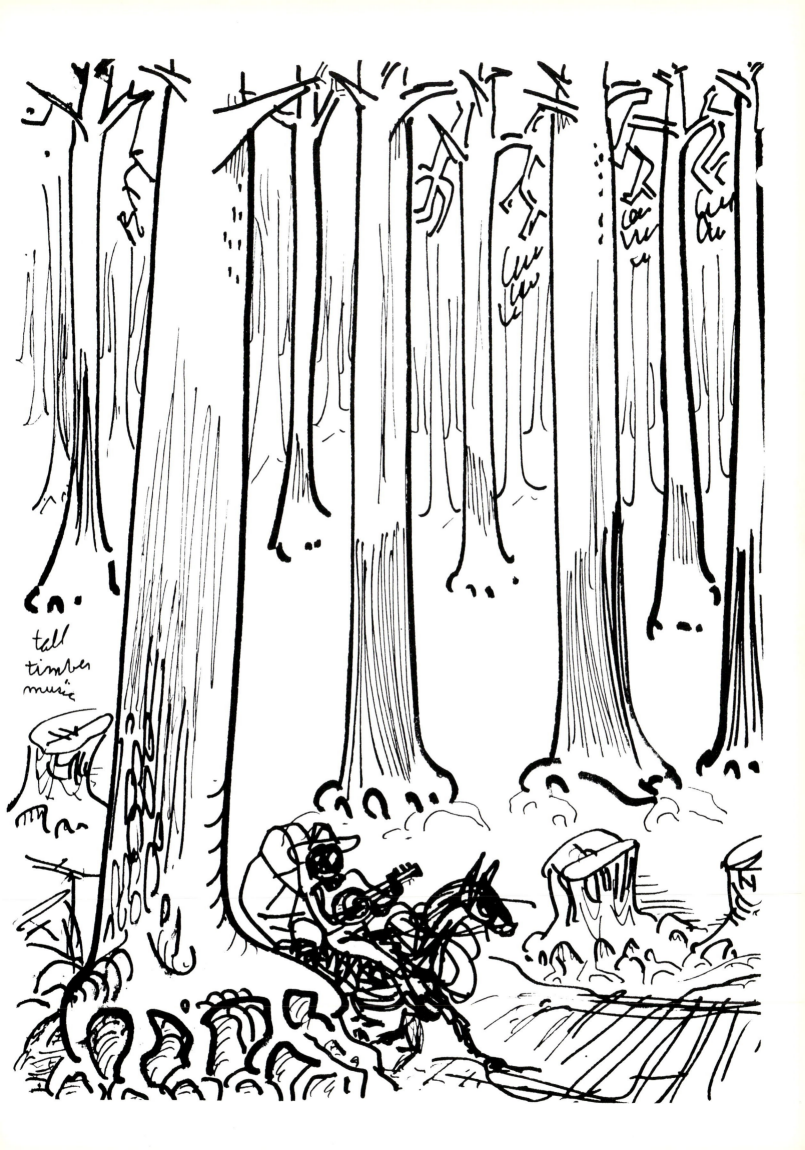

Jailhouse and Field Hollers

r ecently—but less and less—you could still find someone who could recall from personal history the music of the chain gangs, field workers, the river workers; all had their holler, and some of it went into the blues, and some of it echoes in jazz. It was a song that helped lift the bale or hoe a row chopping cotton. "And when you're in the clink, music was a jew's harp, a mouth organ or just your voice," an old clarinet player told me when I had a show of jazz art at a Memphis museum in 1979. "I got the scars to prove I made jail music. Sometimes there was a banjo and you picked at it and sang low to yourself or the other prisoners. Oh, the music helped, cut the misery."

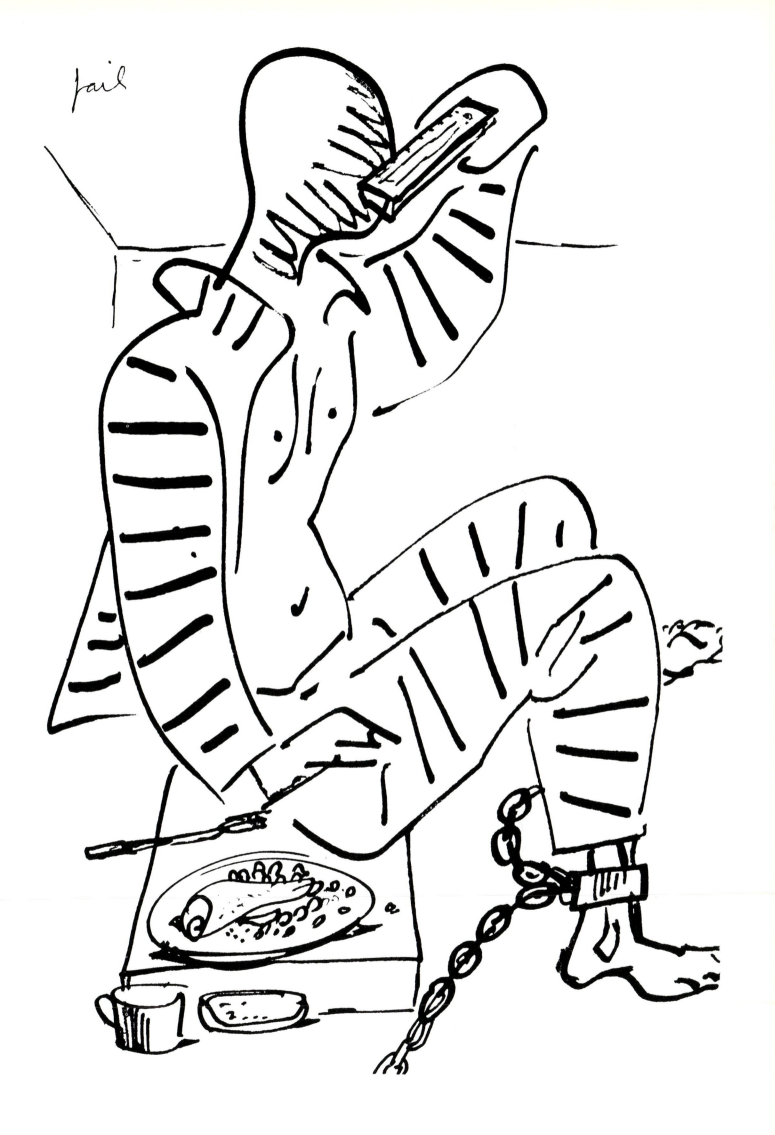

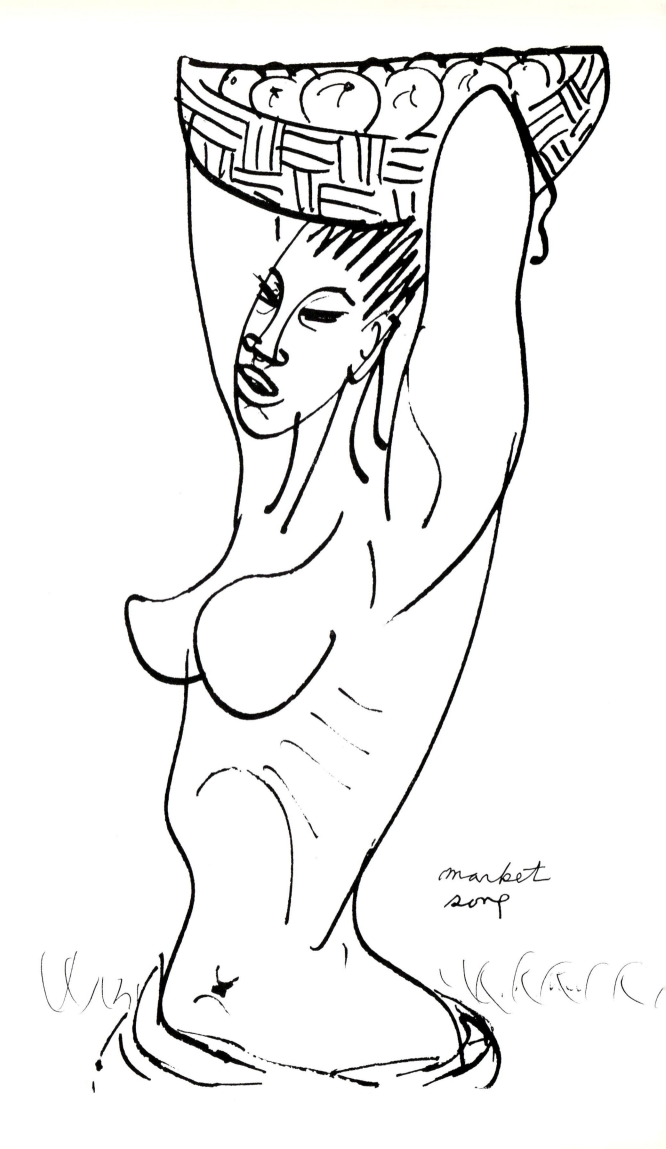

market
song

Church and Field

a lot of what they played and created was from their lives, the church, versions of "Swing Low, Sweet Chariot." The church music had feeling and sounded so good: like the laments in "On That Great Gittin'-Up Mornin'," "I Hope My

Mother Will Be There," and "I Hear Them Bones (of Jesus) Talking."

But not all folk were pious; singin' churchy wasn't enough. Working to song took some of the pain out—and the music took on the beat of bending down, carrying and lifting.

The blacks sang as they cut cotton or hoed 'taters, carried water, chopped

cane, tied leaf tobacco. Sang on the levee and on the railroad, shouted, hollered in the streets, selling soft-shelled crabs and York cabbage. They made it a street dance, and a jail song when "free labor" was needed and they were put in a chain gang. Later, folks in evening clothes sat at concerts to hear Paul Robeson sing "Water Boy."

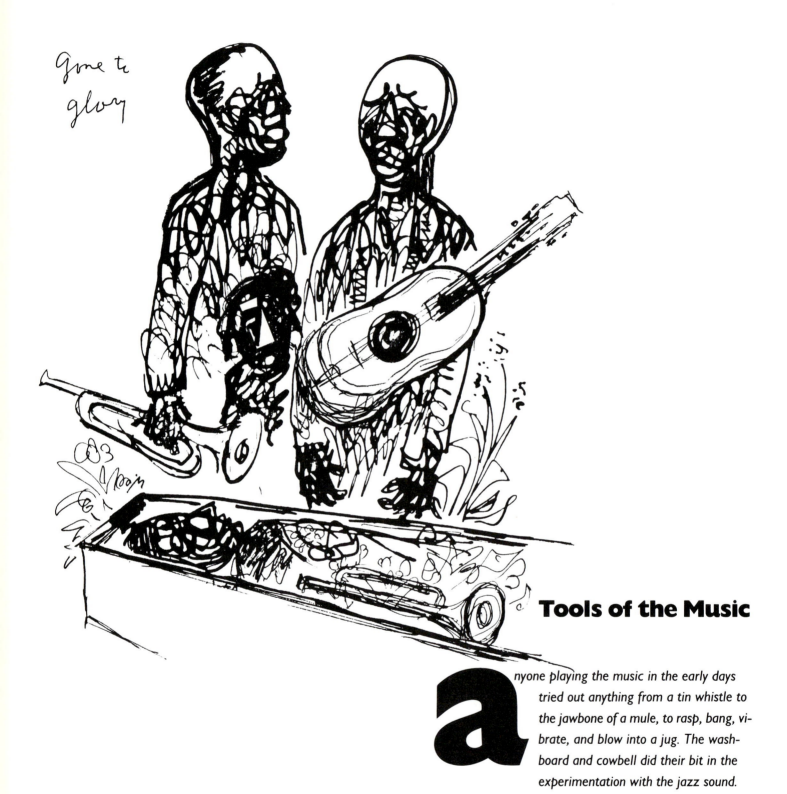

Gone to glory

Tools of the Music

anyone playing the music in the early days tried out anything from a tin whistle to the jawbone of a mule, to rasp, bang, vibrate, and blow into a jug. The washboard and cowbell did their bit in the experimentation with the jazz sound.

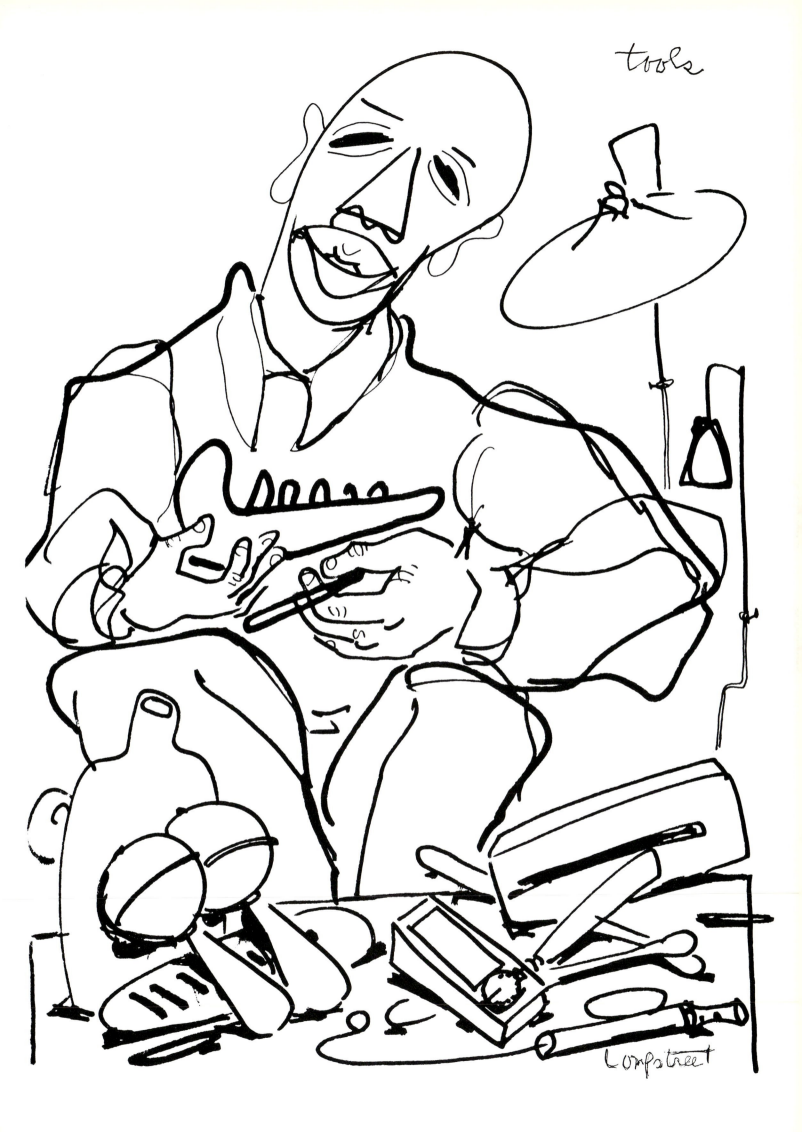

Jesus Saves

Congotreet

In the Field

thomas Jefferson wrote: "In music the Negroes are more . . . gifted than the whites. . . . The instrument proper to them is the banjar. . . ." Songs were sung in the farm jails of Texas, Louisiana and Mississippi. The work holler, the river holler are all different. The field holler is 'Don't Mind De Weather." You find good hollers in many of Leadbelly's recordings and songs—Huddie Ledbetter that is. "The King of the Twelve String Guitar" and the last of the old field and jailhouse holler singers.

On the Road Music

not all jazz musicians went north by river boat or by train. Some, like Jimmy Welton, drifted from town to town "picking up distance and always pointing our hopes north. In the south there was danger from counties needing recruits for the chain gangs, and in the north being rousted to move on, the tin star wanting no strange Negroes in town."

53

Lost Music

his is the only drawing in the book suggested by a photograph. The snapshot was shown to me by a southern doctor. All he recalls of the victim is that he was known as "Fingers," and played piano in back road villages.

alone

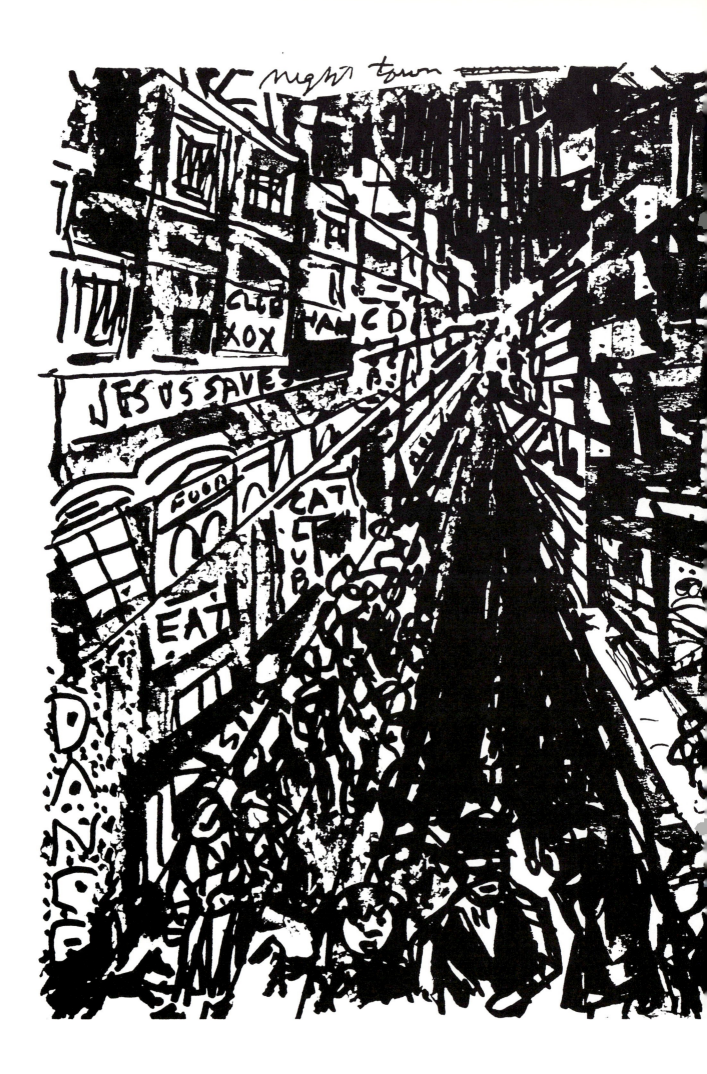

Chicago

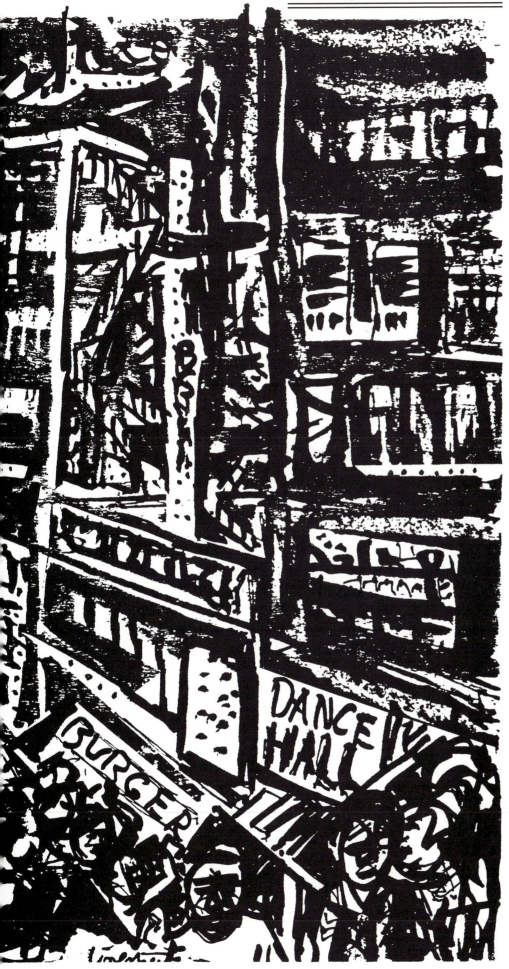

Chicago, the second largest city in the country, is in northeast Illinois, on the southwest of Lake Michigan. The Frenchmen Joliet and Marquette were the first to explore the area in about 1673. In 1795, the United States acquired the territory by treaty with the Indians. Eight years later Fort Dearborn was constructed there, to be abandoned and destroyed in the War of 1812. A new town took root and was finally chartered as the city of Chicago in 1837. Much of the city was destroyed in the great fire of 1871 but it recovered quickly and soon took its place as one of the great cities of the world.

Chicago is a gigantic industrial economic center. Fond of large scale fairs and shows, proud tall buildings, it is American in its delight in big—the biggest commercial building, the biggest stockyard and biggest conventions. Once notorious for political graft and Al Capone, Chicago also in the 1920s brought jazz to national attention.

—*From an old guidebook*

Chicago Chicago

You could say, and perhaps truly, that Al Capone was the patron saint bringing jazz into the wider range of the American scene. As the old-time jazz musicians with whom I talked, explained it: when the Navy closed the sporting houses of Storyville in 1917, a lot of jazz musicians working for coffee and cakes, a survival income, were out in the cold.

The jazz people began to drift north, not the big exodus of popular imagination, but taking to the river boats, going up to Kansas City, Memphis, and then the nation had Prohibition, drinking the hard stuff or illegal beer. Mr. Alphonso Capone was buying the state, the city, the aldermen, the police, some of the press. Scarface took over night clubs, moved in on roadhouses. For these there was a need for a wilder music, and there were all these band boys looking for work. The mob began to hire jazz combos, put them to playing jass or jazz. It was in Chicago that the saxophone first became really popular with the band men.

59

Capone Time

here had been some jazz sounds in Chicago as early as 1915: Brown's Dixieland Jass Band. But it wasn't until the early twenties that what was to be called Chicago style emerged— which was really New Orleans style and what new patterns it had picked up along the river. It began to attract at-tention, almost as much as the rub-outs and gang wars, the daily hustle to make a buck, peddle "alki," and take over a district. The Thompson machine gun matched the jackass bray of the trombone. You'd meet the pleasure seekers, the flappers and the drug store cowboys that John Held Jr. was drawing, and also the hoods with a lump under the left arm pit; George F. Babbitt at conventions (as seen by Sinclair Lewis) having high old times on the hooch, wearing funny hats, rattling noise-makers while the jazz band, which had added a piano to its saxophone tones, played a lot of dance music and let a brass solo ring out. The chorus girls did early versions of what would be the Charleston, the black Bottom. Gilda Gray added the shimmy.

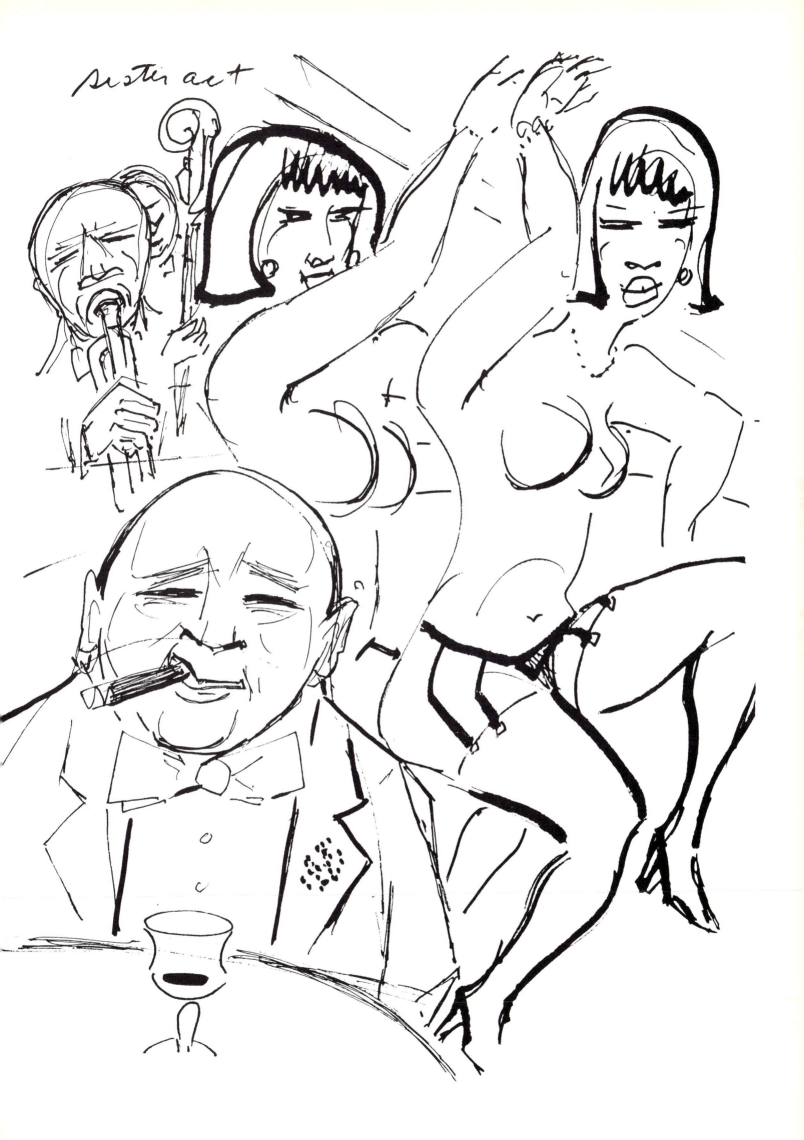

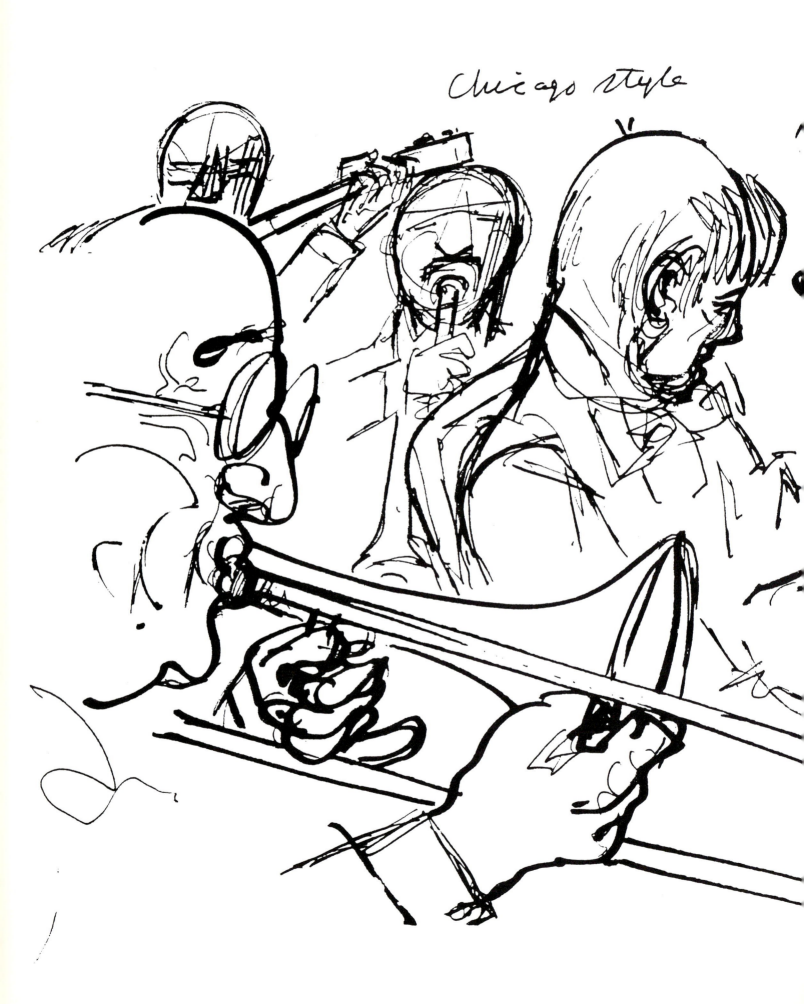

Who Came First?

"Just when jazz first came to Chicago is as much a hassle as which came first, the chick or the omelette filling," Big Toots would say. "Some played it early. They played jazz, shaking from the cold lake breeze blowing in worn-down shoes and pants. There were fancy places, but not for most. Pony Moore's, the Everleigh Club. They had piano players and a band." Bennie Harney, Tony Jackson, Jelly Roll Morton, playing in the houses and at the Elite or Dago and Russell's. Upright pianos with a kitty to feed. Men like Joe Oliver, Fred Keppard. You can hear that early sound for the Oliver band recorded with Gennett, Paramount, Okeh and Columbia. Over thirty-seven sides, some of the first jazz classics, "Mabel's Dream," "Canal Street Blues," "Mandy Lee Blues."

It was like an exciting infection. The Rhythm Kings, white boys, at the Cascades Ballroom and at Friar Inn. Black-and-white jazz sounds. The whites studied the King and his music— played it their way and set what was going to be Chicago style.

63

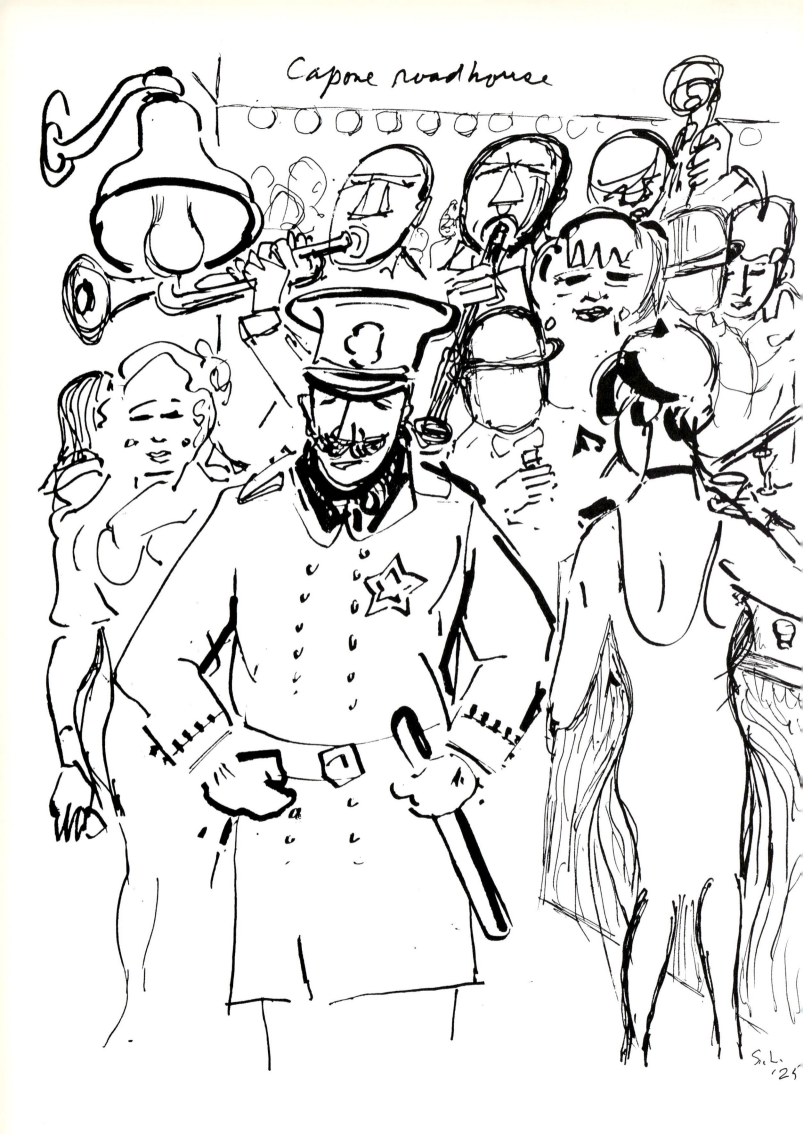

Capone roadhouse

Roadhouse

the white trade would be driving up to a roadhouse in their Model-T, Packard or Stutz Bearcat, the escort young Joe College in raccoon coat, and the flapper with shingled hair, little underwear, flat-chested, long-legged, with rolled stockings. Some critics were to think of it all later as The Jazz Age, The Roaring Twenties. Or did the writers, the movies brainwash us later with the big doses of Old Nostalgia vintage 1920–1929?

It didn't matter, and the young white musicians were coming to hear more black sounds in the Capone joints, hear the new ways of playing. Somewhere high school students played "moldy fig" offerings of the late Stephen Foster and cakewalk ragtime.

But Benny Goodman, Bix Beiderbecke and others were listening hard to King Oliver, Jelly Roll's Red Hot Peppers. Louie had his Hot Five. So were brought together the white lads to try the new rhythms, and call themselves the Wolverines. The black and the white jazz people did their thing, separately, and the blues singers were exciting the customers.

White Jazz

majority of people I talked to about jazz—usually those not dedicated to it—gave me the impression that it is purely a black man's music, and whatever whites took it up merely followed black style and didn't do it as well as the original founders of the music. This is a mistaken notion. There were white jazzmen almost as soon as jazz itself emerged from the street parades, early dance floors, and the first playing dates. Papa Jack Laine, Leon Rappalo, Nick La Rocca were among the first to make the jazz some called Dixieland.

They had better style technically, but didn't push too hard for expression, and their melody came out pure, with a limit on sliding notes, also less vibrato and a smoother glissando. Papa Laine started the first white bands and many took from him the integral white jazz style. There was the Original Dixieland Jazz Band, the New Orleans Rhythm Kings. Some original standards recorded in 1917 were "Dixieland One Step" and "Tiger Rag."

White jazz had its Eddie Condons, Bix Beiderbeckes, Gene Krupas, Charlie Venturas, and Joe Mooneys. One could in no way feel men like Lennie Tristano, Red Nichols, Stan Kenton, Gerry Mulligan, were inferior to black musicians. They might, and could, do it differently, and read it better than it had been put down; they were all true to jazz as they got it out.

The Dorsey brothers, Harry James, Glenn Miller, Muggsy Spanier, Max Kaminsky all have a place in a Jazz Hall of Fame; that is if jazz ever gets around to finding a hall to honor the men and women who made it good and kept it vital, and who would have agreed with Baudelaire: "To dream is not enough. You must know how."

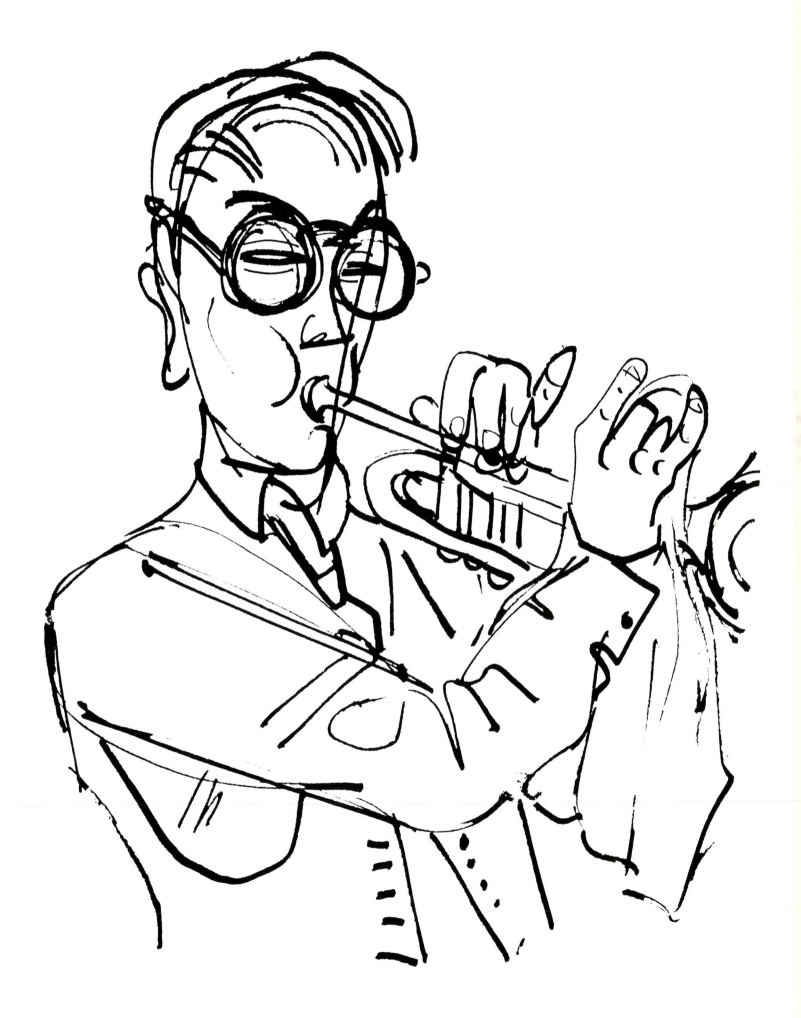

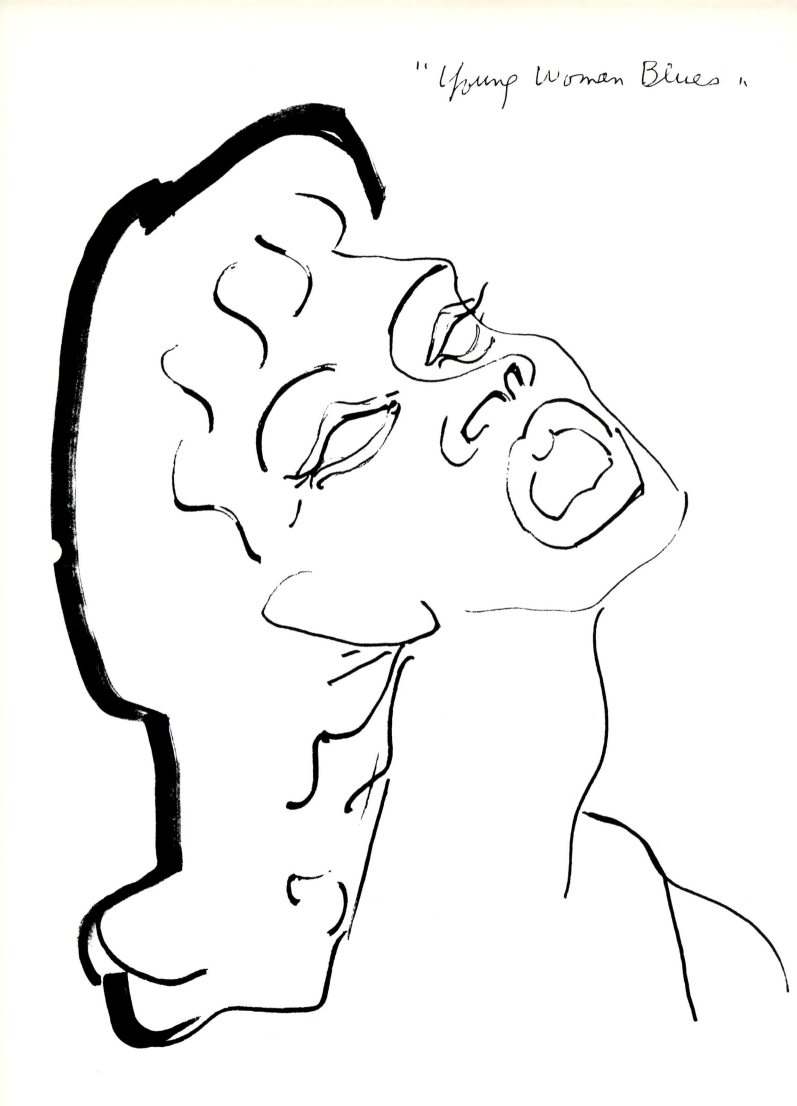

"Young Woman Blues"

The Blues

Originally the blues had come from the back lands of the South. When it blossomed in Chicago with its 12-bar pattern, the houselights went low and the spotlight picked out a chick, often leaning against a prop lamp post. She was there to lament the sadness of love lost, or the lonesome dark of existence. Everyone said no one did the blues like Bessie Smith. As one writer, Carl Van Vechten felt: "It was the real thing, a woman cutting her heart open with a knife . . . exposing it for all to see." It was not Bessie, but Mamie Smith, however, who made the first recording of the blues in 1920.

Hello, Goodbye, Mah Honey

One heard a lot of the same story. You had to travel light, no wife, no children, no dog, no settling in on a porch behind a picket fence. So you picked up love and you had it when it was there, and shrugged when it wasn't. Hasty mating, a bit of music, a little booze and it was on to the next stop. A playing date, a pick-up gig, the lost time sitting in a bus station in a nest of discarded newspapers, or on the platform of some jerkwater depot, waiting for the milk train. And the latest girl there, to say goodbye and write will you, let me know. . . .

one night stand

70

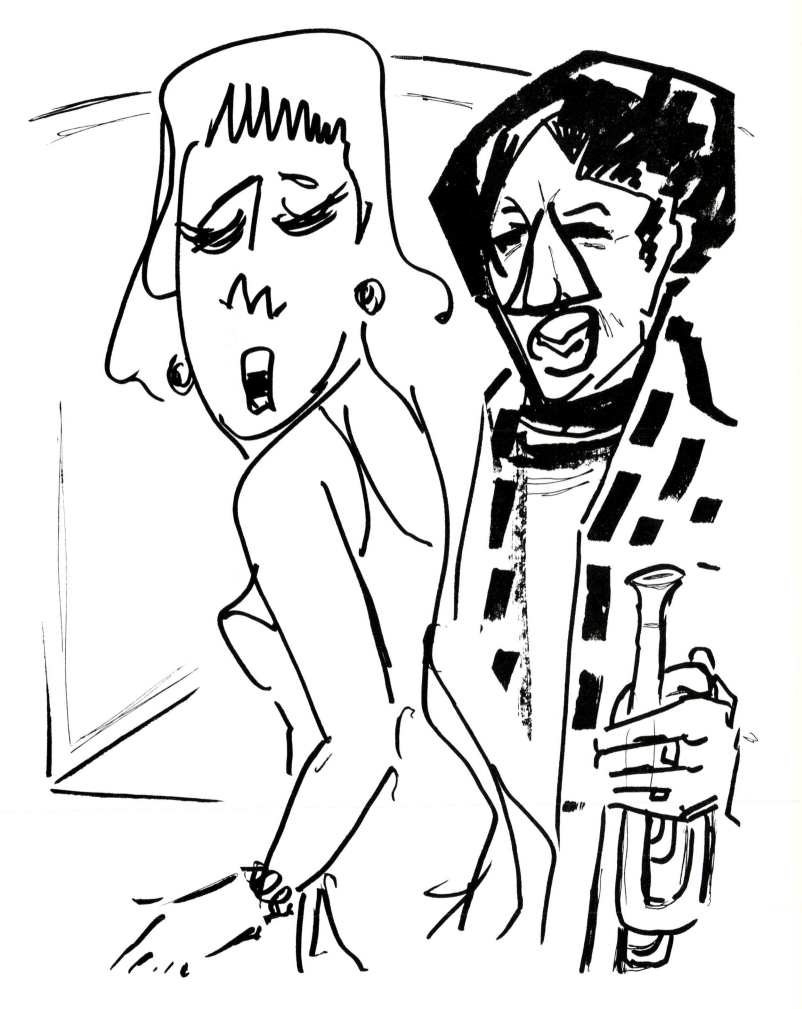

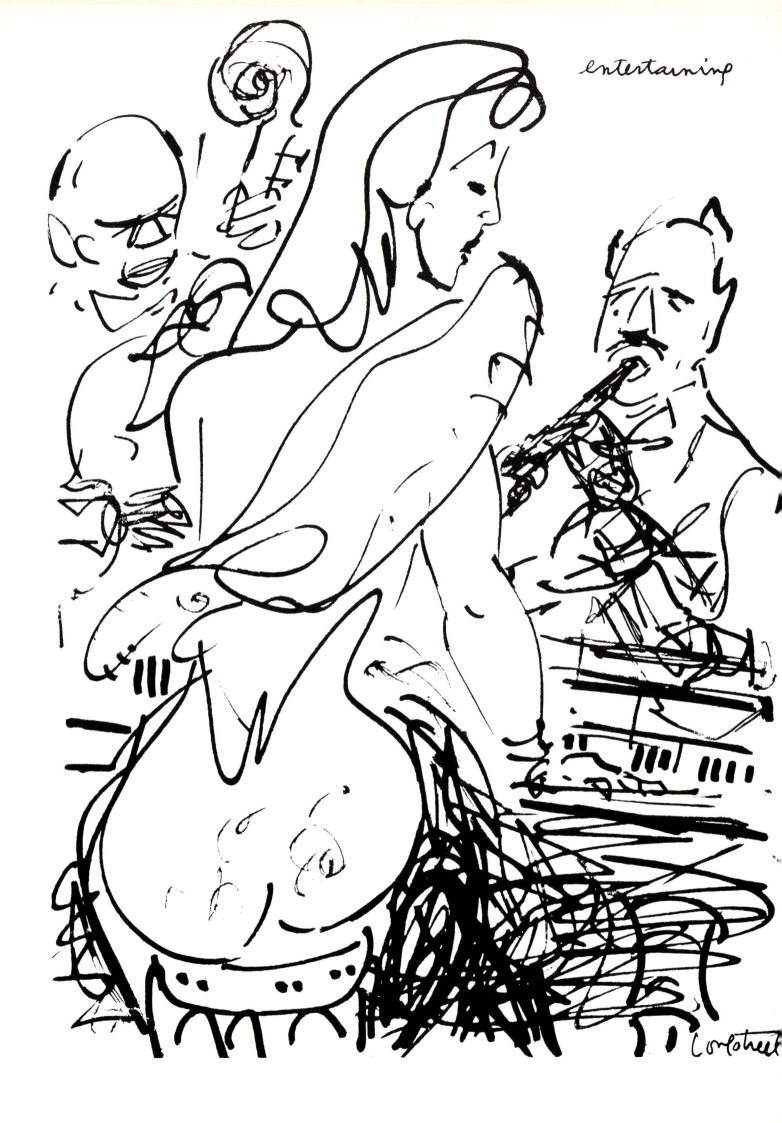

Party music

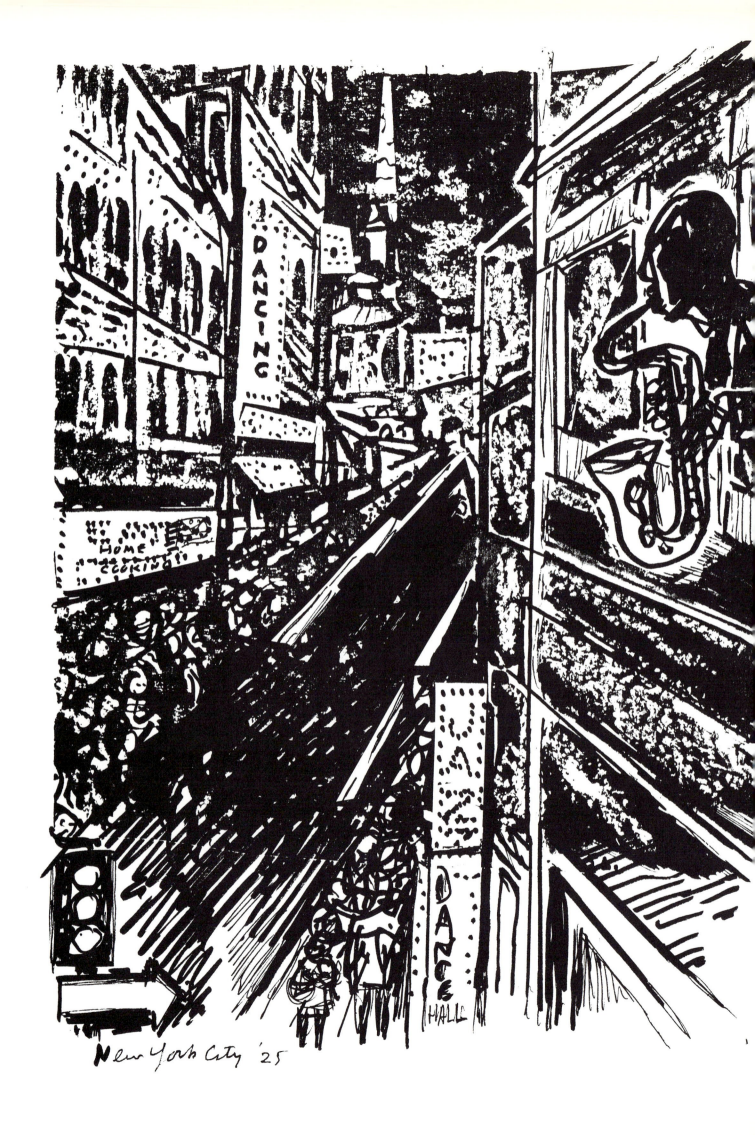

New York City '25

New York

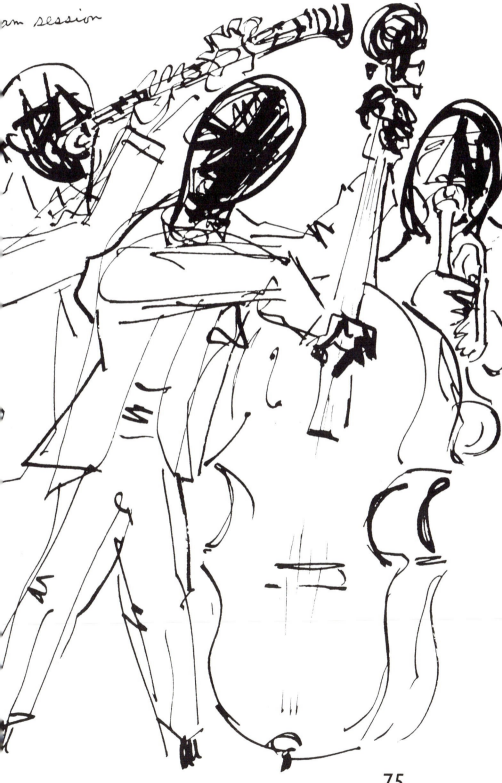

...am session

new York, largest city in the United States and second largest in the world, is in south-eastern New York State, at the mouth of the Hudson River. . . . In 1626, the Dutchman, Peter Minuit, purchased Manhattan Island from the Indians for a reported $24 worth of trinkets; real estate values have increased since then. Sponsored by the Dutch West India Company, the colony called New Amsterdam got off to a good start because of its location as a seaport, and prospered. In 1664, in support of territorial claims, the English seized the settlement and renamed it New York in honor of Britain's Duke of York. New York is a very cosmopolitan city with representatives of almost every country in the world among its population. In fact, native born New Yorkers are in the minority. Manhattan Island, center of the city, is most interesting to visitors, overcrowded, busy and noisy. Harlem is a black city where jazz first appeared in the east—and it is still heard there. The Bronx is in part, mostly a modern brick jungle.

—From an old guidebook

75

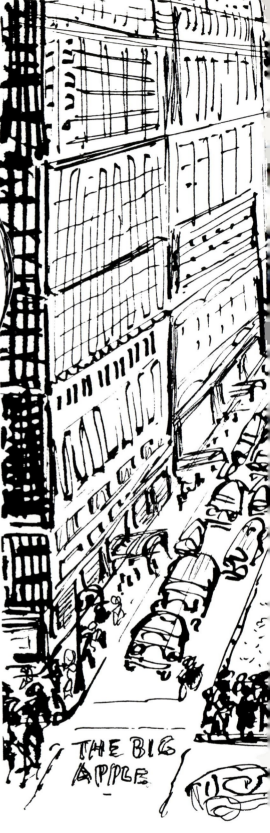

THE BIG APPLE

The Big Apple

nobody knows who first called New York City
The Big Apple. One heard the term in
the late twenties and by the forties and
fifties, it was widely used, over-used,
by the Madison Avenue dolts, mostly as
a term of affection for the stone
and glass city, its slums and high rises
between two polluted rivers. Harlem
named it, part of a language of its own
that could be used with whites that
mystified them—for a time.

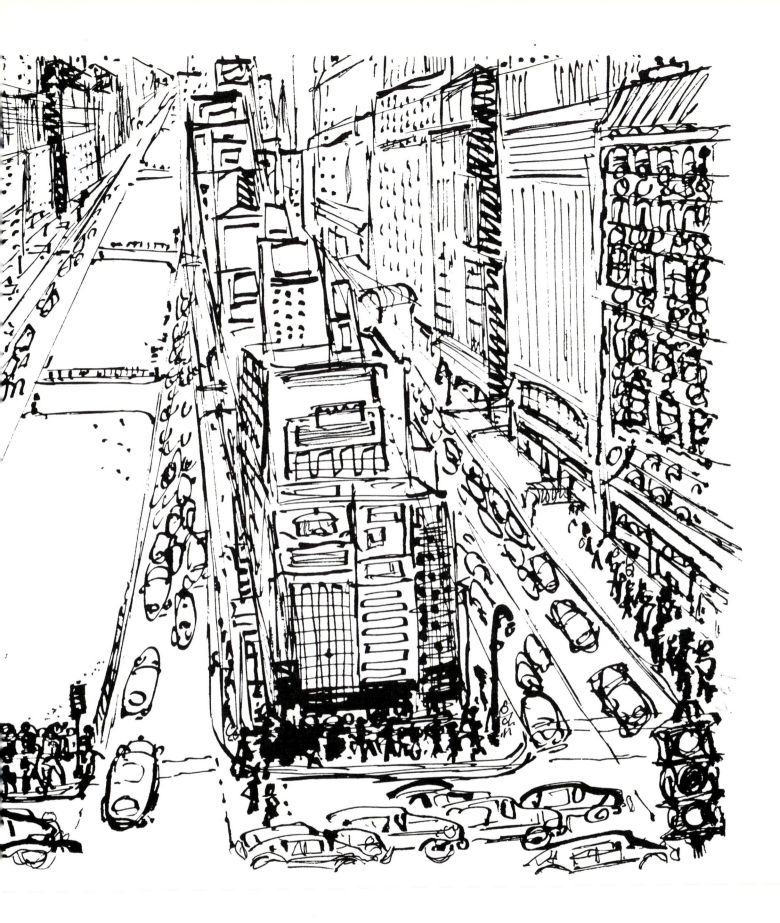

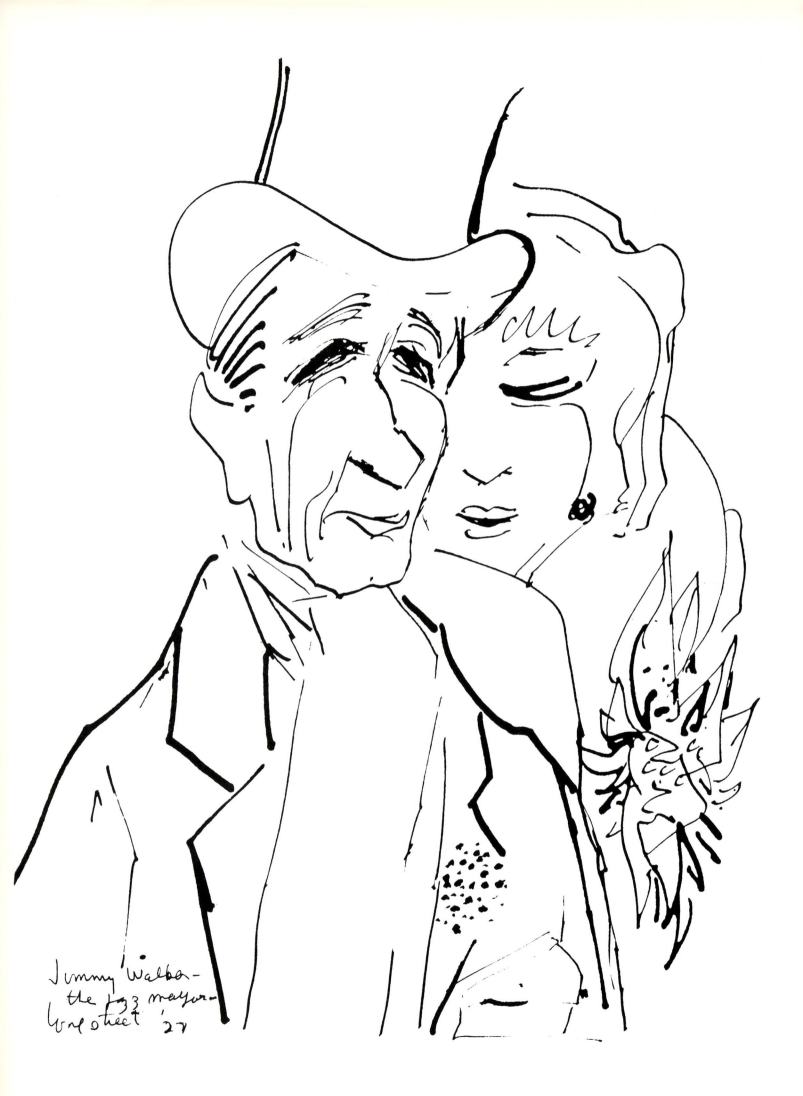

Jimmy Walker—
the Jazz mayor—
W.L. Street '27

The Speakeasy

tear out the walls in a brownstone basement, put in a bar, a phone booth, tack up fake grape leaves, maybe add a mural of the Bay of Naples, a strong door with a small viewing panel, and city hall protection.

A smell of spilled likker, and a hint of the LADIES and GENTS. Cozy, and drinks one could survive. Not a dive to get a Mickey Finn and get rolled in the alley. Not one of the fancy 52nd street speaks where the Peter Arno faces hang out and the characters out of This Side of Paradise drive up in their big cars on a festive night. No, its just called Julio's or Tony's or Frankie's.

At the more posh joints, you can imagine Heywood Broun, Mayor Jimmy Walker, Jay Gatsby, Robert Benchley, department store buyers from Kansas City, a Folies girl, a hooker from Polly Adler's. Or citizens of the Republic who get their jollies being in a real ritzy, snazzy speakeasy.

The Piano Player

the piano player fills in the late hours—no one wants to go home. He needs a drink, he gets a drink, he's lonesome even with all the customers at the club, groping and guzzling. He fingers the keys, a cigarette is a dead butt on his dry lower lip. He's far away from the Tin Pan Alley, Irving Berlin, Jerome Kern stuff for which the theatre crowd has asked before catching the train to Scarsdale. Now he is sliding into his version of "Cherokee" and soon it will be morning. Already outside you hear the crews flushing the streets. The piano player finishes the heel of his glass of gin, ignores the horror of the overfilled ash tray. He puts on a tilted derby, a plush-pile coat with a belt like the dudes strut about in; two-toned shoes. In the street he inhales vapors from the East River refuse barges, decaying wallpaper in the old brownstone houses. The manhole covers are expelling white breath. It's old Moby Dick, he tells himself, down there breathing through the manhole covers, ready to come up through the street and sink this city, sink this city. The piano player begins to walk toward his pad, to the sleep-smelling frail in his bed. Yes, he'll write it down for a jazz band; this dreadful, wonderful, crazy, lyric city. Sinking City Blues . . .

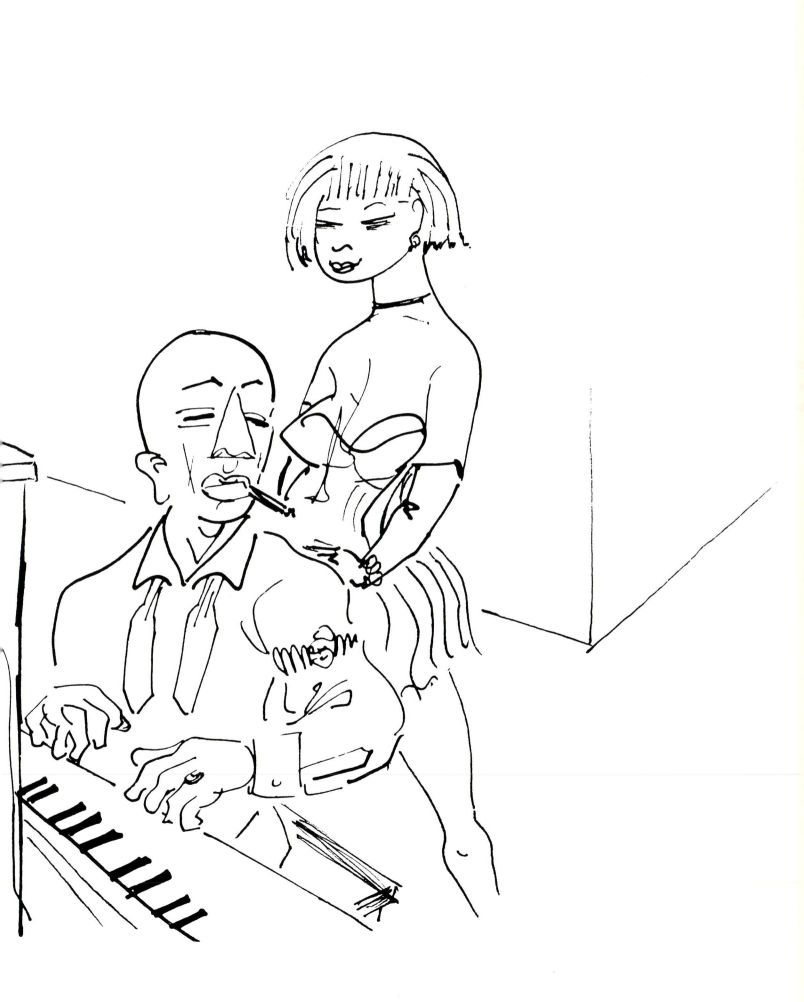

52nd Street

You can take bets
many an old timer
will tell you that
52nd Street during
the thirties, and
much of the
forties, was the
Golden Age of jazz. Nothing like
growing older and thinking it was better
once and more fun and musically the
best sound of all. In the basements and
on the ground floors of the brownstone
houses, you'd hear the music nightly.
There were the nightclubs and the great
comics; show girls and good hot jazz. It
existed on 52nd between Fifth and
Sixth Avenues, with a little spillover
here and there around Radio City. You
still hear echoes of the names of the
joints in unpublished memoirs: Kelly's
Stable, Downbeat, the Onyx, Jimmy

the Big Apple

dance floor

82

Ryan's, the Hickory House, Deuces. And Cloudland, a club that seemed a mirage that one would hear about but never found; it was supposed to drift from site to site; may have existed only in the dreams of the hazy addled mind of some player or dazed patron. But the players were real enough. Art Tatum and Erroll Garner and Nat King Cole were there, and Cozy Cole on the drums. Honey Bear Sedric, Billie Holiday too, after time in the slammer—she did duty on 52nd, as did Ella Fitzgerald. Doris Day passed through, tinged with jazz before she went to Hollywood to play virgins professionally.

Yes, it was a good street for jazz, and a sad street when the recession came and the drug pushers.

The Cotton Club

the real Cotton Club that I knew rather well in the middle of the twenties was from 1923 to 1936 a speakeasy and an after theatre supper club. Situated above a playhouse on the corner of 142nd Street and Lenox Avenue, it seated over seven hundred people at small tables, had a jungle-styled decor, a dance space for those who wanted it, along with a floor show of black, and what were called "high yellows"—TALL, TAN AND TERRIFIC—dancing girls. Mostly they were at least five feet six, and under twenty-one.

The Cotton Club was backed and run by white gangsters—the rumor of this added to the thrill of "Wild Harlem" for the customers, who were all white but for some important black performers, high rollers, racketeers, bootleggers and gangsters at a few tables. The shows, in a haze of smoke and booze, loud and fast, could run as long as two hours, three a night, beginning at 2 AM.

The first big national radio broadcast of jazz music came from the club in 1927, with Duke Ellington's band, to be replaced by Cab Calloway. The club's entertainers, at one time or another, included Lena Horne, Bessie Smith, Josephine Baker, Bill Robinson, Buck and Bubbles and others who filled my sketch books.

Among the guests to be seen there—sipping the addled champagne and local gin—was the playboy mayor Jimmy Walker (the band always played his song "Will You Love Me In December As You Did In May" when he entered), Irving Berlin ("Darktown Strutters Ball" or "Alexanders Ragtime Band"), Charlie Chaplin, the Queen of Romania, even the then Prince of Wales. Also such prime hoodlums as Dutch Schultz (the muscle and money behind the Cotton Club), Legs Diamond, Lucky Luciano.

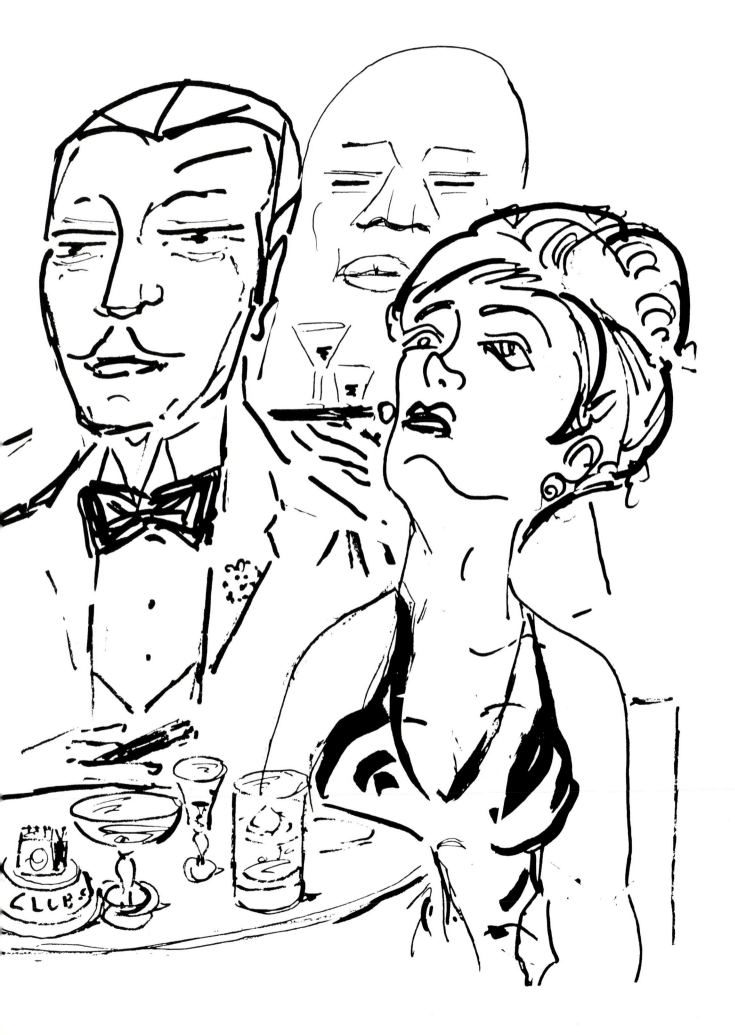
Cotton Club '26

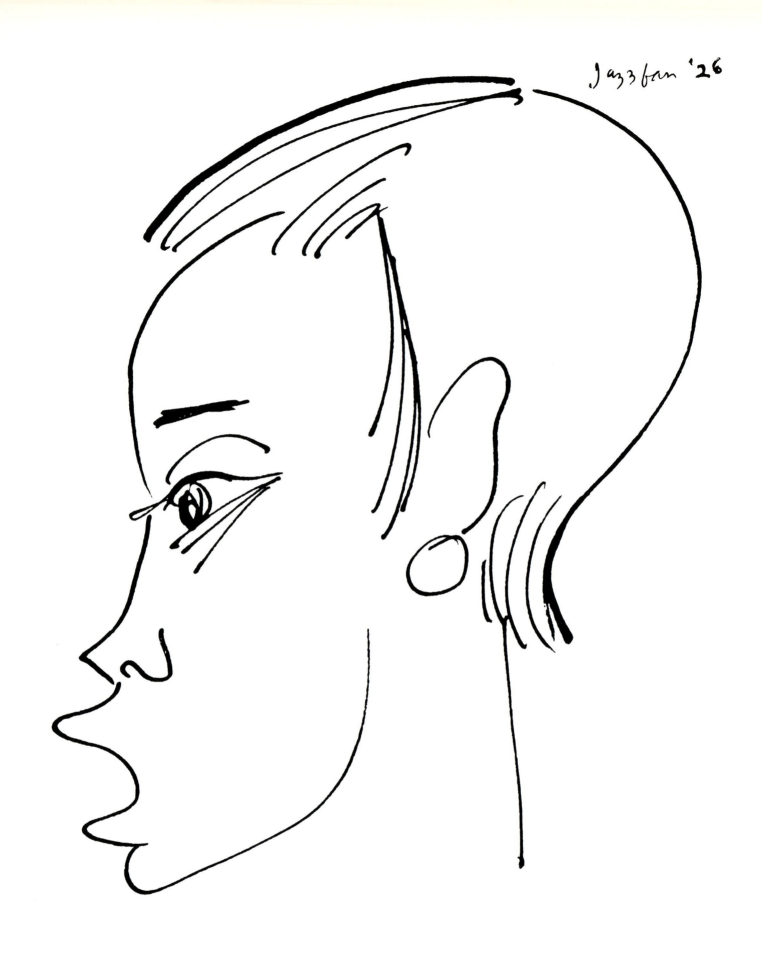

Jazzban '26

Stephen Longstreet

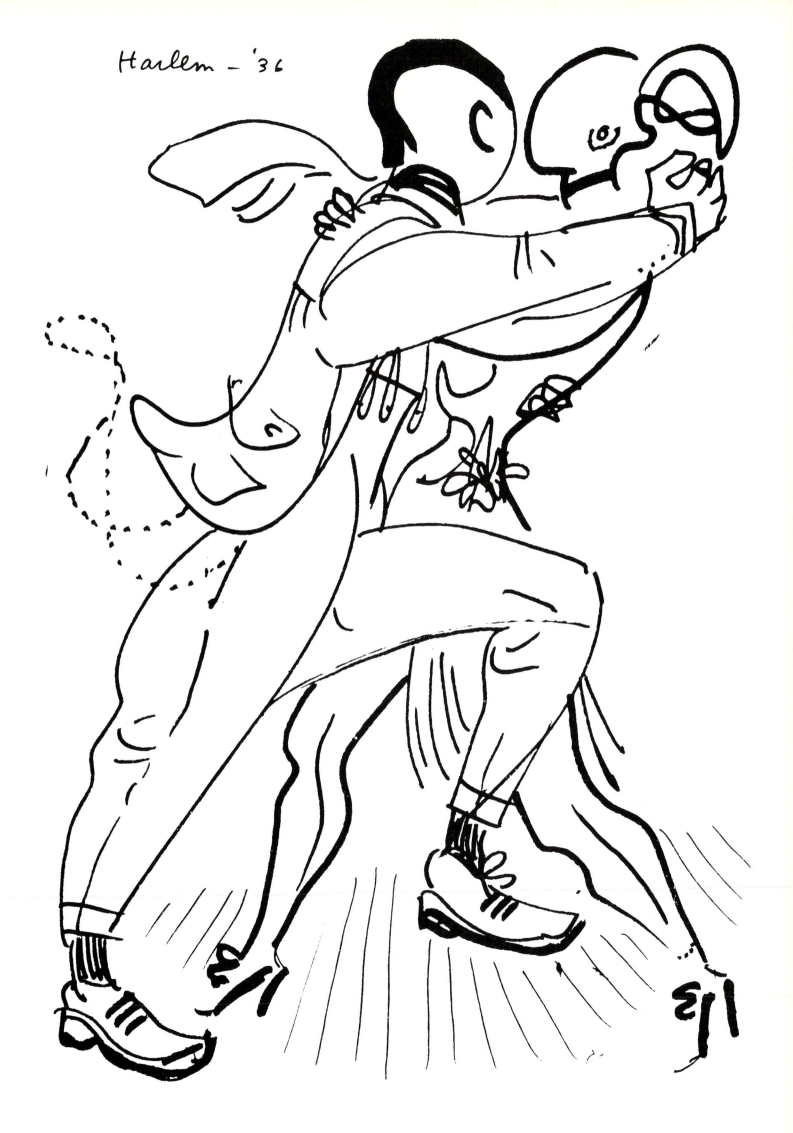

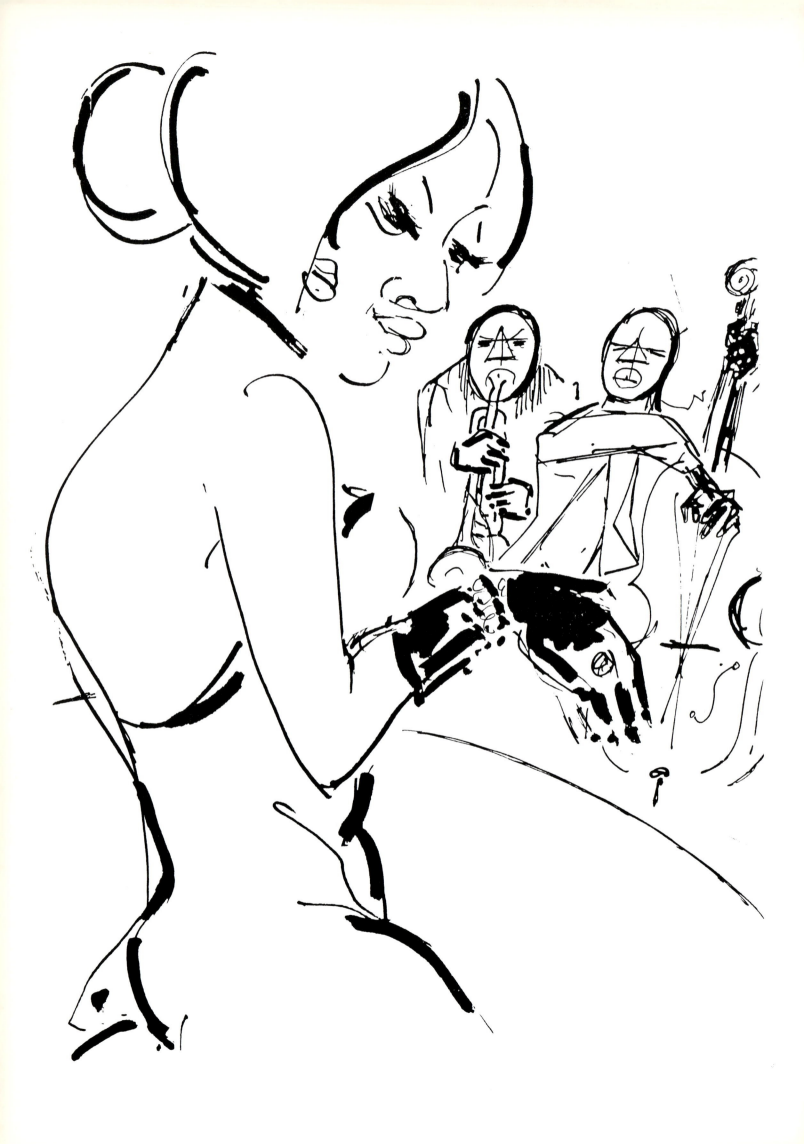

Barroom Blues

Prohibition had come in on the night of January 1, 1920, and the Casino, a white mansion in Central Park with candlelit tables, wide verandas, and Joseph Urban decor, began to attract the first "cafe society" set (not yet called that) among the wisteria vines of the place. They brought hip flasks of gin or bourbon and talked of jazz in Harlem after dinner. Someone recalled in a letter: "The saloon . . . appeals first to man's sense of the beautiful. . . . In flashing crystalline, glass polished wood, hammered brass, beautiful frescoes, brilliant lights, warmth and cheer, he is bidden welcome . . . the free lunch counter . . . loaded with the most tempting food cooked by master hands."

Posh Places

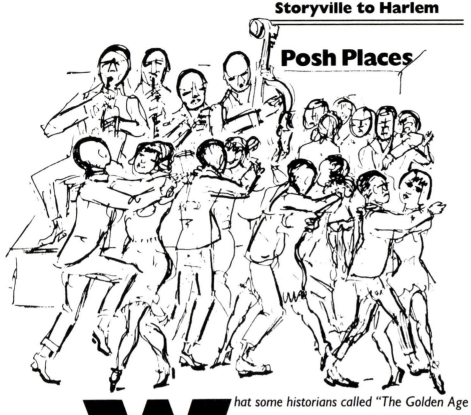

What some historians called "The Golden Age of Jazz" could be found, some of it, in those ornate clubs—Belle Livingston's, Texas Guinan's El Fey Club—that were the centers of the well-heeled when they came to the city and the natives who were later called Cafe Society. A mixture of playboys and debutantes, flappers and college boys came to town from the Yale-Harvard football games or Rutgers vs Princeton or the annual Army-Navy hassle. The club bands often had an electric light bulb inside the bass drum, and for mutes why not silverplated derbys? In the Village, Barney Gallant's ran wide open, and you'd find Edna St. Vincent Millay there, Sinclair Lewis, and Professor Seagull, along with Eugene O'Neill, advertising copywriters, deranged poets, painters who said "fuckpicasso." Barney was the first club owner to be jailed in 1919. But a petition signed by a priest and a police captain got him only fifteen days in the can. He came out to open the Club Gallant on West 3rd Street.

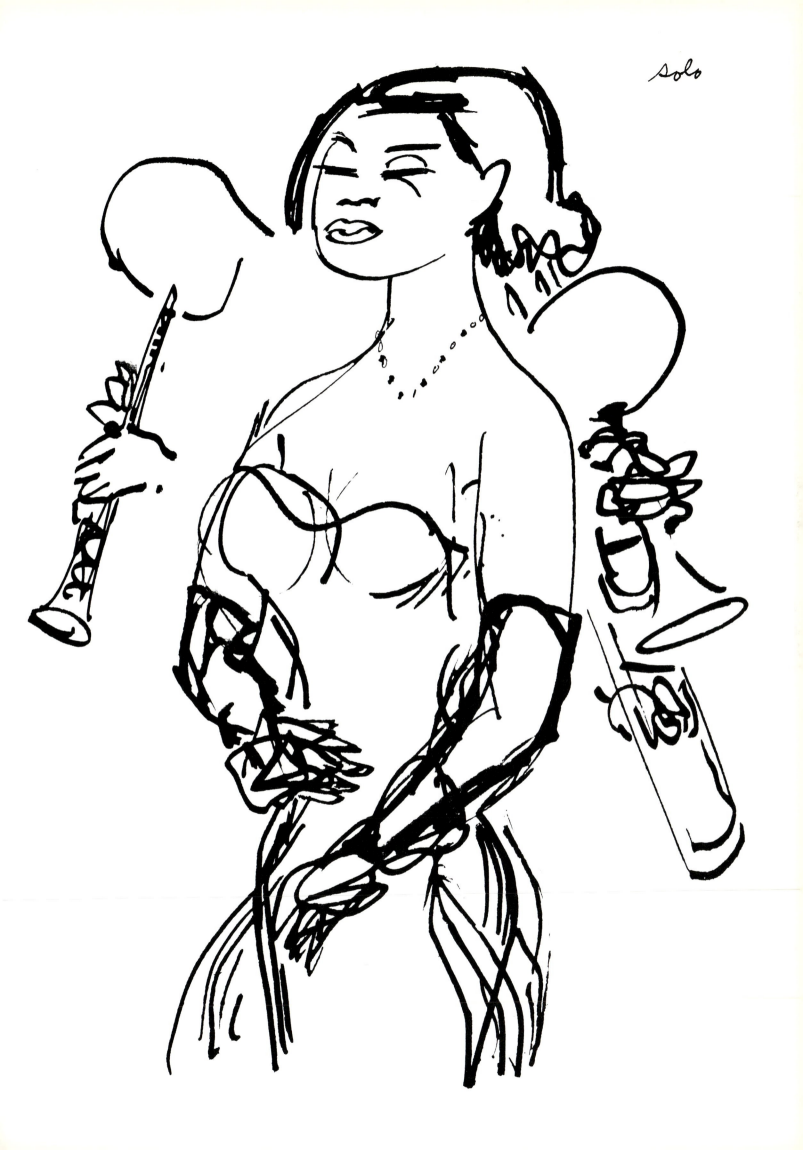

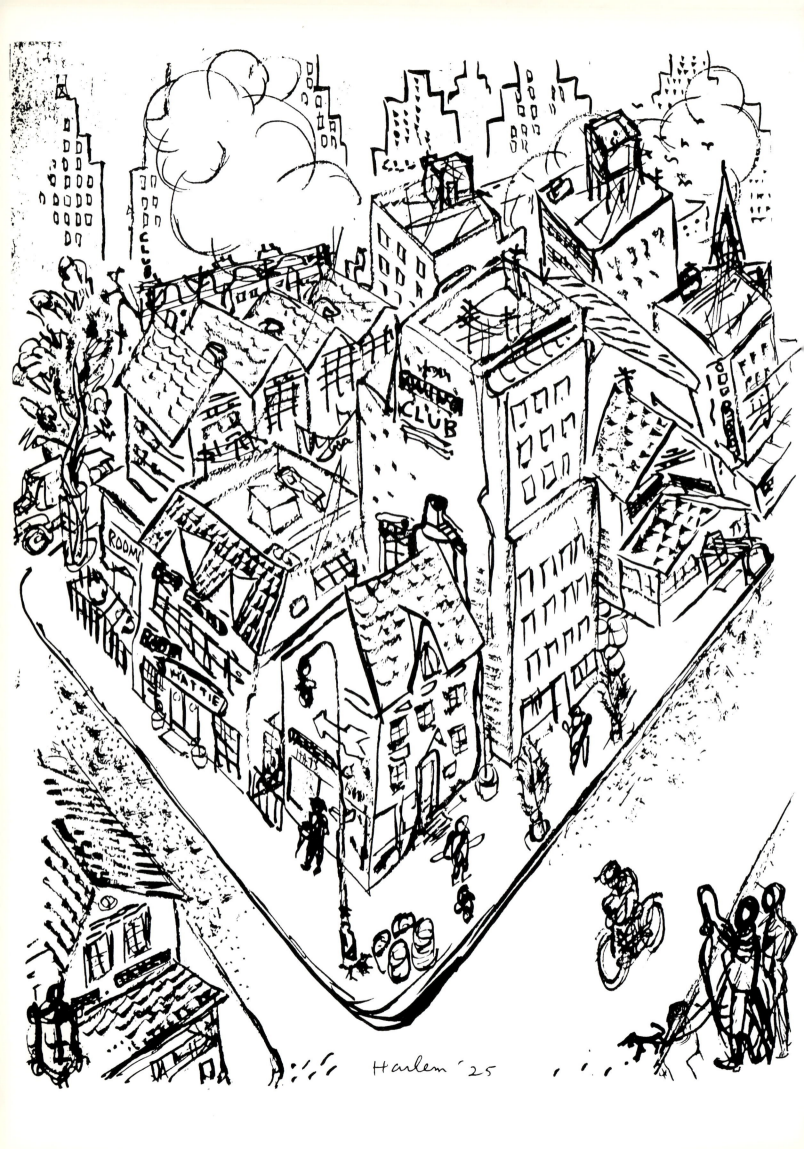

Harlem '25

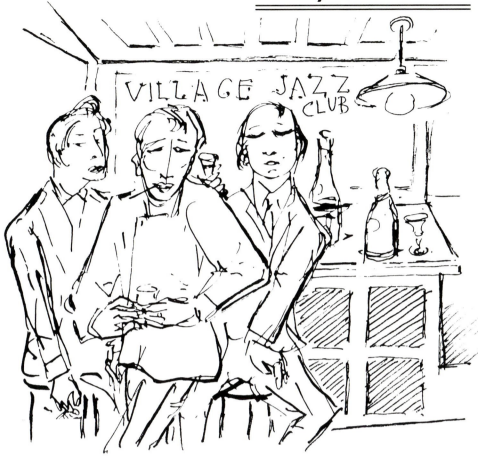

The Flapper

She was among the first to become an image of the so-called Jazz Age; a title used by the media. She gave the popular action to the Charleston, and when the car radio appeared, she seemed, in popular cartoons, to always have her long legs sticking out of the back of a car.

The flapper seemed to dominate many of the plays, the movies, the gossip columns, and the popular novels, which suggested a time of turning to the speakeasy as a national forum and water hole with a jazz sound track.

Katherine Brush's Young Man of Manhattan, Dorothy Parker's Big Blonde, the first stories of John O'Hara and Dos Passo's Manhattan Transfer and U.S.A., put the jazz-hunting youth into those cataclysmic years, a tune as if played on a loud saxophone.

The New York of the hurdy-gurdy man grinding out "Santa Lucia" and "Funiculi Funicula," the leisurely dining at Mouquin's on 27th Street, was gone. The new sound of jazz in Harlem signaled different times. The posh eating and gathering-place for the new woman was soon to be the Casino in Central Park, with its two bands, Leo Reisman and Eddie Duchin ("In Dreams I Kiss Your Hand, Madam . . .").

Down Beat

 f some college dance affair, or country club, wanted jazz, there would be pickup bands of jazz players that weren't the best. In Harlem they were called moldy fig outfits, Mickey Mouse bands. The cross some jazz groups had to bear was being forced by poverty to play in creep joints like the Chantee Club where there were B-girls to get a sucker drunk. Wood alcohol could kill. In 1928 it was claimed the stuff caused the death of 800 people, perhaps half of them in Harlem, from rotgut and knockout drops, bath tub-brewed gin, or distilled hair tonic. Many a good jazz man died before he could afford a silver flask and a good connection with a trusted bootlegger who got it "right off the boat."

94

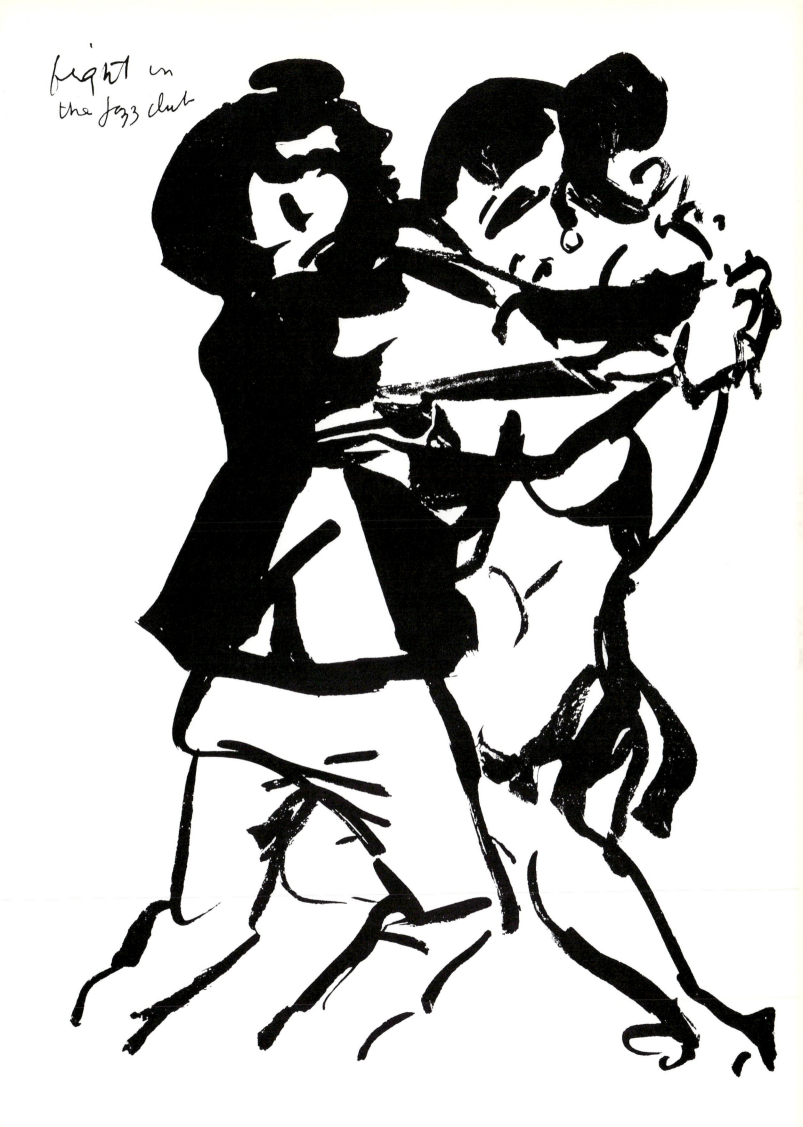

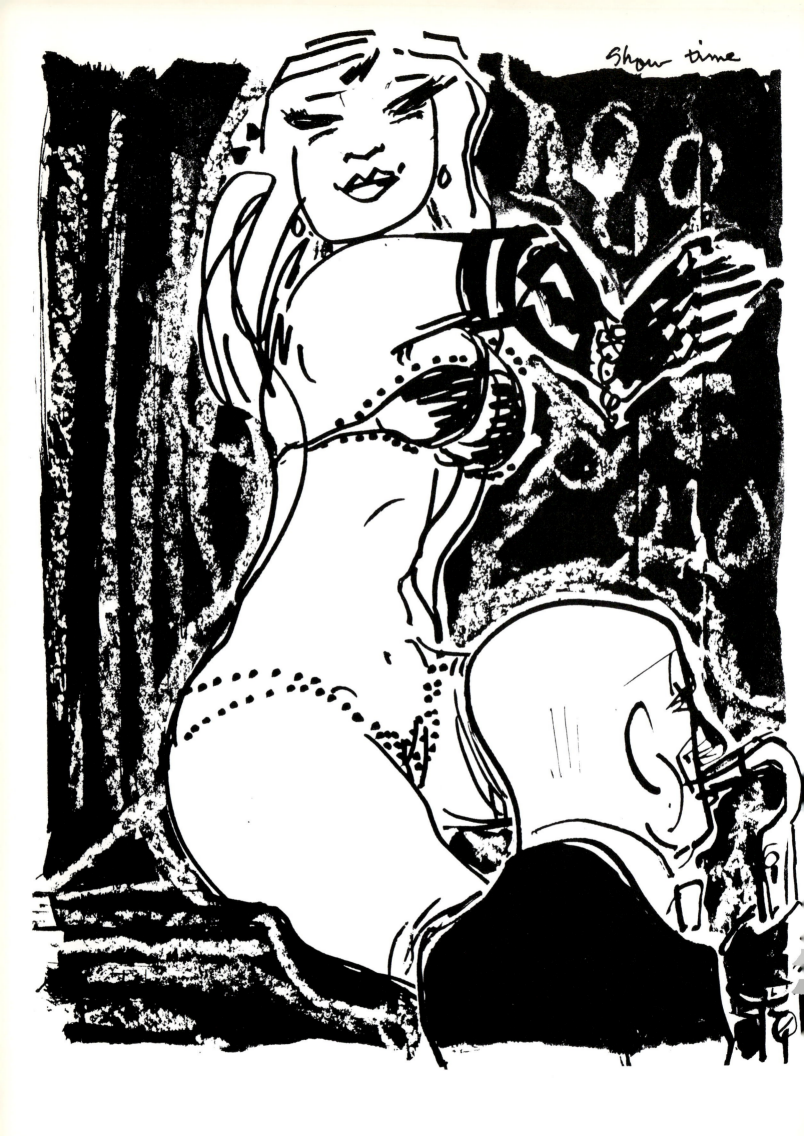

Show time

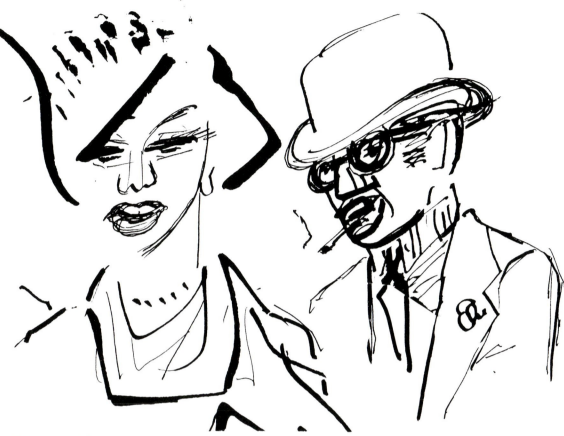

Showtime

there are those who claimed the best jazz in the 1920s, 1930s and into the 1940s came out of Harlem or was in the big touring bands: the Dorseys, Count Basie, and in shows like Blackbirds, Shuffling Along, Hot Chocolate *that were bringing some of the good sound down toward Times Square. The speakeasies and clubs gave jazz flashy publicity through the sleazy kind of journalism that came in with the tabloids: the Daily News, the Mirror,* the Graphic. Columnists of new ilk— Winchell, Sobel, O. O. MacIntyre— called any loud music "jazz."

The police were friendly, the Fire Department too, and City Hall. Some clubs paid the right people, some paid the gangsters. You'd find Bea Lillie, Legs Diamond, John O'Hara, and the mob bosses in the same club listening to "Livery Stable Blues" or "St. Louis Woman."

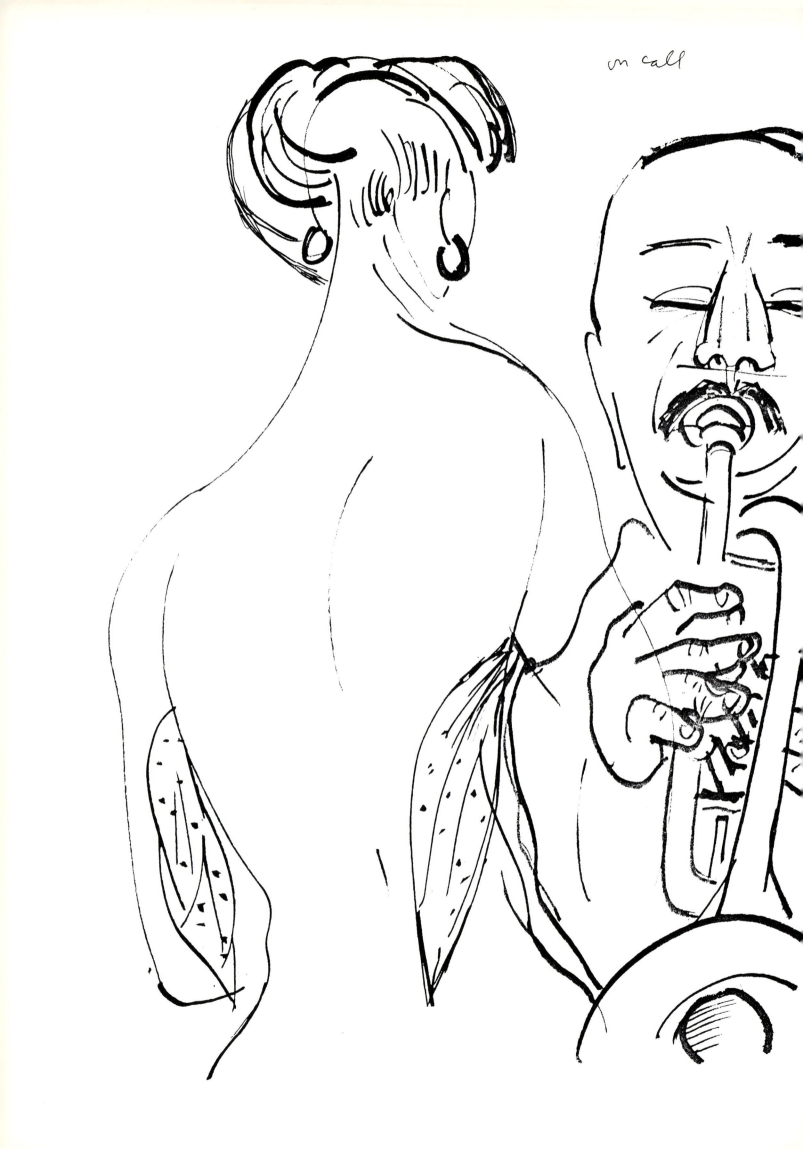

Hooch Joint

f they serve good food, the tablecloths are red and white check (a lot of garlic in the pasta, sharp knives for tough steaks); the whisky is fair or deadly, the beer is needled, shot with ether. The labels on the bottles are often misspelled. . . . The air is blue grey, hazy with tobacco smoke, a kind of musky body odor, dying perfumes, and where the combo, Saturday nights, plays on a low platform: a horn, a sax, a dog-house bass being slapped, an upright piano with loose strings. A cop may come in for a drink, or to take the payoff. Sometimes there is a chemical blond crying in the phone booth—she'd asked the band for "Melancholy Baby." The piano does "Frankie and Johnny," the horns please some barfly who wants "St. James Infirmary," "Sugar Foot Stomp," "Tiger Rag," "Royal Garden Blues." There is a fight at the bar, a woman—false rumor—has tried to slash her wrists in the john.

99

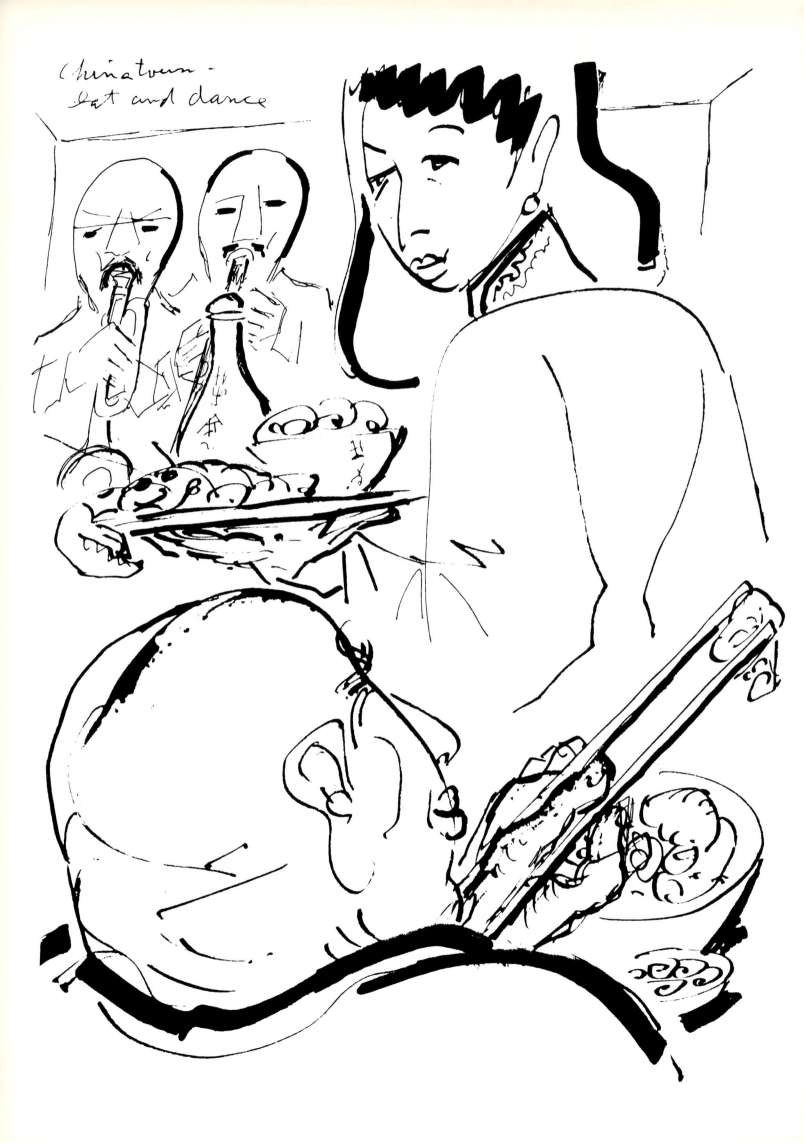

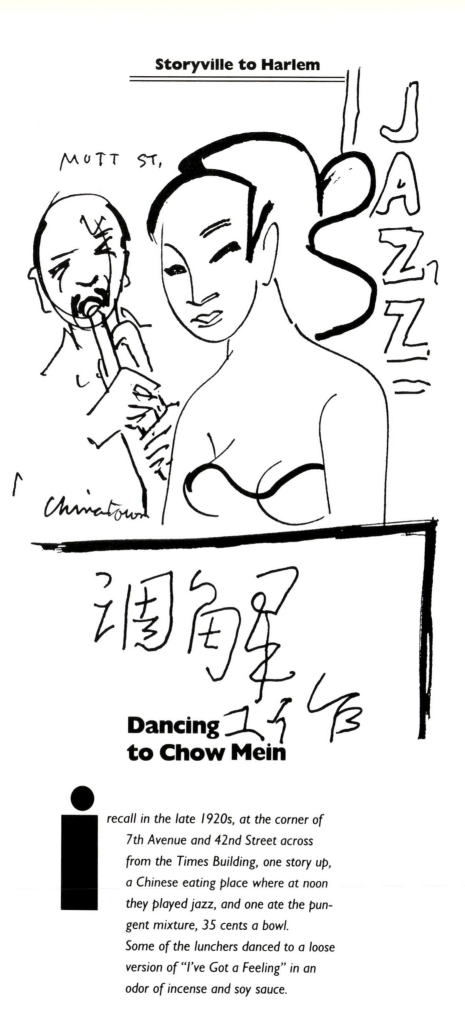

Dancing to Chow Mein

I recall in the late 1920s, at the corner of 7th Avenue and 42nd Street across from the Times Building, one story up, a Chinese eating place where at noon they played jazz, and one ate the pungent mixture, 35 cents a bowl. Some of the lunchers danced to a loose version of "I've Got a Feeling" in an odor of incense and soy sauce.

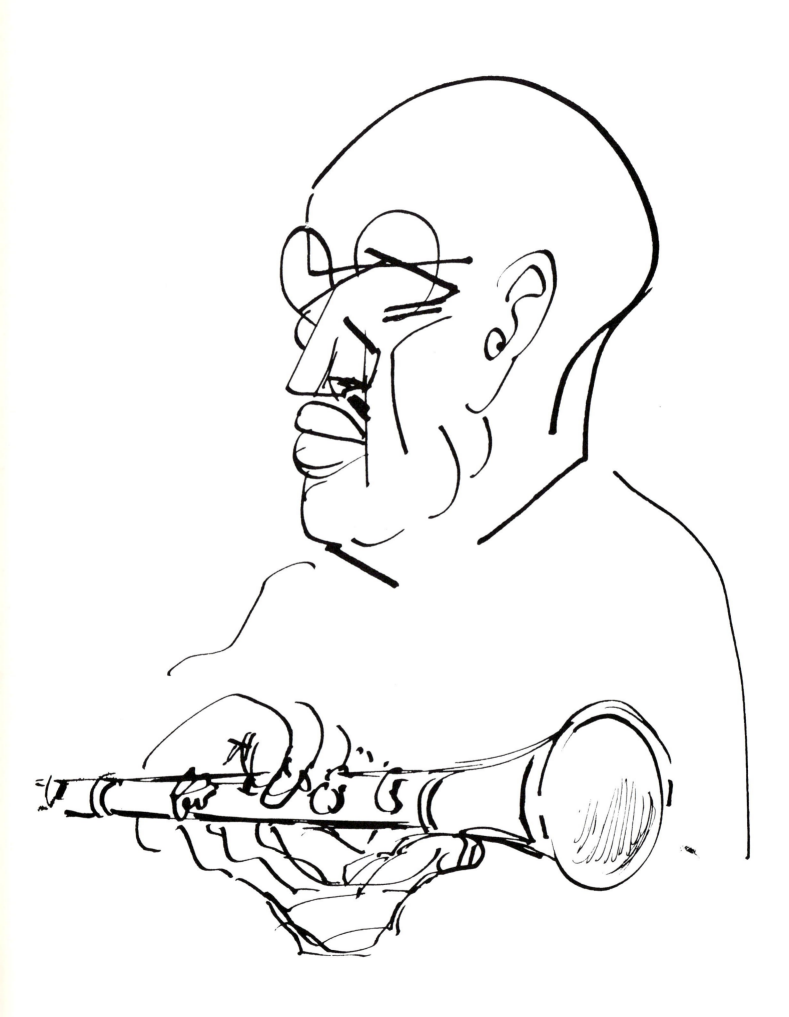

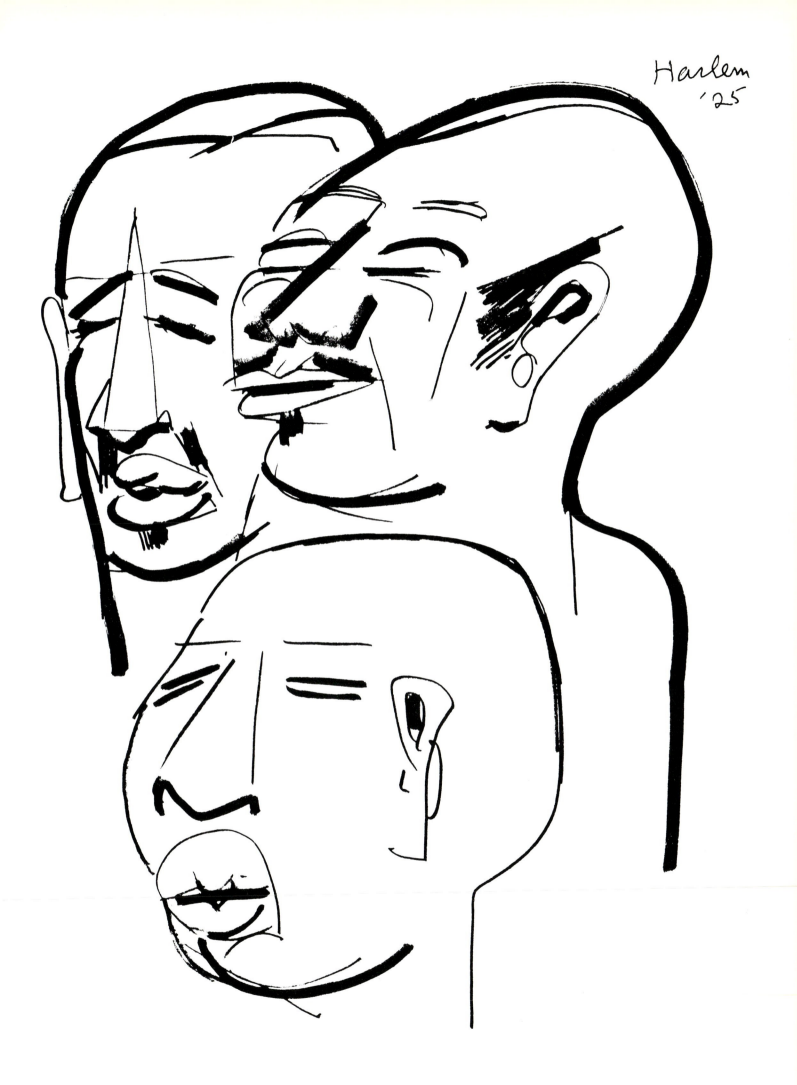

Harlem
'25

How to Die Young

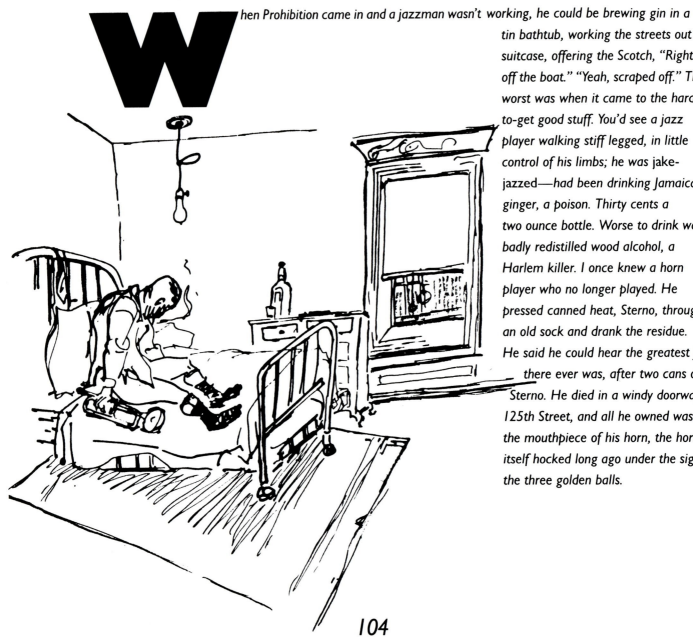

When Prohibition came in and a jazzman wasn't working, he could be brewing gin in a tin bathtub, working the streets out of a suitcase, offering the Scotch, "Right off the boat." "Yeah, scraped off." The worst was when it came to the hard-to-get good stuff. You'd see a jazz player walking stiff legged, in little control of his limbs; he was jake-jazzed—had been drinking Jamaica ginger, a poison. Thirty cents a two ounce bottle. Worse to drink was badly redistilled wood alcohol, a Harlem killer. I once knew a horn player who no longer played. He pressed canned heat, Sterno, through an old sock and drank the residue. He said he could hear the greatest jazz there ever was, after two cans of Sterno. He died in a windy doorway on 125th Street, and all he owned was the mouthpiece of his horn, the horn itself hocked long ago under the sign of the three golden balls.

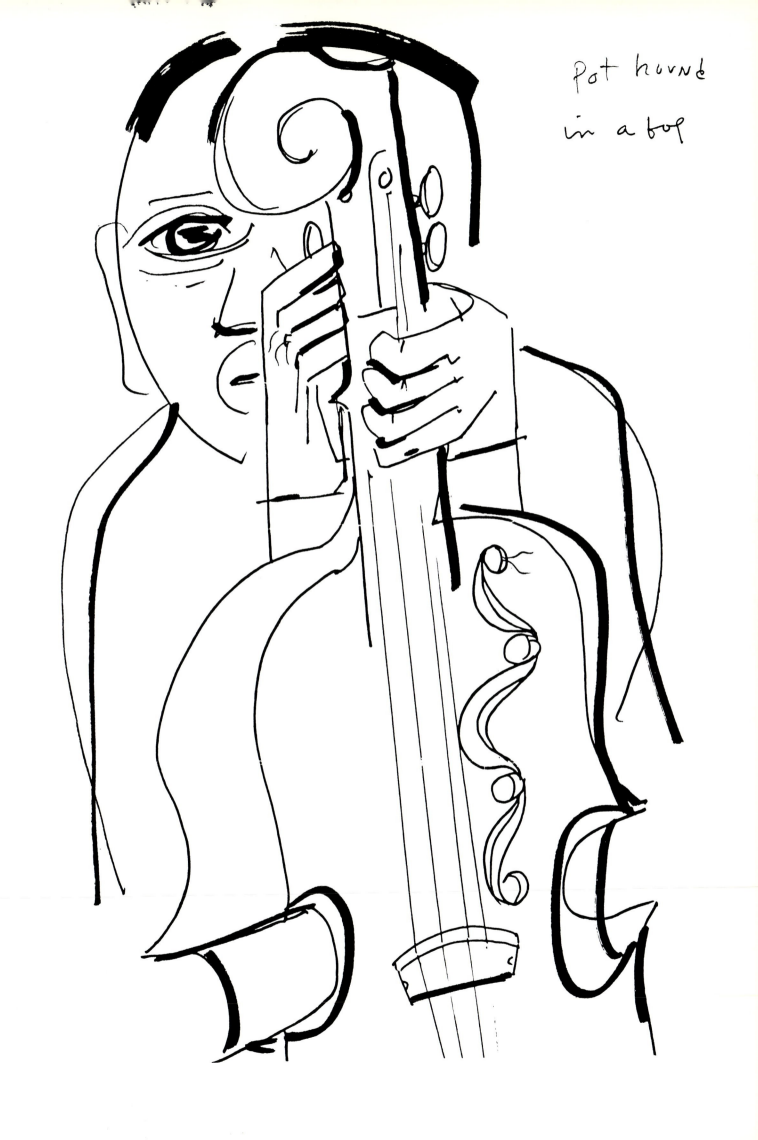

pot hound
in a bop

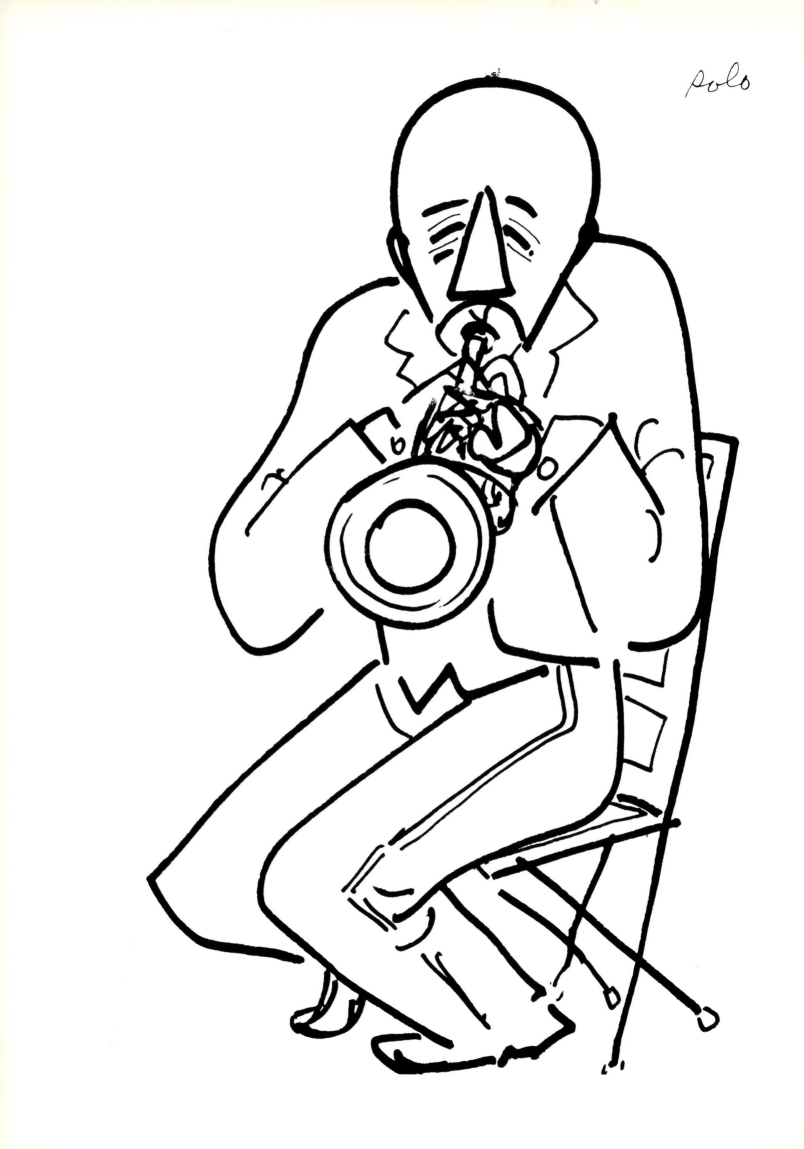

Bad Stuff

ne had turned from drink (Tiger Piss, King Kong) to snow (cocaine). Also marijuana—called a reefer early on, sold by people known as vipers (no law against its use in the 1920s.) Lots of jazz had a scent. Marijuana also called mezz (after Milt Mezzrow, white jazz man), muta, golden gauge, muggles, grefa, musta, hemp, roach (names like pot and grass came later). They added a folk color and language: "banana oil" and "horse feathers" terms of nonbelief; "bee's knees" and "cat's pajamas" terms of class.

They laid her out in her cocaine
 clothes
She wore a snowbird hat with a
 crimson rose.
And they wrote on her
 tombstone this refrain:
She died as she lived, sniffing
 cocaine.

107

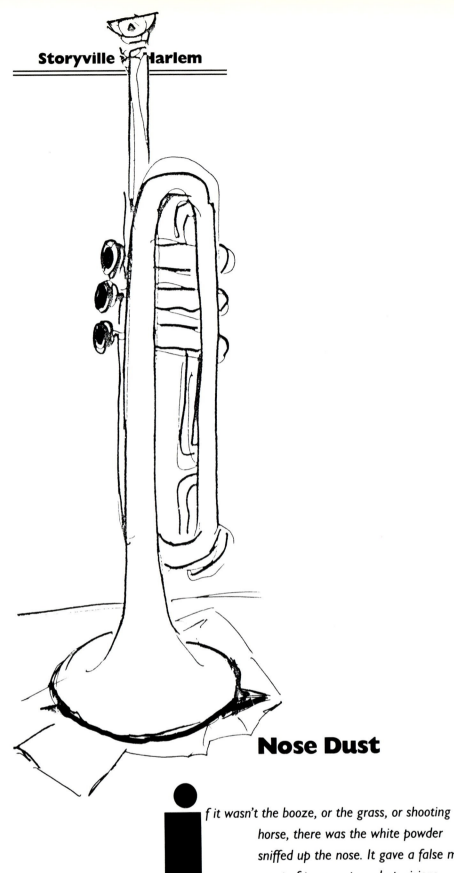

Nose Dust

if it wasn't the booze, or the grass, or shooting horse, there was the white powder sniffed up the nose. It gave a false moment of peace, opened up visions that would, in the end, betray. The nose suffered, and in time had a crazy life of its own.

108

a snow bird

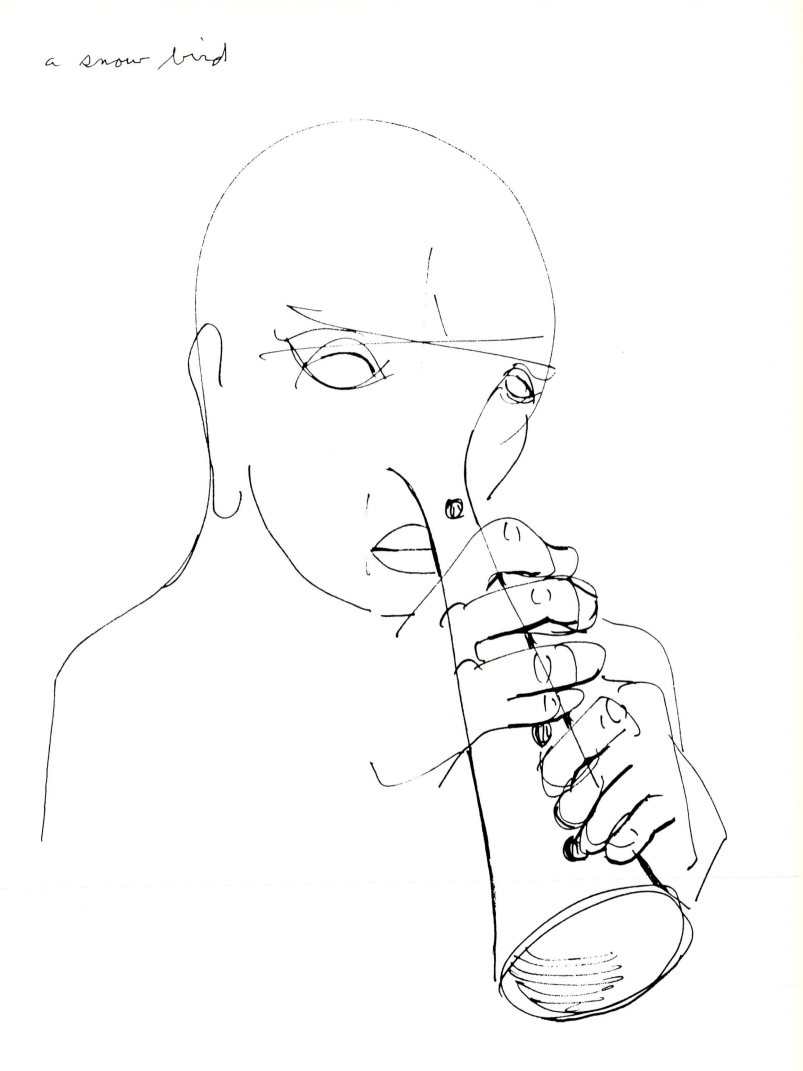

band manager

Stephen L.

The Bread

no longer called moola, jack or gelt, *money was bread. Hard to earn, easy to spend. Between the musician was the agent, the band manager, playing the ponies, sometimes union dues, often hard-faced men born with a cold cigar in the corner of a snapping turtle mouth. Underpaid by upfront club owners, the real owners usually an Italian family of vice. No wonder the wily band manager was often of more value to a group than an arranger. If, like Judas, he betrayed you, he could at times provide the needed bread to keep out the cold, cough up a hand out for some joy in a doll. And maybe someday the William Morris office will call and ask "What about lunch?"*

The Pad

the homeless, the unemployed, the dispossessed jazz musician could usually get floor space for a pallet or mattress on which to lay his head. In time, any place where one could establish a kind of residence was called a pad. Usually a room in a coldwater flat, sometimes a section of a loft where the only thing of value could be a musical instrument as yet not up the spout (pawned). Several people, wed or not, could share a pad. Related to the pad was the kip, meaning a bed or a sleeping area—kip time often hinting to a sexual shacking up.

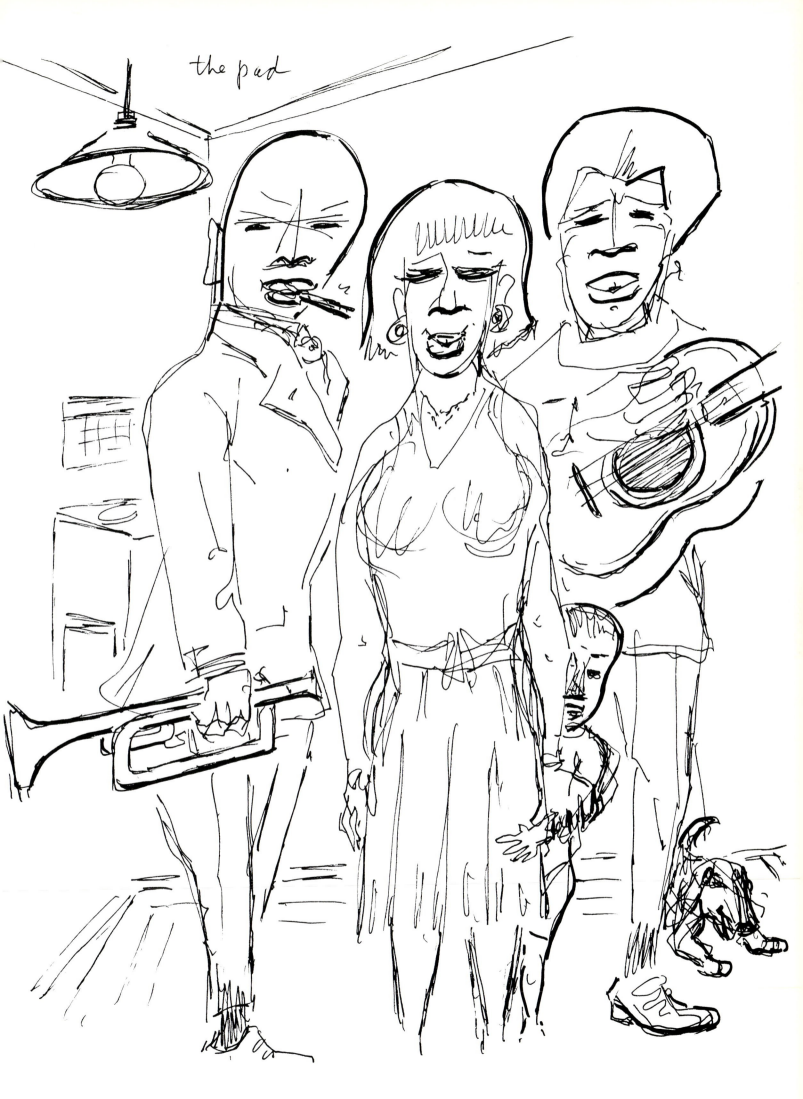

Changing Times

there was a kind of hovering sound between the city's pleasure seekers, from the "Black-birds" chorus of Harlem, down to the tearooms of the Village. Jazz men and their music were often features on stage at the great rococo Art Moderne film palaces, where even the demented luxury of the mad Ludwig of the true Bohemia was outbuilt: places like the Times Square Paramount, and Radio City Music Hall, which emerged from a huge hole in the Rockefeller ground.

There was never any thought of muggings, or prowling drug pushers trailed by narcs. You could get rolled if you flashed big bills, and got sexually serviced, even clipped, in some of the notorious, mangy midtown hotels. The tabloids featured Homeric gang wars of the Mafia, and the casting of Gone With The Wind.

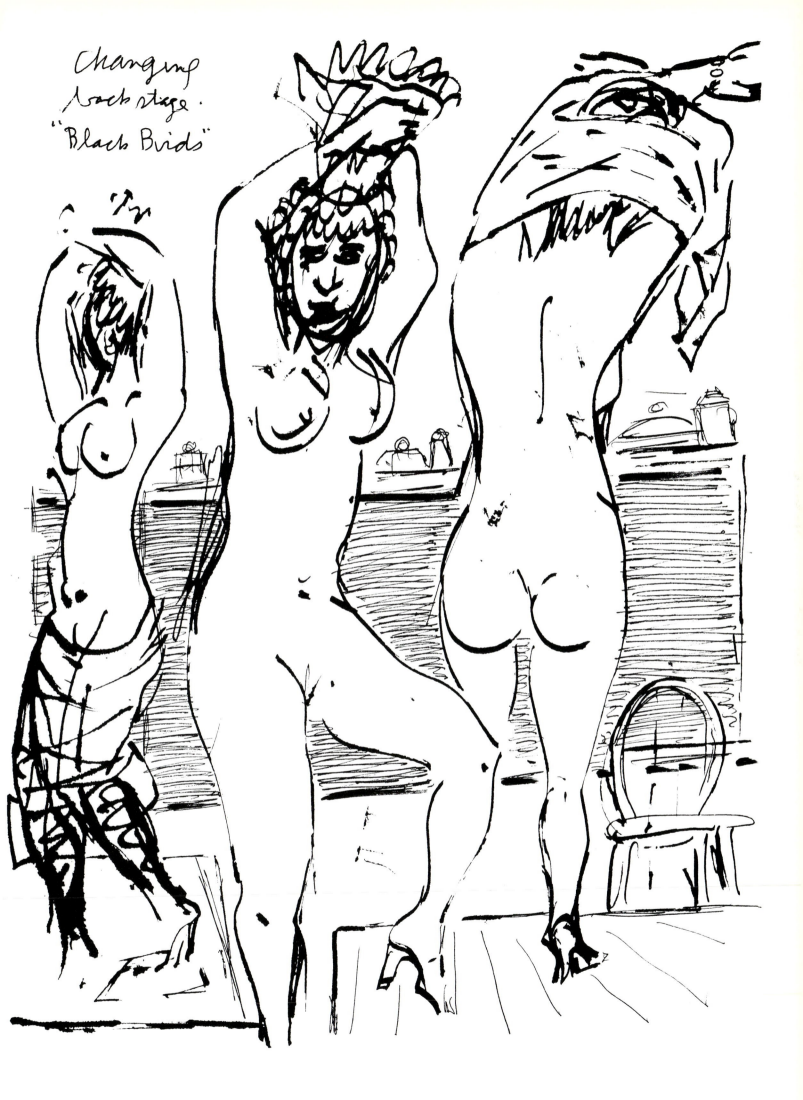

Changing
back stage.
"Black Birds"

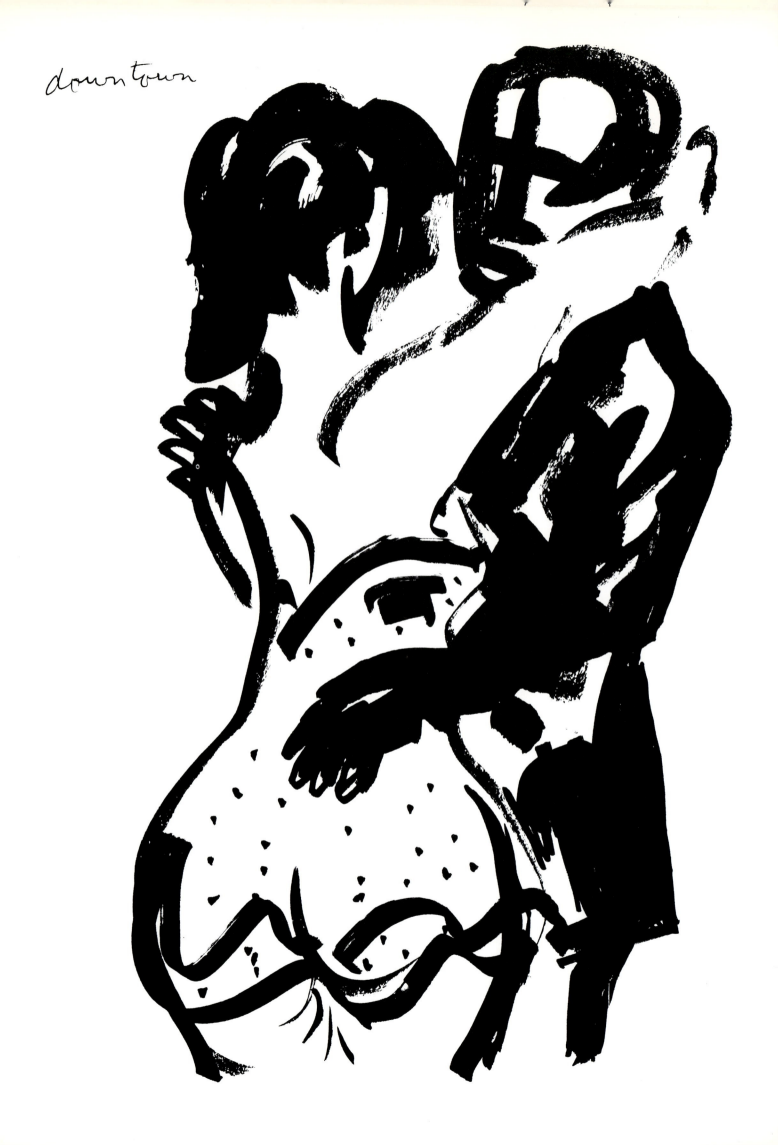

Downtown

the young and middle-aged who gathered in Greenwich Village before World War I were mostly artists, writers, truth and sex seekers who had come from farms in Nebraska, from Chicago—yearners for culture who felt the closer to Europe, the better. Some were classified: the tramp, Harry Kemp; the dreamer, Floyd Dell; the realist and magazine editor, Theodore Dreiser; even a Yale man, Sinclair Lewis. All thought jazz was as exotic as Picasso or Stravinsky.

Some were people in beads and sandals, who had little talent or serious ambition to paint, write or compose music. They liked the life, wanted experiences not found in Main Street, or in places like Pasadena, Detroit, or that mythical Zenith, home of Babbitt and Elmer Gantry.

By the 1940s, jazz combos were common in the Village. Eddie Condon had attracted a following with his jazz banjo, and the Blecker Street philosophers of Marx and Kafka were also rapping about Duke Ellington's Concerto for Cootie.

Changing to Music

*b*etween two world wars, New York was no longer the city of society's "400" or Stanford White's naked girls on a velvet swing. There was a new kind of hurry and bustle in the old town, with only memory connecting it with the past of the Edwardian, polished brass doorknobs, the genteel Washington Square houses, the placid walks in Central Park, the manly sanctuaries of the Hoffman House and the Ritz Bar. The music changed.

The city was harder, faster, the five-cent fare still took one underground in the subway at ear-shattering speed. Roseland Ballroom and others at ten cents a dance were not patronized just by degenerates.

The city's black population had jumped during the first war, as share-croppers and pushed-down Negroes came north for boom time pay. There were soon 150,000 in Harlem, scuffling for jobs, and their wives or girl friends doing housework.

118

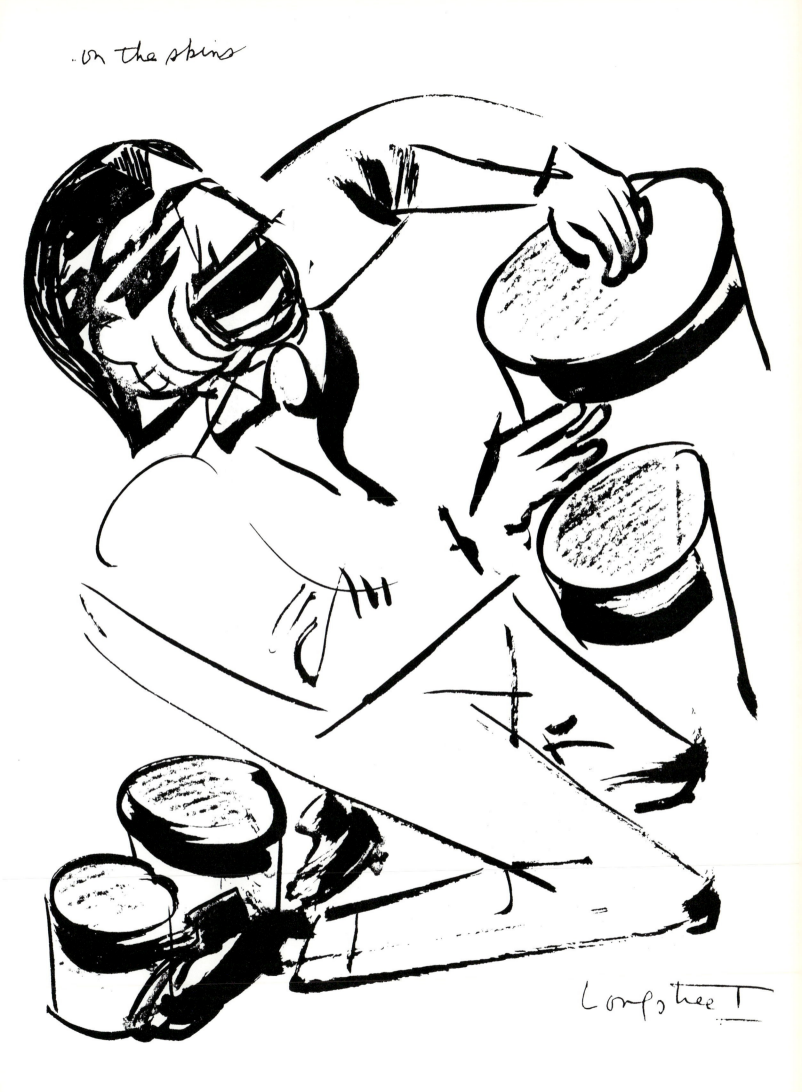

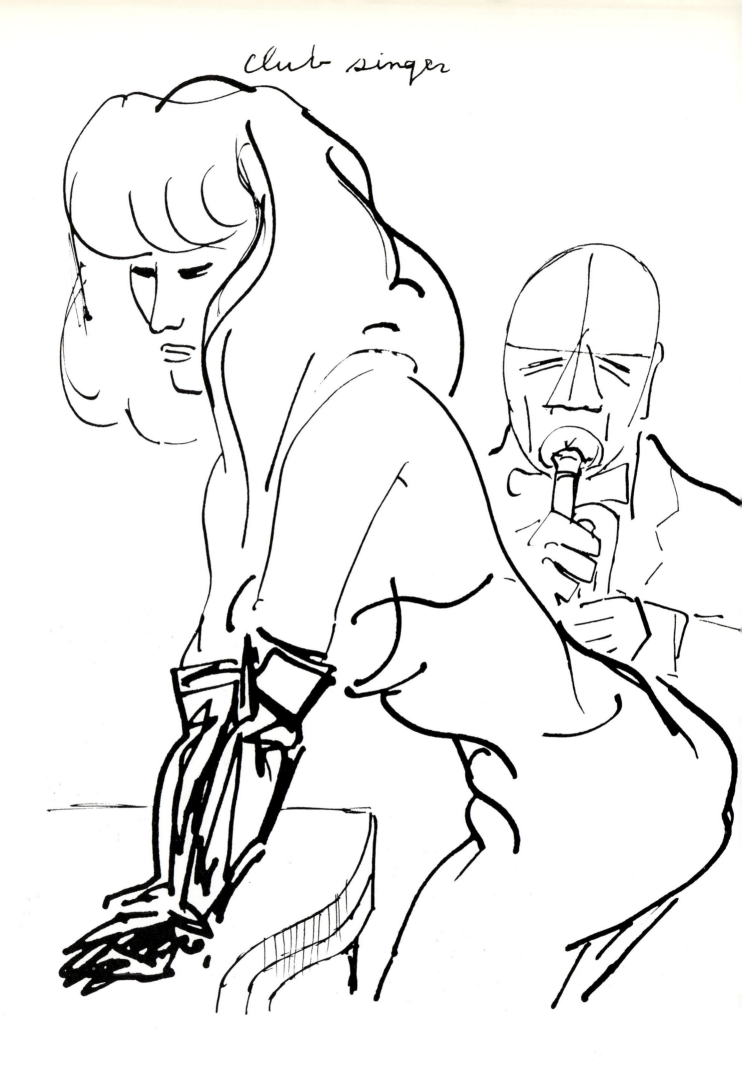

club singer

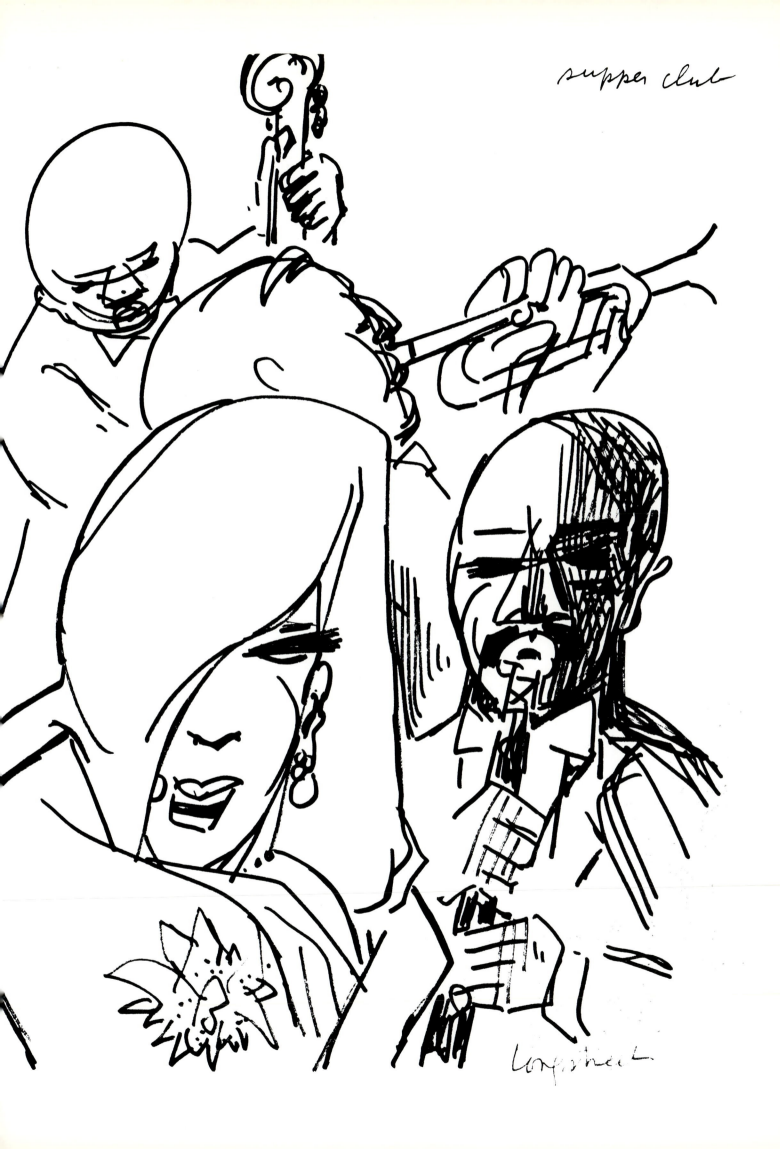

supper club

Longstreet

Burlesque

jazz caught up with burlesque when the strip-pers and baggy pants comics needed more earthy suggestive sounds, the whawha of the trombone, the steady sock of the drummer outlining every bump and grind of the torso artist with a rhinestone navel and beaded G-string; jazz urging, tossing her anatomy at the geeks and low-priced hedonists feeling tight in their clothes, and sucking air.

As a group of art students, we used to go down to Minskys (Reginald Marsh among us) to try and catch the unchic Rubenesque bodies on paper. Surprisingly, it was often splendid jazz; as long as they played it loud to a basic beat, they could improvise and re-phrase it.

The girls didn't have much voice, but added a twist and the queen of all grinds:

> Rich gal she lives in a big brick house (bump)
> Poor gal she lives in a frame (grind)
> My gal she lives in the big new jail (twist)
> But it's a brick house just the same. (bump, bump)

The band put jazz to its strongest use, adding to the musk of smoke, stage body paint and stale breath, something powerful and a bit shameful.

Up from Ragtime

verybody now knows the first real artist of ragtime was the composer, Scott Joplin, who wrote two operas but is best known for his "Maple Leaf Rag" and the music popularized on the soundtrack of the film The Sting. Ragtime was at its height, survivors will tell you, from 1890 to 1919, and had an influence on the Tin Pan Alley Jewish song writers who heard in it the Schul chants of the High Holidays. Ragtime is syncopated styling, a melody right handed eight beats to the bar, accenting the first, fourth and seventh beats, while the left hand is taking four beats to the measure. There is also a kind of dreamy lyric quality if the player has created a good mood on the keys. Melodies are the main charm—the looser you play, the more melody you can get away with.

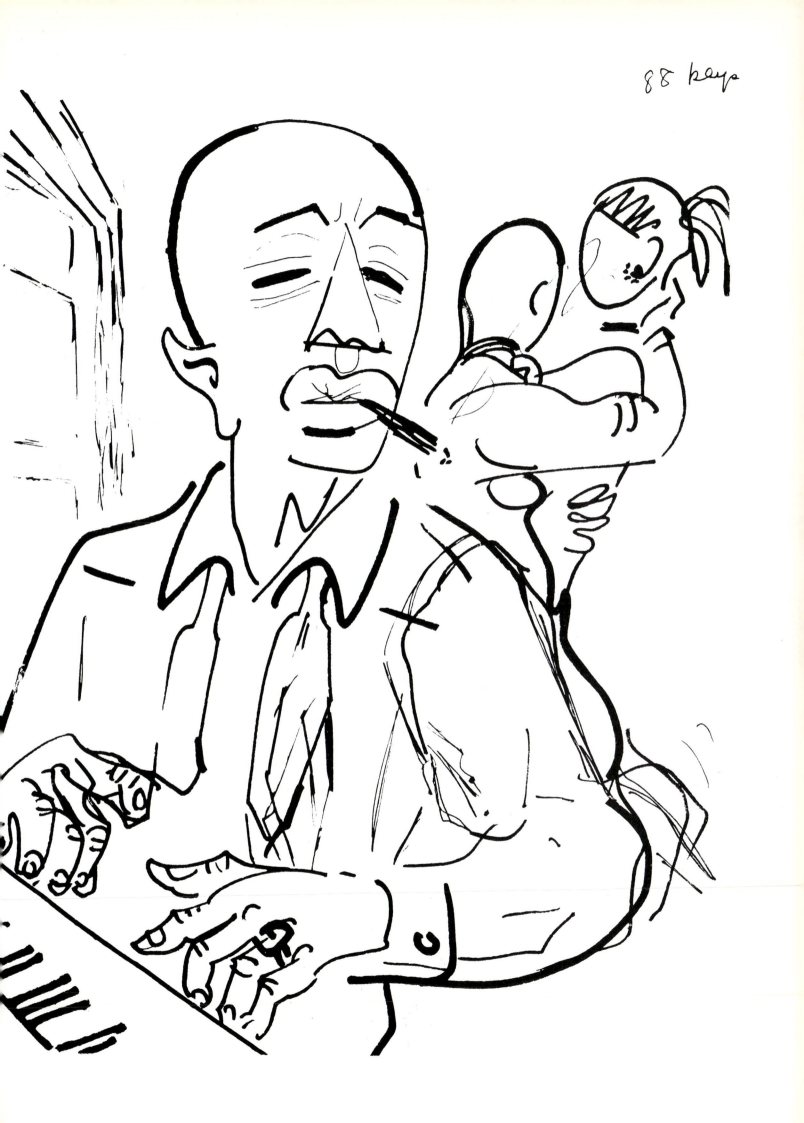

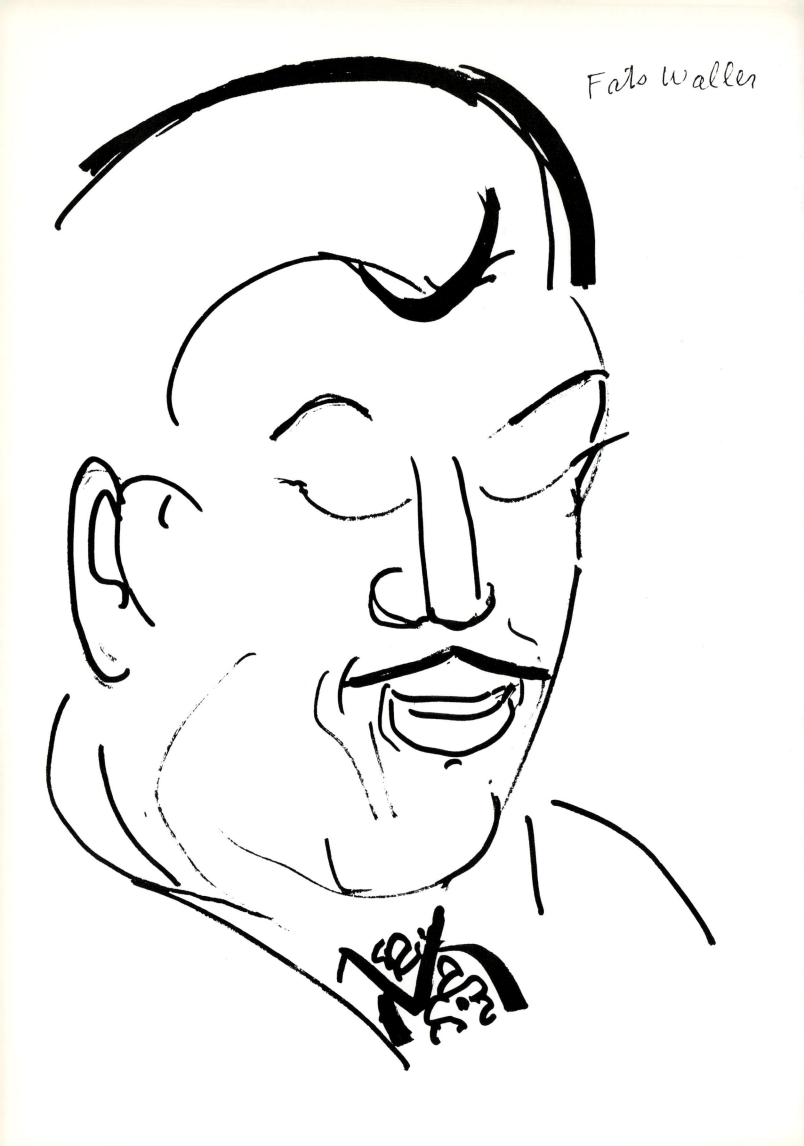

Fats Waller

Stride Piano

When you hear a good stride piano, you know it for the real thing: there is that old ragtime flavor, a loping bass, an intrusion hinting of rhythmic European styles. The heavy bass keeps it on the ground. A real stride piano man sets the mood going, phrasing some of the delicate feeling of pleasure that the 88 keys can give out. The Daniel Boone of the stride style was James P. Johnson, and if he had a musical son it was Fats Waller. Listening to Fats at the piano, playing his own stuff like "Honeysuckle Rose" or "Ain't Misbehavin'" and doing the vocals, you sensed how he could kid it and yet take it seriously. Always being true to the style, even when he played jazz on the organ. His trademark was a tilted derby, rubber-band-thin mustache, and the style and talent of a true artist.

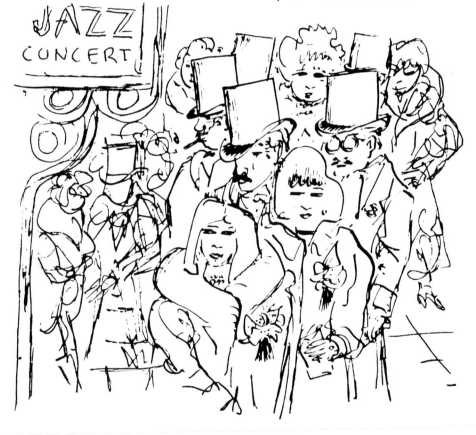

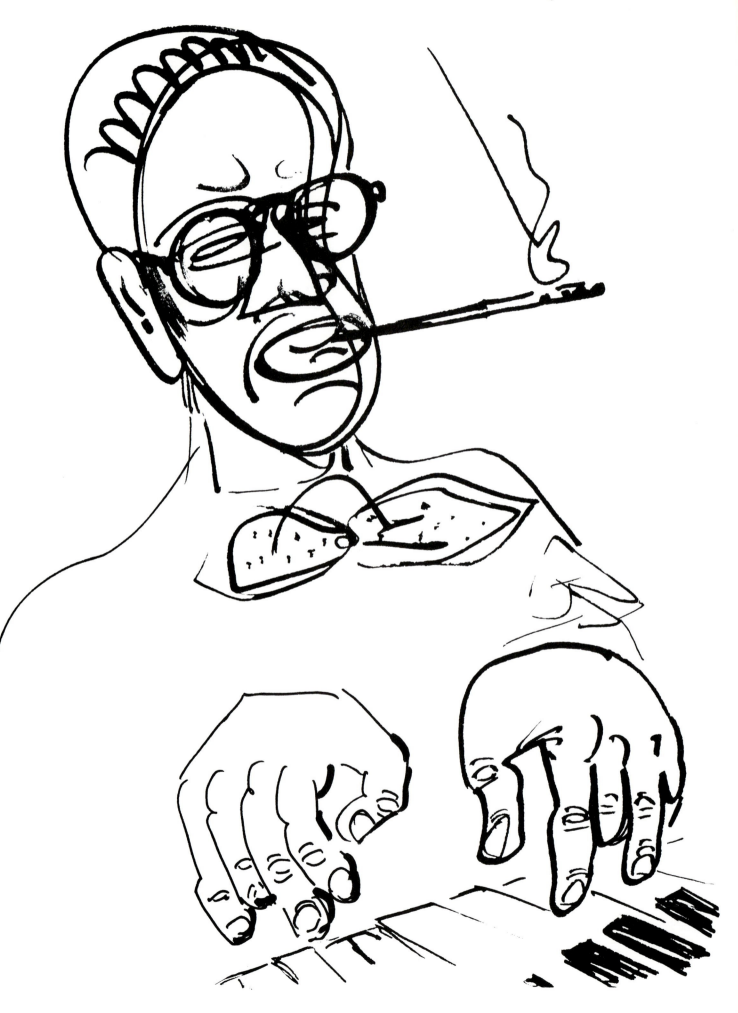

piano bar

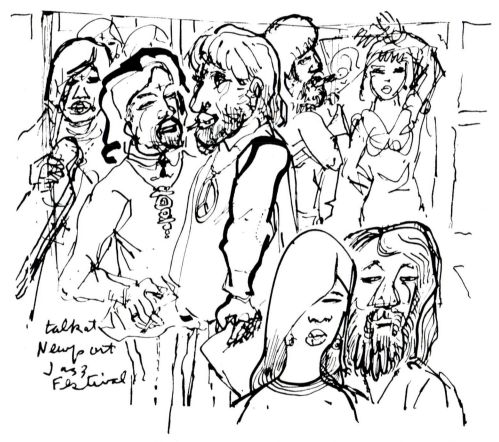

talk at
Newport
Jazz
Festival

What's Boogie Woogie?

 style, a mood? Coming from where? One source said stride was ragtime in a new style with freewheeling melody: the treble melody and the bass playing against each other. And so it just came about when the piano player noodled the keys and mixed up the blues and saloons, barrelhouse and whores, and recalled maybe the strings of a tuned guitar. Eight beats to the bar, the rolling bass was what held it together. It was best on a loose-stringed upright piano that had gotten kicked around, the keys yellow with age, like an old race horse that could still react to the starter's bell. People who heard Earl "Father" Hines said the style brought together memory and nostalgia and some of the gritty edges of a hard life. Some said it helped the player if he was primed like a pump with a couple of gins, but the true stuff came not from the booze, but from the deep blue of the striving for living.

129

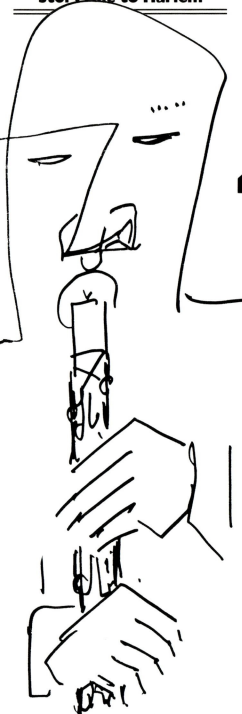

Songs and Dances

the dance and the music were the outlets of black life in a festive mood. While the black bottom, lindy hop and jitter-bugging were Harlem specialties, way back when jazz was forming there were already cakewalk, jig and ragtime stomps and struts. Some sang hiding songs, ring songs and street corner rhymes. One ballad became "John Henry," who loved like a stallion, worked like a steamboat engine. Add gambling songs, songs of women, whores, yellow girls, songs of fighting, razor brawls in dives and honky-tonks. Music and whisky and tumbled desire all came into the music—low down, or beautiful and earnest. It was something inside the black life that was work, love, and trouble. From "Lonely Woman Blues," to "I'm Goin' to Lift My Standard for My King."

Jazz produced many dance steps, from the Charleston to the black bottom, but much of the gyrating could be put under the general title of jitterbugging: a flinging of agitated limbs, twirling and tossing about of partners. The Savoy Ballroom was the main trend setter, much later the Peppermint Lounge.

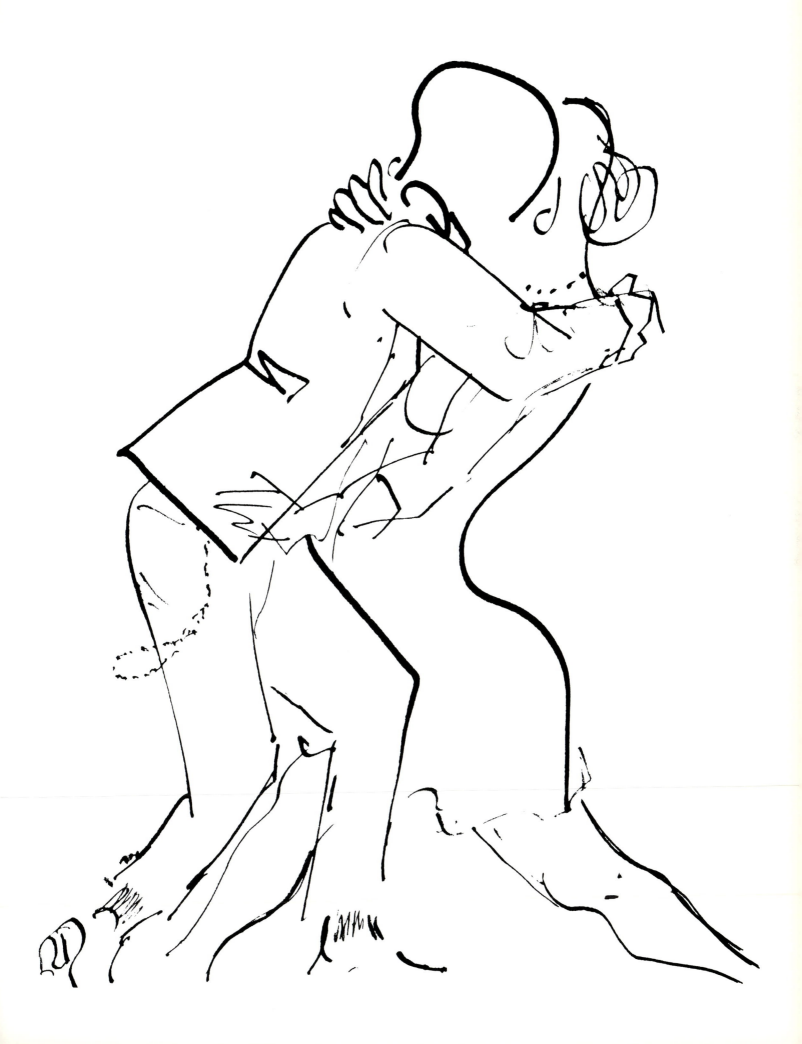

The Charleston

the Charleston first attracted attention in New York in 1922, featured in the all black show, Liza. The next year it exploded on stage in Running Wild *and the dance became a sensation. (But Noble Sissle claimed it wasn't new; he had seen it in 1905 in Savannah.) The movies spread the antic steps through two dancers turned movie actresses, Joan Crawford and Ginger Rogers. And yes, George Raft, heavy with grease, danced the Charleston nightly for the suckers at Texas Guinan's club. "It didn't take talent," said Will Rogers, "Just energy." Later on, its only rival as a dance form to jazz music was the black bottom.*

132

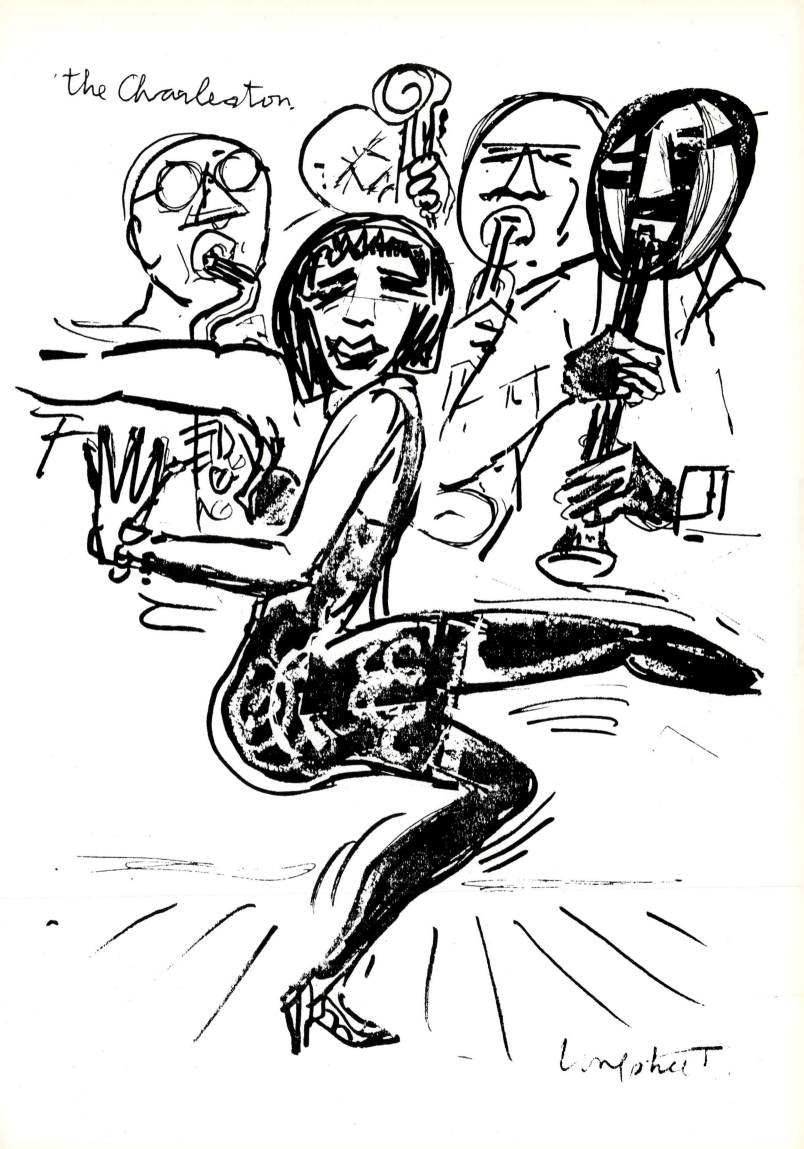

The Black Bottom

the black bottom was done basically by hops, forward and backwards, with slaps on the behind. It came from southern folk dancing, went north in 1919, and first hit black show business in Harlem's Dinah, in 1924. The town saw it on Broadway in George White's Scandals of 1926 being danced by Ann Pennington who was taught the dance by black teachers.

Later it became so toned down and tamed that it was acceptable on most ballroom floors. As Josephine Baker told me: "When the plump matron from Scarsdale is patting her derrière to tea hour jazz, it's not worth talking about seriously."

134

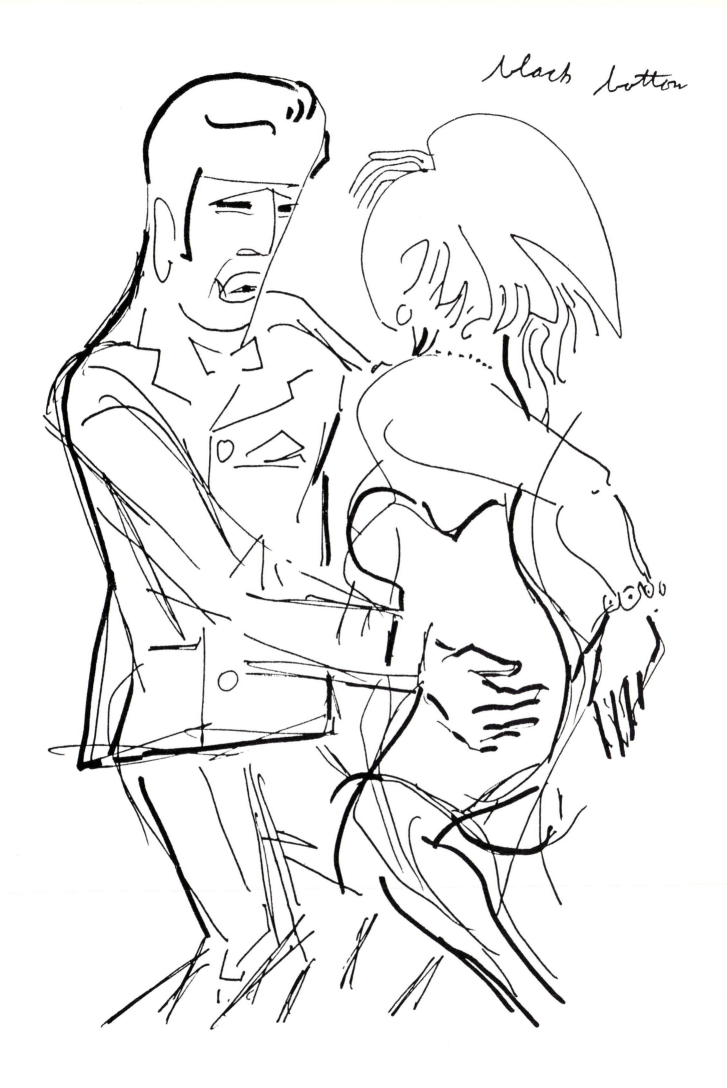

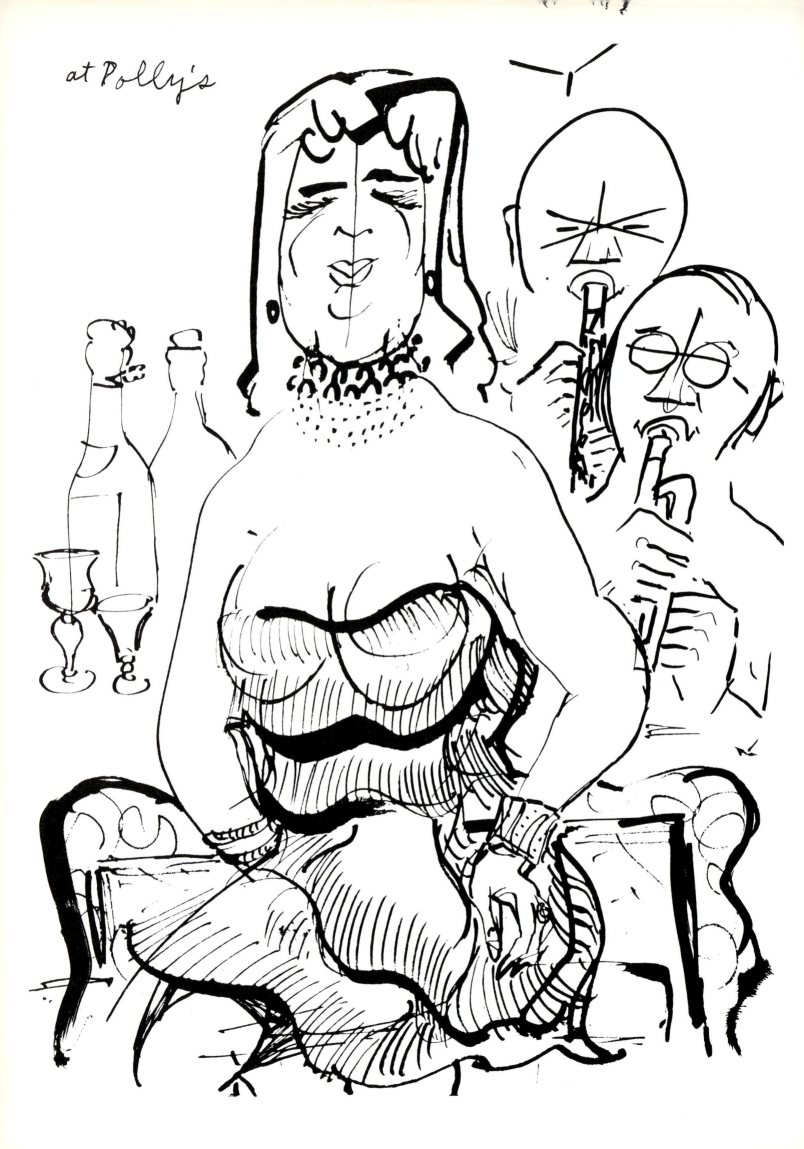

at Polly's

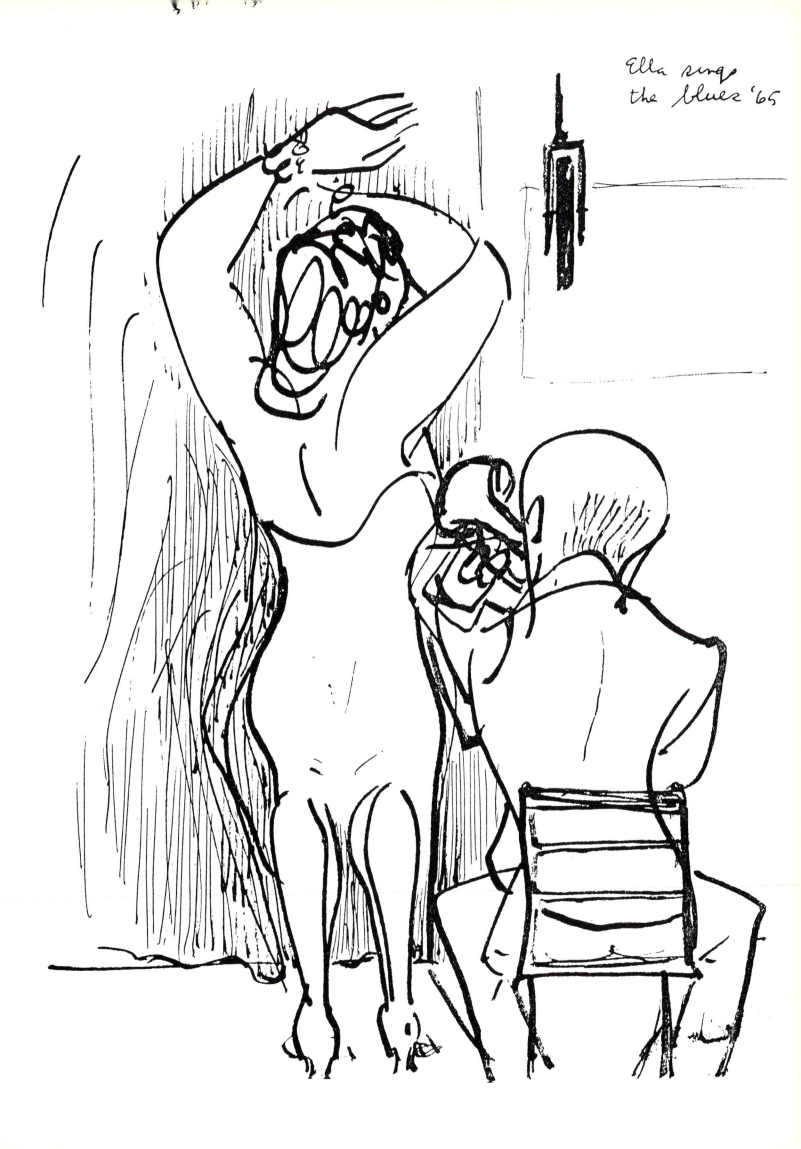

Ella sings
the blues '65

bar piano

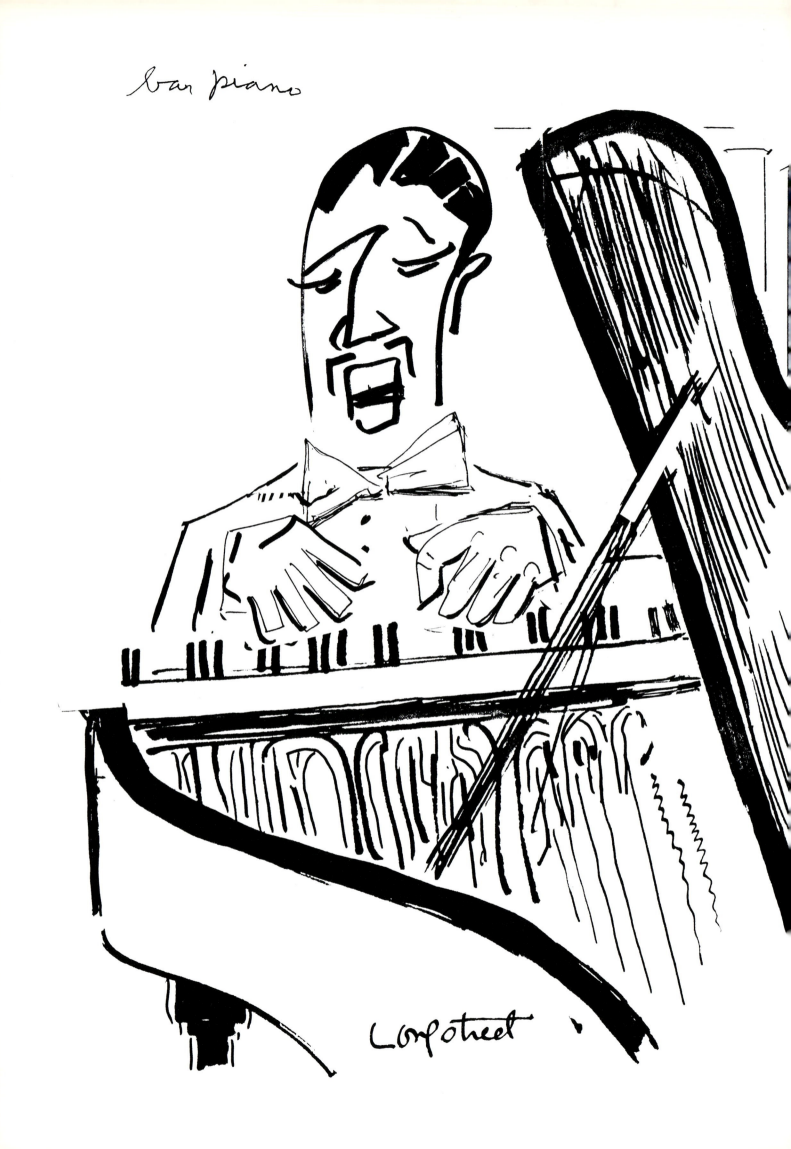

Longstreet

Piano Parts

You can get confused about the piano, as to when it first appeared in jazz. Certainly you could not carry it in a street parade. When the sporting houses got legal, owning a rosewood piano was a showing of class. But the piano really, properly, came to jazz in the dives and honky tonks and unabashed dancing of a weekend night. Now Jelly Roll had worked the houses and the gully-low joints, fingering the keys, and he once told me how to fix up a jazz piano; he'd tell anyone; he

liked to talk: "Find a saloon or a madam that owns a battered upright, old and loose in action. If it's in tune, beat it until it takes on that special out-of-tune twang. The bright boys, they call that jazz dissonance on the blue scale. Pick a crate with a mandolin attachment so that when the plucked note is right, you got yourself almost a harpsichord, and don't make your sound

too clean. The old dirty tone is barrelhouse blues. To get that, pad the piano strings with old newspapers or some burlap bag and kick the front board hard for drum rhythm. Don't care how it looks, just how it sounds. They don't make pianos like that no more. Barrelhouse on concert grands? No. Rumshop piano is the only kind to grind out 'Barrelhouse Woman,' 'Shreveport Farewell,' and the 'Harry Brown Blues.' Keep that treble tremoloandi on the ground bass, and end in the descending bass. The slow blues, a walking bass going up, coming down, and the beat of a breathing locomotive. Yeah!"

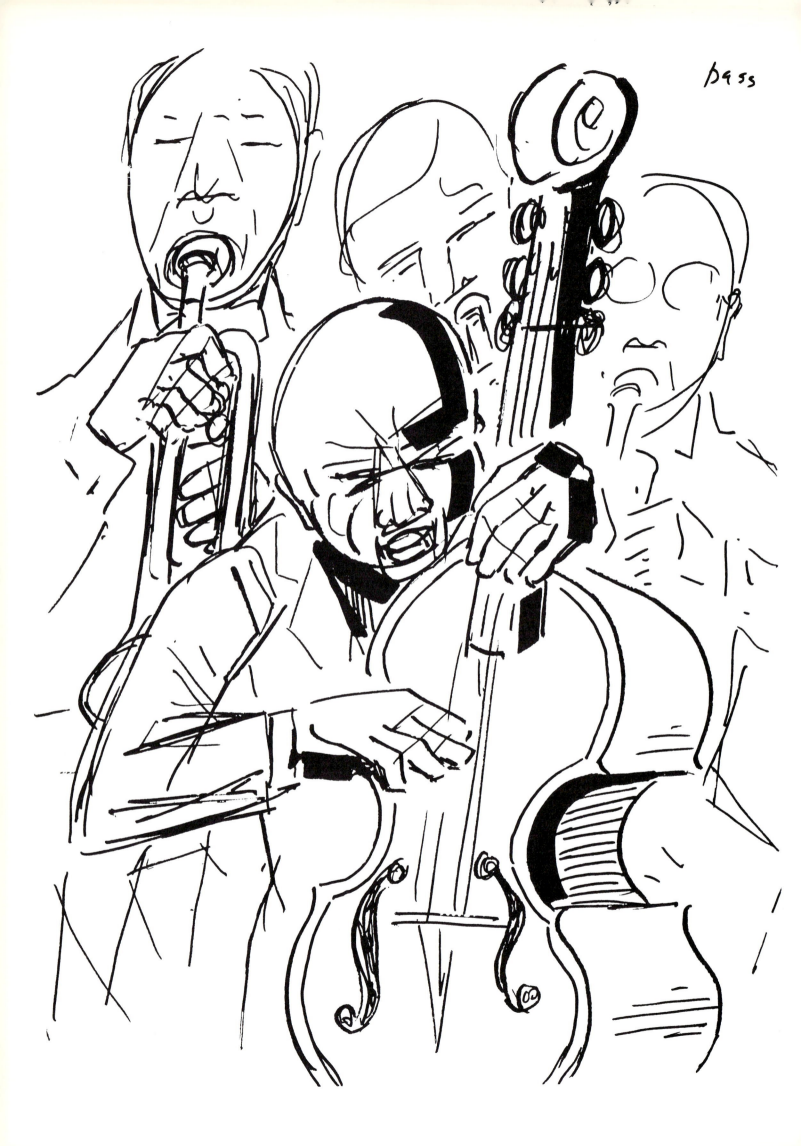

The Boys at Bass

"Who needs a bass?" some folk new to jazz ask, as they watch the finger plucking of the bloated fiddle, an instrument standing taller than many men. It's the bassist who guides the players, keeps them keyed to the proper chord, creates a chain of notes and with its thump keeps the beat going. Bop put pressure on the bass for a fast tempo, and tough melodic signals. There was even, at times, a freestyle and ad-libbing on the cello. We recall the skill of Oscar Pettiford, Sam Jones, Ray Brown on the strings. Watching the fingering, the slaps and glissandi of a boss bassman handling the fifths and four to the bar, one saw art. Under a Paul Chambers or a Charlie Mingus, the bass was one of the major gears in jazz. "It was a bastard to carry," one Chicago bassman told me. "But during a hard time, I wished it was big enough in which to put a chimney, and move in for the winter."

There are those who feel the tuba and the sousaphone do bass sounds as well as the wooden "doghouse." Many plucking, slapping bass players also play the tuba. As Red Callender said, "They're easier to get on a bus, but not much."

The Drums

You can begin by asking what's the difference between the term drums, *and the* term percussion. *Drums are what you beat, made mostly with skin heads. Drum shapes come in all sizes—from snare to circus—and you hit them all with sticks, metal whisps, your fingers, a palm or a fist if so inclined.*

"Percussion aids" Toots said, "take in the whole magillah; chimes, Chinese blocks (even a washboard), a jug in which to blow, cowbells, cymbals, maracas, a mule's jawbone, xylophone. A drummer is like a ballplayer who can play lots of positions: first base, short stop and left field, but he is never the pitcher."

There were a great many masters of the skins. Baby Dodds, Gene Krupa, Chick Webb, Jo Jones, Joe Morello, so many others. To see high-feeling drummers in action was as good as a Bill Robinson dance. Arms windmilling, legs pumping, the bang into the big bass drum, sticks attacking, whisks in action, wooden blocks, bell and the brass plates singing. It was motion and sound in a close friendship or angry roaring.

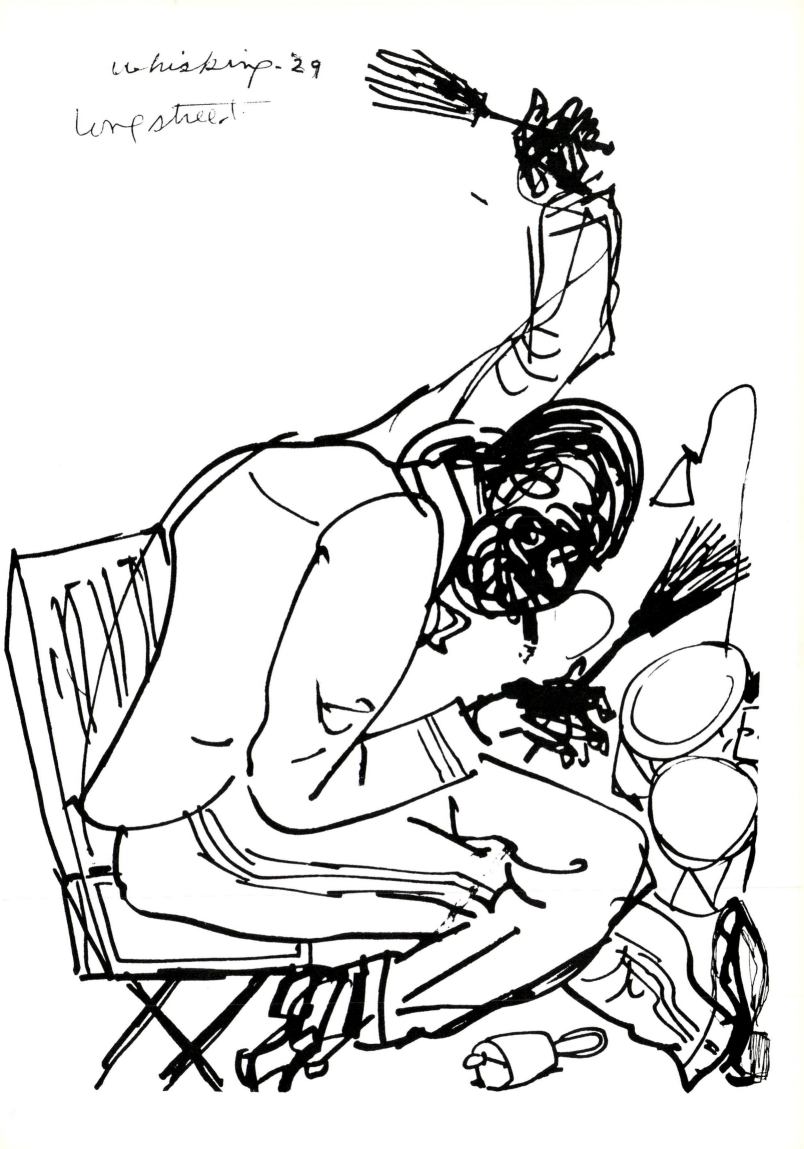

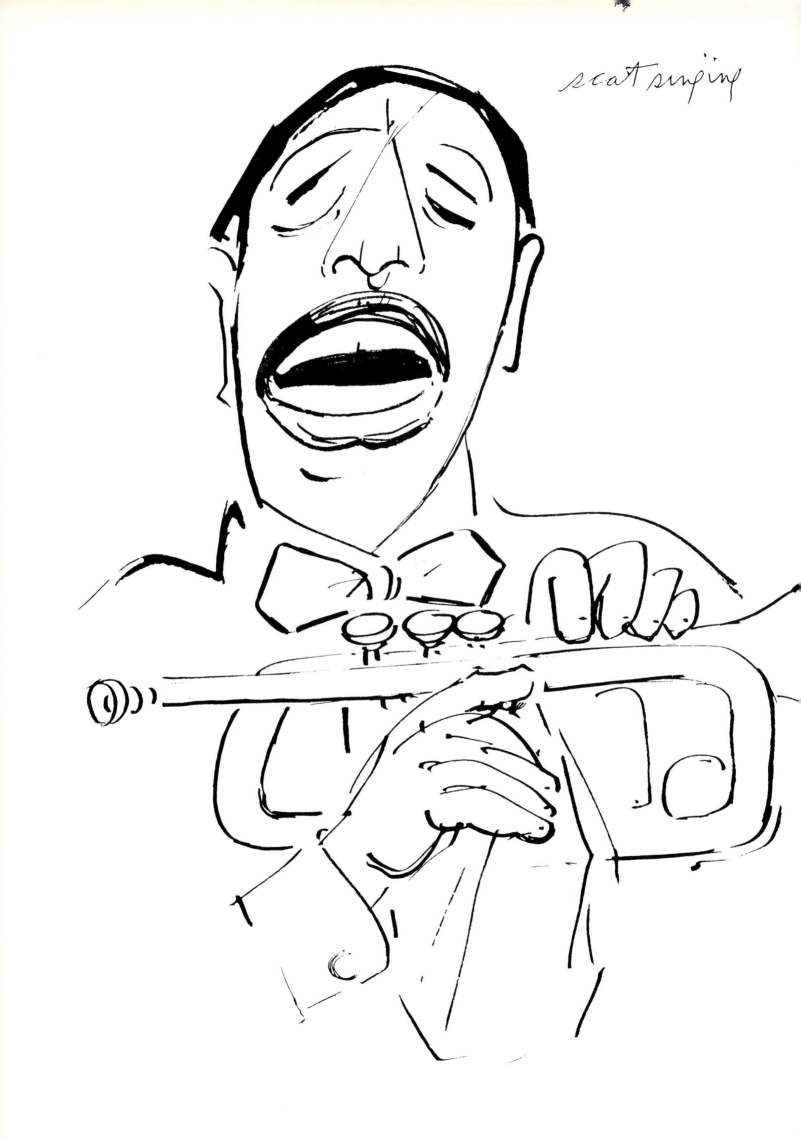

on grass

Singing Scat

cat is a novelty; a vocal trick that consists of heavy and nonverbal sound, making a kind of silly order out of itself, a non-sensible language stringing together sounds like bop—adee—bop—bop—scoop—de—bop . . . bling-bling, bing—bang-bing. The effect is to try and make an instrument out of one's vocal chords. And when it's moving fast, it can become a true percussion tool.

Louie Armstrong gets credit for being scat's inventor and its most famous innovator—or, some claim, most notorious distorter. He insists it just came on because, in the middle of a song, the words faded from his mind. In Louie's mouth, scat singing often has ironic, critical accents. Dizzy Gillespie is also talented as a scat singer. Other singers like Roy Kral and Jackie Cain produced a low-keyed delightful style of scat, still nearly wordless, but having mood and emotions suggestive of the uncoded mystery of existence.

One form, called vocalese, uses not only the song, but a musician's improvising to put together words à la Gertrude Stein—trying to capture the personality of the bop player. But no matter how heavily you lay the words on jazz . . . the real thing can take it and survive.

145

Big Band Era

hat makes a good big band work?" I once asked Red Nichols when we were involved together in some radio shows. "What? At first, eight or nine men playing music together. Now, maybe a twelve to sixteen piece group." When the big band got its pressures up, it gave off a tonal sense you didn't get with small combos; you had stronger sustained rhythms, backed by loud vocalists, or you muted the brass, and you could divide the music into hot swing and sweet swing. Swing was the most popular form jazz took with a wider public. It pleased the wild young, and also made music for the sedate Wasp ballrooms. It was a touring era, with the big bands in buses and trains, and some in the early passenger planes, moving about from country club to college gym, from stage shows in movie palaces to sales conventions and on to some pretty banal movie soundtracks. Benny Goodman, Bunny Berigan, Woody Herman, Count Basie. Swing was the only jazz style that came close to the later popularity of Elvis and the Beatles.

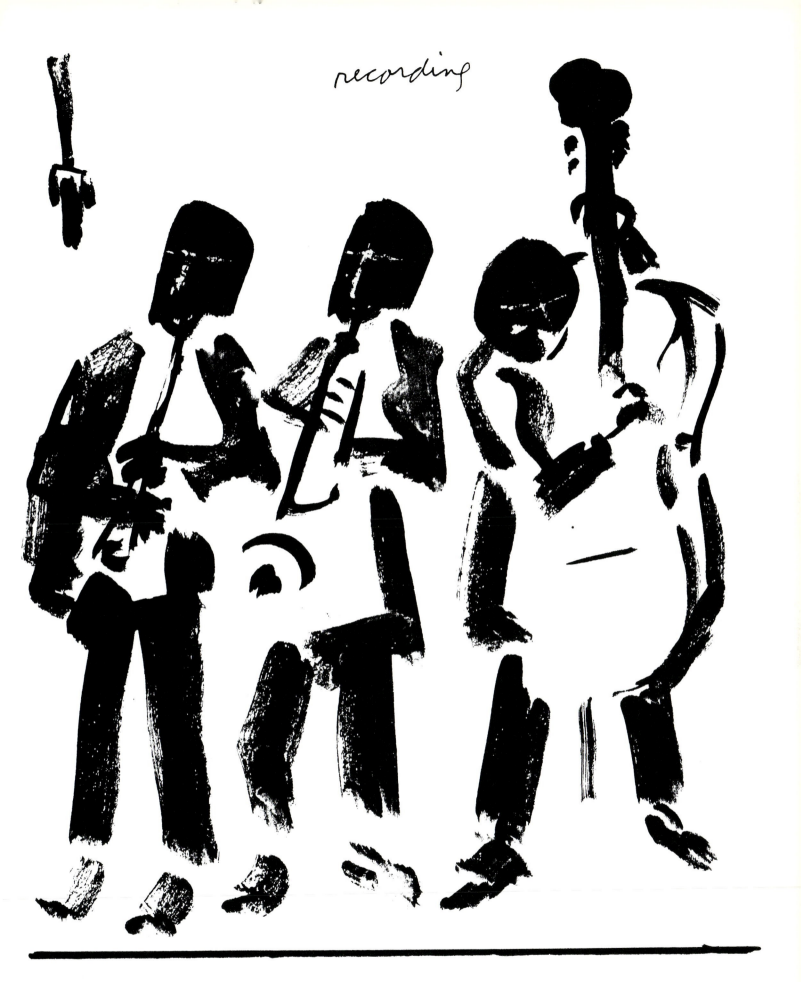

Big Time Swing

the jazzman who made it to a big band lived high, drank the best. As Big Toots told me, "Had me wall-to-wall women, drove a watermelon pink Caddy, flashed a diamond pinky ring, and no longer fanned my soup with my hat. Oh, it was prime livin' with big band jazz, then sweet swing got too sweet and those punks came over from England to go epileptic to spook music. Gigs got hard to find. I still have the alligator shoes and the demands for alimony from a couple of wives in memory of the good times."

History, some wise cat once said, is myths agreed upon. Take swing. You can pick your facts from several lines of thinking about it. Was it in 1928, that "Kansas City Stomp" was recorded by Jelly Roll Morton's Red Hot Peppers? Or did swing come down the pike in 1929, when a ballroom exploded as Walter Page's Blue Devils played the new style? Or do you prefer 1932, when Duke Ellington presented the country with "It Don't Mean A Thing If It Ain't Got That Swing." (Anyway 'swing' was in the title.) Some purists—who want to let the white boys into the act—say it all happened when the Dorsey Brothers, with arrangements by Glenn Miller, gave us the true big band swing, and by 1936 there was a "Swing Music Concert" at the New York Onyx Club with such big names as Tommy Dorsey, Bob Crosby and Artie Shaw.

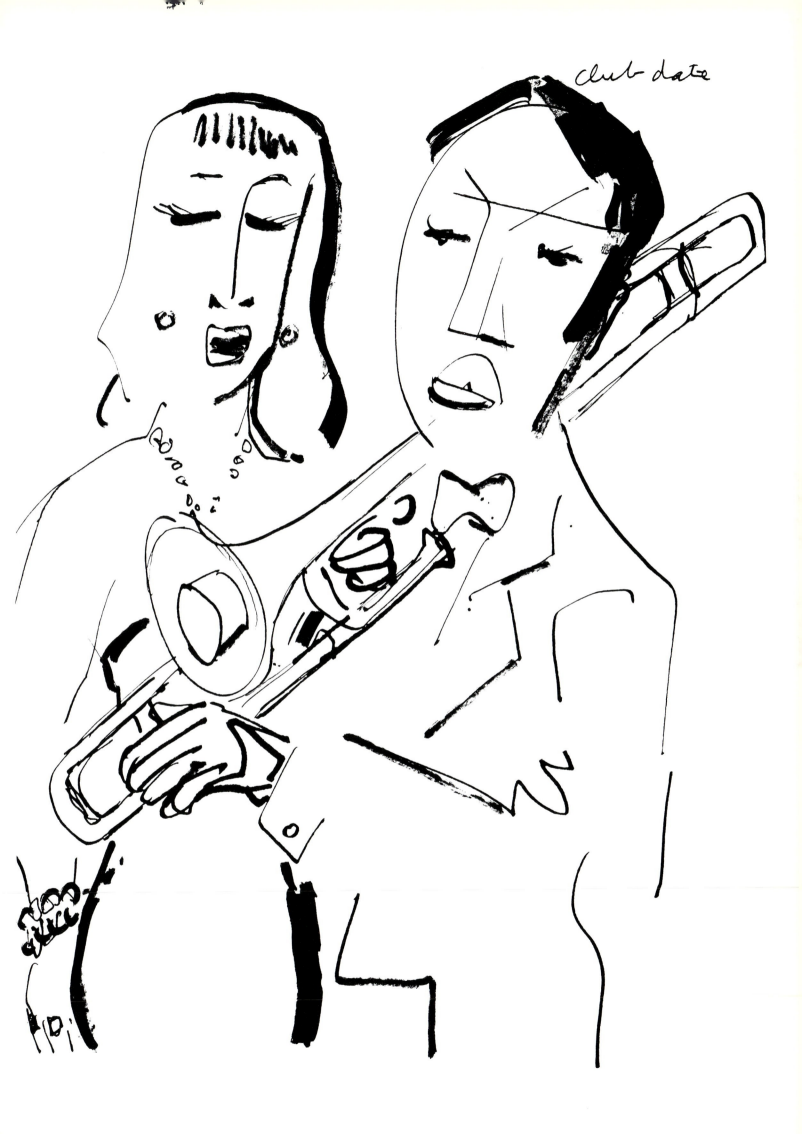

club date

country club

longstreet

London

An Other Country

the black jazz folk I knew of in Paris when I was a teenage art student made me think that for all their critical attitude toward America, most of them were homesick, and lived their lives, in hard times or good, as if acting out the pioneer spirit, presenting jazz in Europe clearly as an American music. You'd meet them cavorting at some Bal Négre or playing a session in some cabaret. Morning, they would be having first drinks at the Dôme, the Rotonde, or some other place, sleepy, some hung over, others making plans that would never mature.

There was no color line, they would say. They had white girls, and some of the female singers had white lovers. Smoking, drinking, making good music, enjoying "the scuff" (food) the good life when they had "the lettuce" (the word bread for currency was not yet in use). It was a good time when the clubs and cabarets went heavy for the jazz sound in the 1920s but there were hard times too— you'd see them with their horns in paper bags, rapping with some Dada artist, neither communicating well in two languages. Or rapping over Antheil's Ballet mécanique and his Jazz Symphony ("a moldy fig") or part of a group around Kiki, the famous artist's model whose Japanese lover-artist Fujuta played jazz records.

at Buck
Tops - Paris

Jazz in Europe

as more American jazz groups got to cross the big pond, there were more admirers of jazz—native talents like Django Reinhardt who produced jazz on a gypsy guitar, and Hugues Panassié, jazz critic and creator of Le Jazz Hot Club. The big names came over: Louie Armstrong in 1932, the Duke the next year, and Coleman Hawkins in 1934. Bop and post-bop was what the Europeans liked best. And the jazz lovers were usually more ardent and excited about the music than most of the citizens of the United States: their fervor in record-buying, concerts, festivals, amazed many tourists.

More and more jazzmen settled down for good in France and the Scandinavian countries. Home is where you go and they have to let you in.

Paris after Dark

the big tourist spot was
the Bricktop Club, a very
posh place where a
jazzman could get a gig
at times. Bricktop (La
Rouglot) claimed her red
hair was natural and she had a
personality to go with it. The jazz there
was good, even if the Prince of
Wales took over the drums one night
and proved he didn't know anything
about the real jive or riffs. Near morn-
ing, the black and white exiles
would hate to go home; after a last
cognac, they'd lift their shoulders
into their topcoat collars and with some
partner move off slowly; hunched-over
symbols of the bitter bread of voluntary
exile. . . . "Hear that railroad train
whistle."

The Paris Scene

It wasn't just Gertrude Stein at 27 Rue des Fleurus and Ernest Hemingway in Montparnasse who took on exile in Paris, set up a "lost generation" and kicked the gong around in their own way in Montmartre, the Latin Quarter. Even Benjamin Franklin was an expatriate earlier in Paris. There were blacks who left the redneck country, the bigotry of Whitey, the horrors of slum life, and found in Paris a freedom from the yoke of intolerance, where color was not a sign of inferiority.

Even before the Great War of 1914–1918, the music halls were playing ragtime. Then, after that war, there were players from the army bands who didn't see any reason to go on shining shoes, or to become Pullman porters. Jim Europe came from leading army orchestras and began playing jazz for La Vie Littéraire crowd. In 1919 there was Sidney Bechet and a touring Original Dixieland Jass (not Jazz) Band that went round Europe spreading the sound. Bechet also wrote the music for Josephine Baker's appearance at the Folies Bergère where— in La Revue Nègre—she won fame and notoriety dancing in only a G-string made of bananas.

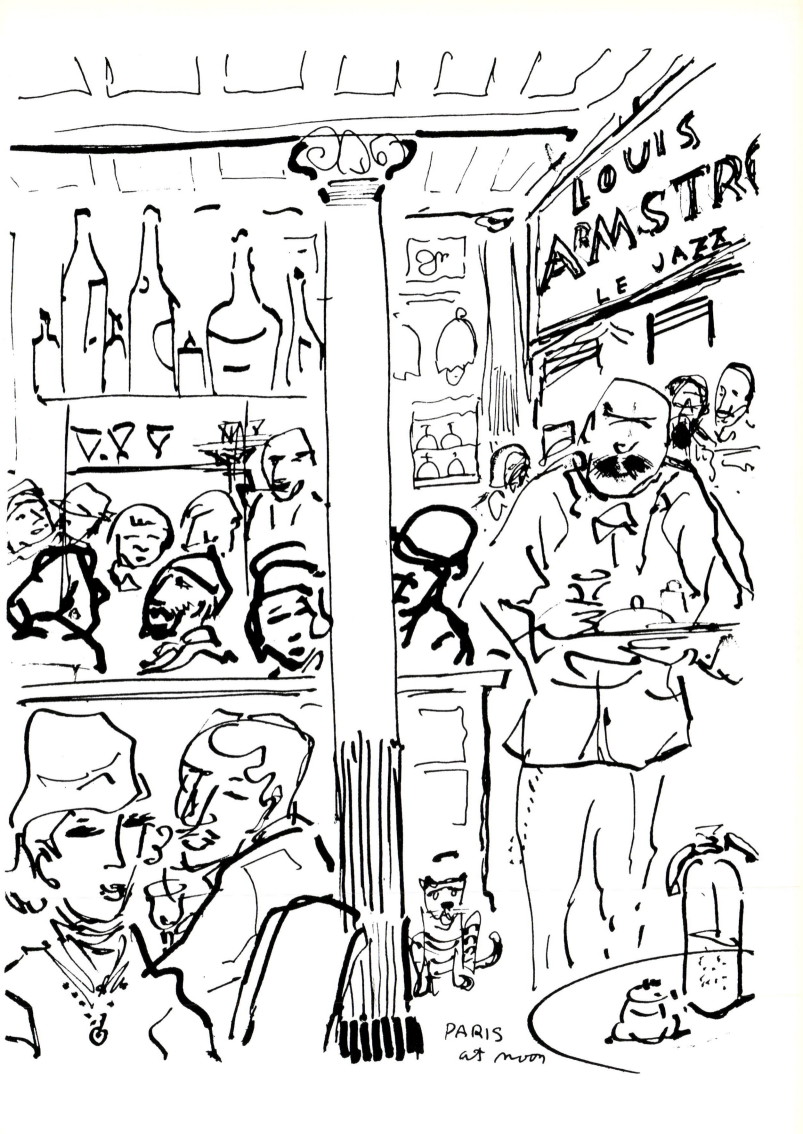

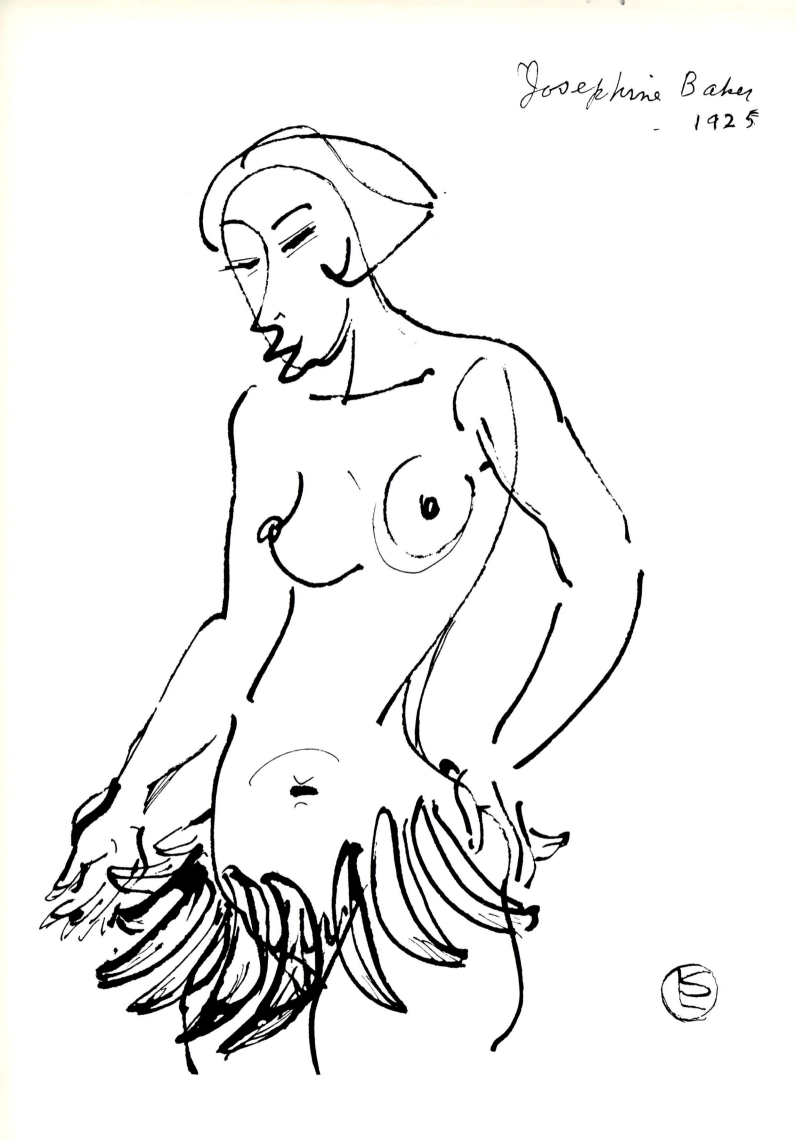

Josephine Baker
1925

Josephine Baker

I first saw Josephine Baker in Shuffle Along *in the middle 1920s. She had come "out of nowhere," aged sixteen, and was in the chorus. But coming on to decorate a number, she suddenly went wild: mugging, taking crazy steps, mocking the dance routine. The audience rose to cheer and soon she was moved up as a feature star, getting $125 a week ("A lot of the green stuff for a newcomer in them days"). She went on to* Chocolate Dandies *as a specialty dancer.*

But her ambition was to get away, and two years later Josephine Baker—arriving in Paris aged eighteen—became, some insisted, "more French than the Eiffel Tower."

The last time I talked with her was in 1951 when she came to the United States to earn money for the orphans she was raising. Some columnists, like Walter Winchell, attacked her meanly, and dishonestly, as "a communist" and tried to have her barred. She was playing downtown Los Angeles at a commercial theatre, and I visited her in her dressing room during her costume changes. She had filled out, was no longer the jumping sprite. I did sketches of her as we talked of the old times: the usual Nostalgia Road trip. I asked how her life was going. She quoted, "De L'audace, encore de l'audace et toujours de l'audace."

I recalled the funeral long ago of a forgotten jazzman in one of those stone heavy burying grounds of France, and someone spoke these same words of his ardor for jazz, over his grave. "Audacity, again audacity, and always audacity."

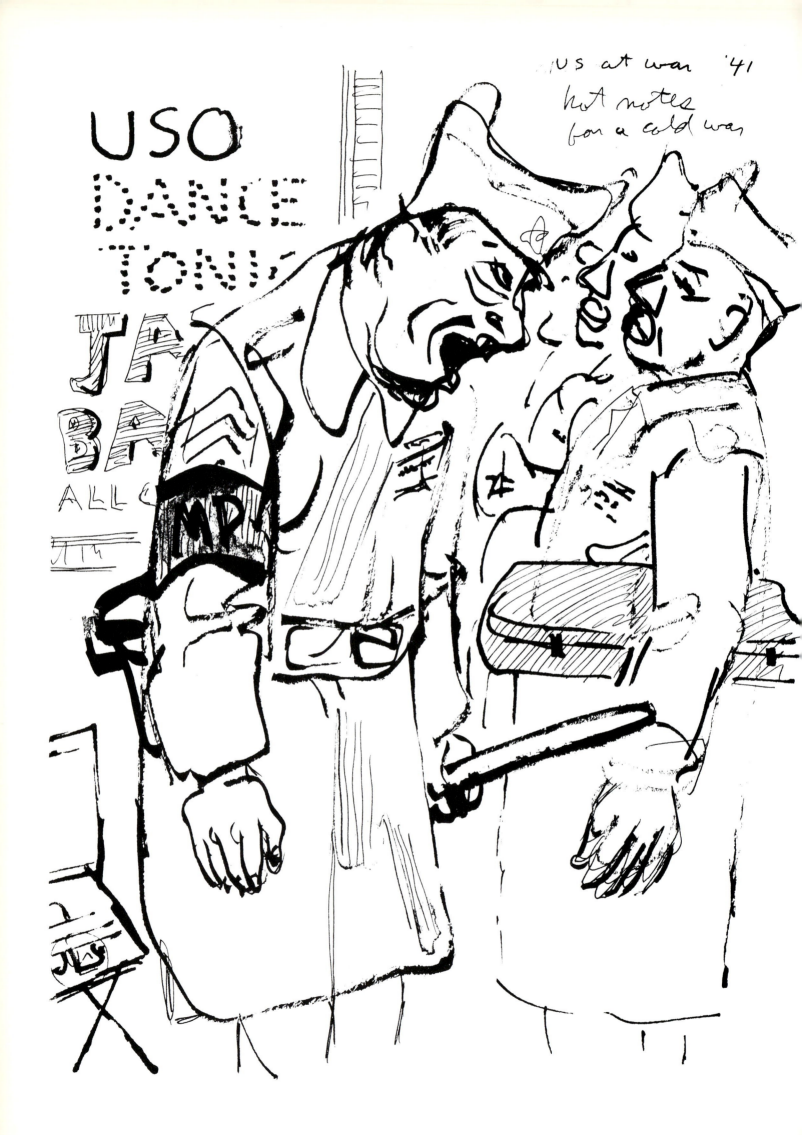

Jazz Stars

for some, the hard times passed quickly and high living came as the recording industry poured out million record royalties. Concert tours, often of debased jazz crossed with rock, could make multimillionaires. Some handled success, some didn't. The ultra touch of class Big Toots saw as "a white chauffeur, and reading a French menu."

Bessie Smith

bessie Smith's fame rests as much on the drama of her life and death as on her work as an early singer of the new music. In 1910 when she was in The Rabbit Foot Minstrel Show, her great talent was recognized by the boss's wife—none other than Ma Rainey. Later, on her own, Bessie toured the nightclubs of the south, becoming more and more a jazz voice of great conviction. She was earthy, and she knew how to hold the spotlight. Her specialty was the blues. She made early recordings, but they do not appear to have been released. When Bessie began to sing for Race Records (supposed only to interest black people) her fame spread as

her tone of slow sensuality took over. Her problems were the old bogies: drinking and being hard to get along with. "You were her friend today, her enemy tomorrow, and her friend again next week." The booze seemed to set her mood, and her private life moved from the honky tonk set to the roadhouse dudes.

Her tragic death became a legend, in fact several legends. Badly injured in an auto accident in Mississippi, was she refused admittance to a white hospital? Or did she bleed to death when the medical staff treated the white victims first? "Only sure thing," Kid Ory said, "is that she sure was dead."

"Chattanooga Choo-Choo."

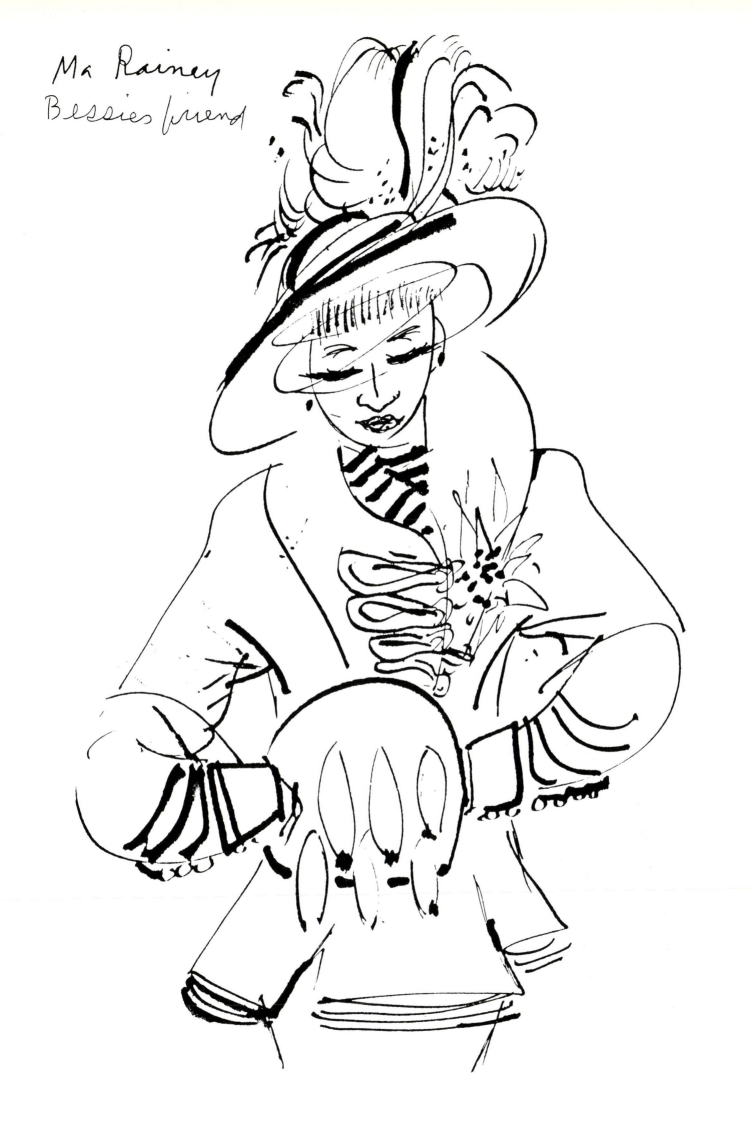

Ma Rainey
Bessie's friend

Bix Beiderbecke
(NYC)

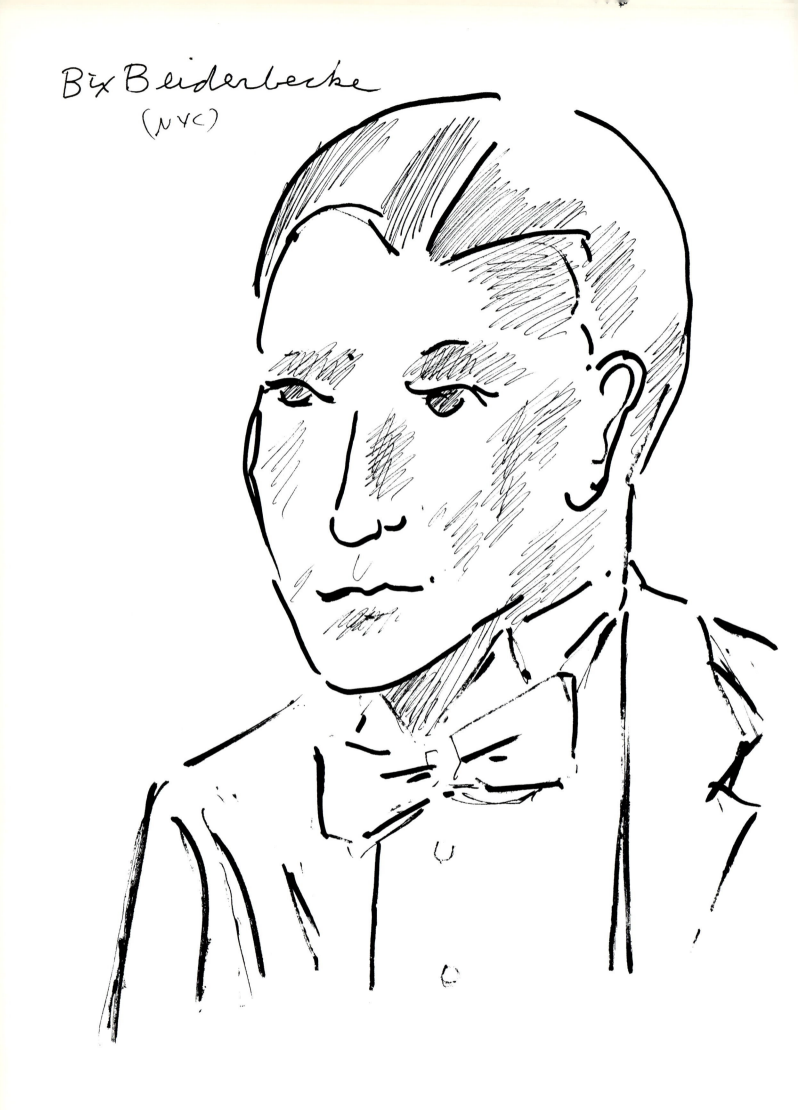

Bix Beiderbecke

I recall rare contacts with the man in the late 1920s; he didn't talk much: I'd greet him, he wearing a crumpled tux with a stained shirt front, hair inky black and slicked back, well oiled. He had the pale face of a mystic and a lush. His first name was really Bix, and he came of a solid middleclass Davenport, Iowa family. Maybe he was one of the greatest white jazzmen in history, certainly one of the first white geniuses of the music.

Bix started tickling a piano aged five. Getting a cornet, he played Nick La Rocca recordings, note by note. By 1923, he was with The Wolverines, the prime white jazz group.

Bix was a drifter, a man wondering about his own destiny and the music. He was with Goldkette, the Dorseys and, in the end, Paul Whiteman; Bix didn't care for the style—"jazz flavored music"—but he needed the bread. To ease his mind, he began to compose for the piano and recorded the classic "In A Mist." He was a drinking man and an unhealthy one, as was clear when a few of us would join him in a speakeasy. He was at his best in a solo on a bandstand, giving out clear notes, clean notes, fast too. "It had the richness of the best gravy," said Langston Hughes. "Its brassy sound was that of a master." In 1929 he was too sick to keep a playing date at Princeton, and died of the booze, aided by lobar pneumonia.

169

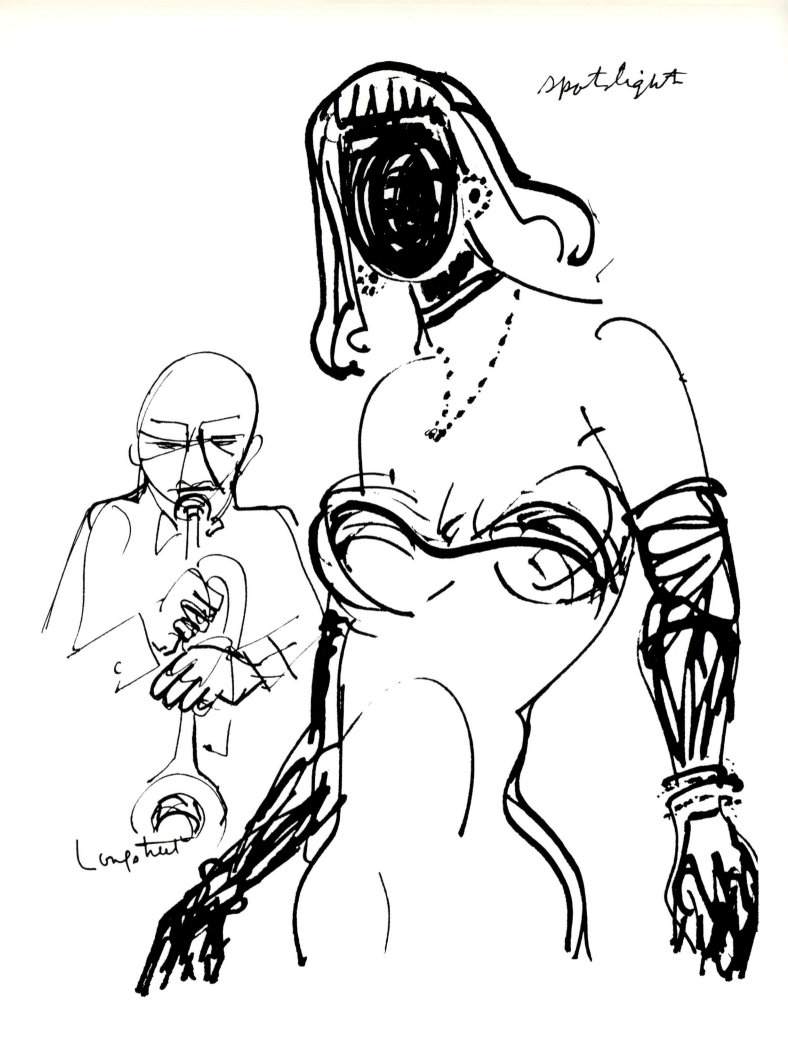

spotlight

Longotreet

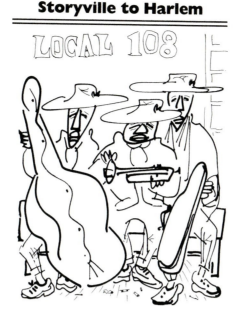

Billie Holiday

orn during the Great War in 1915. No father, then coming to New York with your mother. The city cold, very cold. Hard, hard living. How will the movies use that part of your life when you were working the hot sheets and got nicked, got four months in the slammer on Welfare Island? Later, The Log Cabin Club let you sing for tips. But it was a unique voice—it was called to the atten-

tion of Benny Goodman—and there came a time you played the Apollo Theatre—the Harlem place—and then you were a star, Billie Holiday.

The best you ever did was with Teddy Wilson, Fletcher Henderson, Count Basie, Artie Shaw. People collected recordings of "Strange Fruit," "Lover Man," "God Bless The Child." When the recording of "Gloomy Sunday"

caused some freakouts to commit suicide after listening, the song was taken off the radio air waves.

God didn't bless this child. The hard living, jangling nerves had been beaten off by alcohol, by addiction to hard drugs. That led to arrest. In 1947, Billie went to the Federal pen for some time. The blues were autobiography. If she kicked the drugs, it only increased the drinking. She collapsed during a drug arrest and died in a hospital. If jazz had geniuses, Billie Holiday was one.

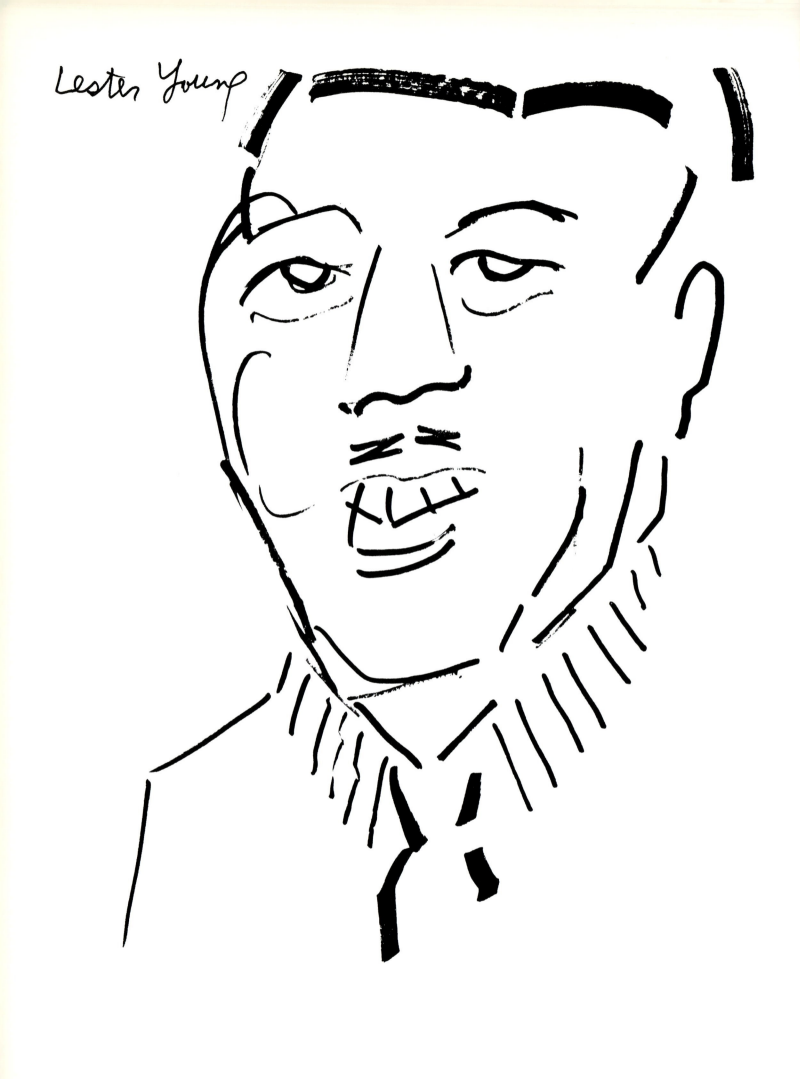

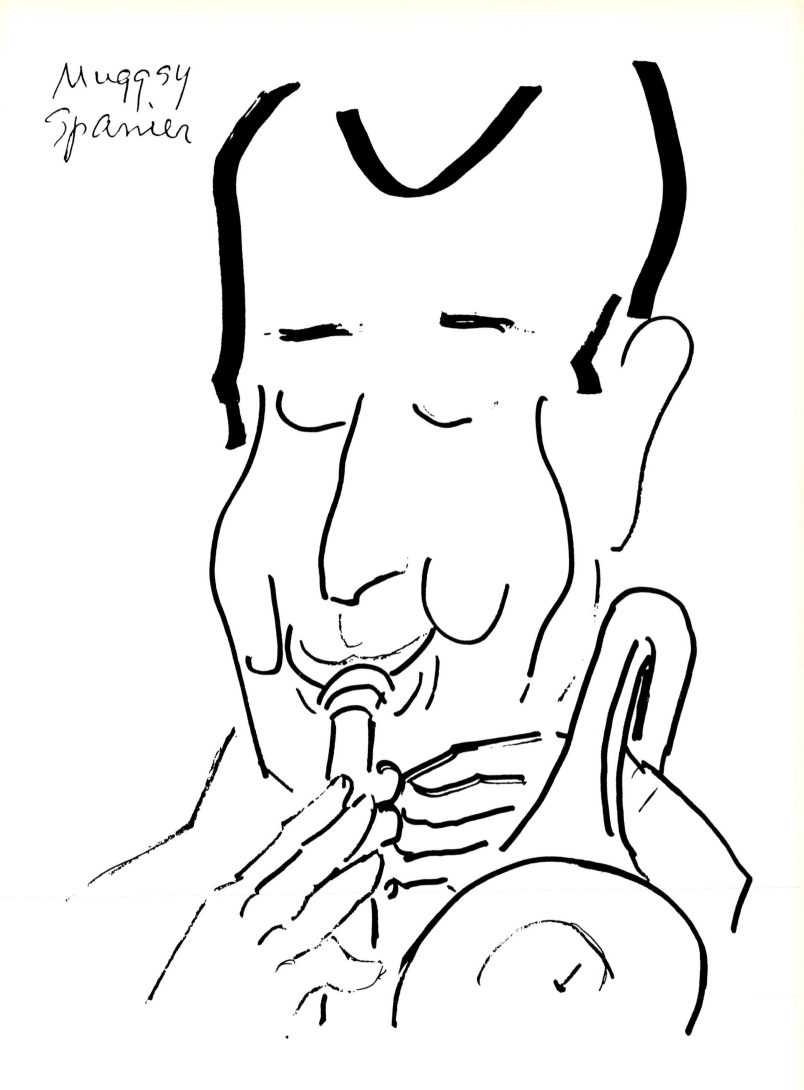

down town

Benny Goodman

hicago and jazz came together to produce Benny Goodman, the great clarinetist and dedicated band leader. At age ten, he was in a synagogue music school and two years later was seriously studying his instrument at the Jane Addams Settlement House. At thirteen he was a professional performer in a dance band. Jazz fascinated him and at sixteen he was with Ben Pollack's white jazz group. Moving up to recordings and playing dates, he had his first big band in 1934, took it on tour and found solid fame and glory at the Palomar Ballroom in Los Angeles. From the 1930s through the 1960s, most of the great jazz sidemen played with Benny Goodman. In 1962, Goodman's big band was touring in the Soviet Union, making converts among the young comrades.

175

Count Basie

he was born William Basie, but a press agent felt jazz needed a nobility. He would talk to you and tell you about being raised in New Jersey—how his mother played the piano and he was a kid drummer. Took organ lessons from Fats Waller. Stranded during a tour—marooned in Kansas City—he played with Walter Page's Blue Devils, and with Bennie Morton. By 1935 he had his own band. Along the way he composed "One O'Clock Jump." Came the 1960s, his band seemed to have lost a bit of its oomph. I used to visit him in the little club he was running on the Sunset Strip in Hollywood. He was heavier than I had known him when we were both younger; he retained a settled-in approach to life. "Sometimes you're a sky rocket, sometimes you're down. Mostly you're running with your second breath, loping, loping along. Diamonds or just coffee and cake." He never lost his poise. There was a sense of the sadness of change. But right up to the end, he remained one of the best of big band leaders.

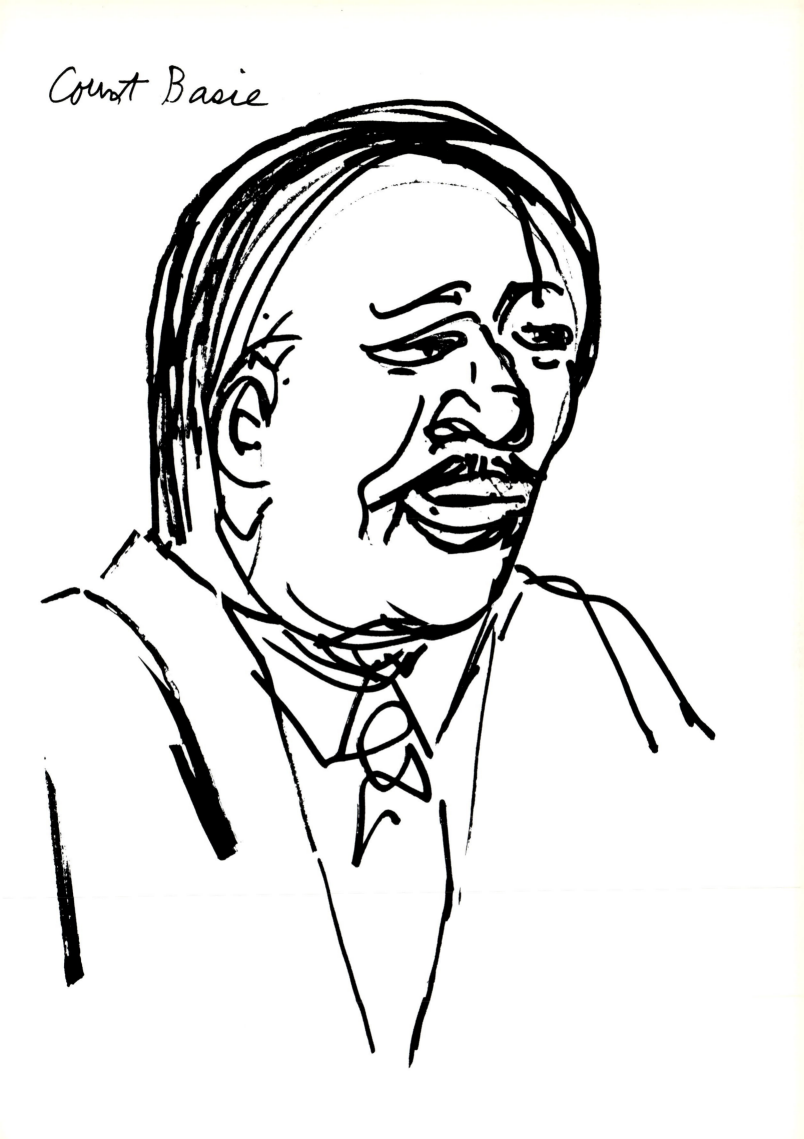

Count Basie

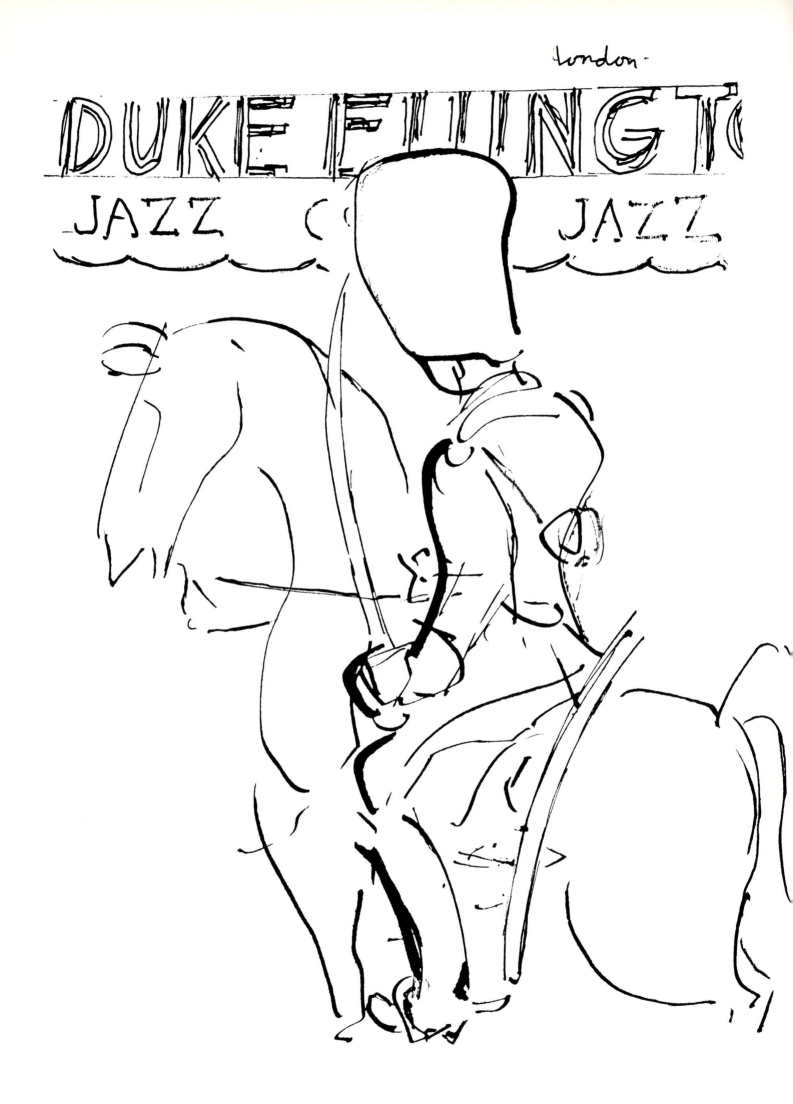

Duke Ellington

born Edward Kennedy Ellington, he came from a well-to-do Washington, D.C. family, carried himself, even as a kid, with aristocratic grace and was already called "Duke" as a boy. He began to study painting, but his ear for music proved stronger than his eye for form. He started playing ragtime and stride piano. He first band was the Duke's Serenaders that later became the Washingtonians. As he explained, "Always go first class." Fame came in 1927 when he was booked into the Cotton Club. As a composer he showed a smooth natural style, an early success being "Mood Indigo." Ellington was a prolific composer, and some critics saw in his work the influences of J. S. Bach, Delius, Debussy and Stravinsky. His honed, wonderful orchestras brought jazz some of its most delightful music, full of wit and a sophistication that made jazz comfortable in white tie and tails. He liked the fast life, took pleasure in his vitality, and his motto "I love you madly" covered some of the complexities of a great talent moving between two worlds, the black and the white. When someone told him he was "the black Gershwin," he smiled and said, "Georgie: he's the white Ellington."

179

Charlie "Bird" Parker

born in Kansas City, a place where in the twenties and thirties jazz was in the air. When he was eleven, he owned a saxophone, inspired by Rudy Vallee's radio shows. Buster Smith, the clarinetist, used him, but Parker moved on to a small group run by Jay McShann—here he stood out as an extraordinary sax player. Sadly, Parker since his teens had had the heroin monkey on his back, and it caused trouble in bands that wanted to keep their playing dates. He went to New York in 1939 and joined Dizzy Gillespie and Kenny Clarke in launching bop. Parker was a soul mate—giant size—as he moved on to the new style, but he was also a problem to himself and to those who admired him. By 1946 he was heading for a whale-size break-down, and ended up being committed to the Camarillo State Hospital. Released, he did some of his best work. But trying to cut down on drugs led to heavy drinking. The loss of a daughter brought on an attempt at suicide. There followed two more commitments and Parker's playing was not as it once had been. Booked into Birdland, the Vatican of jazz named in his honor, he bombed, and died of a heart attack while watching Tommy Dorsey on TV: dead at the age of thirty-five. So passed an amazing performer who changed the form of his art and needed no legend created of his life; everything said about him seemed true.

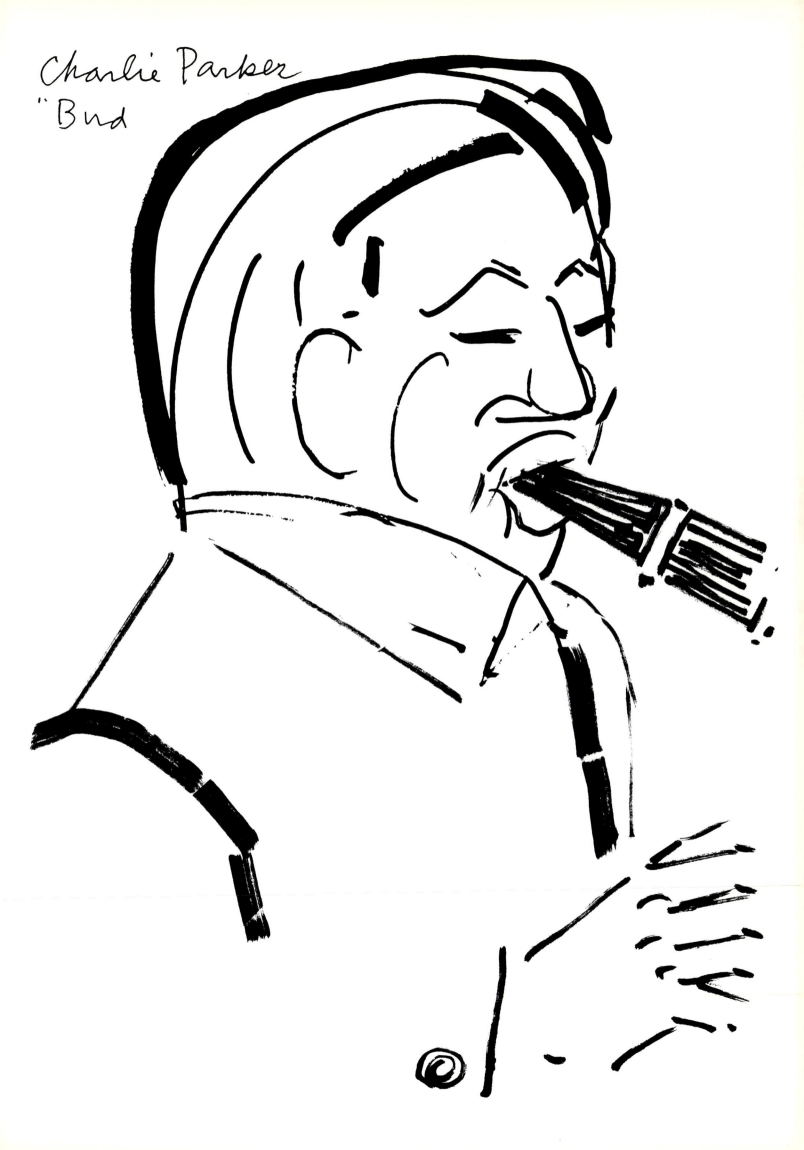

Dizzy Gillespie

"**g**iants come in many sizes," the late jazz critic, Ralph Gleason, once said to me. "Of course, a lot of it is inside and comes out in what they do, not how tall they are." Dizzy came from South Carolina where his father often played in bands. The boy tried out his old man's instruments. At fourteen, he played a fine trombone. He won a music scholarship, and when his family came to Philadelphia to live, he began to pick up band jobs. He toured, played with Cab Calloway and began jamming with Charlie Parker and Thelonious Monk. Afro-Cuban styles interested Dizzy, and as he sang bop songs, he found he could be funny. He formed big bands, he toured and was aware he was one of the creators of modern jazz. His trumpet had a jolly sound, always adventurous, with a solid controlled tone. Some may object to his humor, but it is part and parcel of the Dizzy picture, like the upthrust bell of his special instrument. As a composer, he is as fine as his playing: "Night in Tunisia" or "Anthropology" alone would make him one of the great talents in the history of jazz. In his fascinating, oddball "Kush," there is an ironic genius. Dizzy had the strength to resist the temptations of hallucinating destiny that brought down his friend Charlie Parker.

182

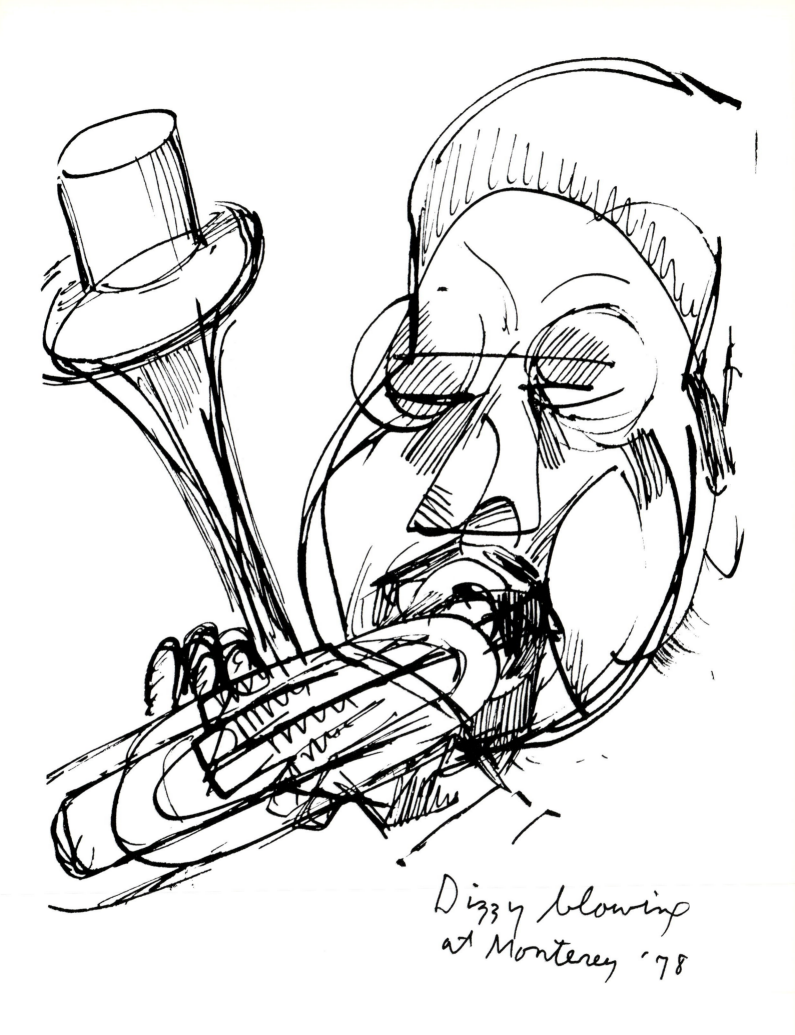

Dizzy blowing
at Monterey '78

The Coltrane

oltrane began playing alto saxophone in a North Carolina high school, later switching to tenor, and in Philadelphia was for a time in the Ornstein School of Music. He played around with various groups and in 1949 was with Dizzy Gillespie's big band. He was early into heroin, also whisky, and was a chainsmoker. But his work with Miles Davis was fine and he was an amazing soloist: some called it "sheets of sound." Always a student, he wandered into East Indian music, hunted for African forms, mastered the soprano sax and had a firm belief that Albert Einstein's Theory of Relativity could be proved by music. His progress into the outer fringes of bop was an influence on the best jazz, changing the form of the music, and his range was a miracle, from the lowest going three octaves higher. He appeared in Grove's Dictionary of Music. But the pains were coming on stronger. He became a vegetarian, took up Yoga, read the Bhagavad Gita. In 1967 he was dead of the drinker's disease, cancer of the liver.

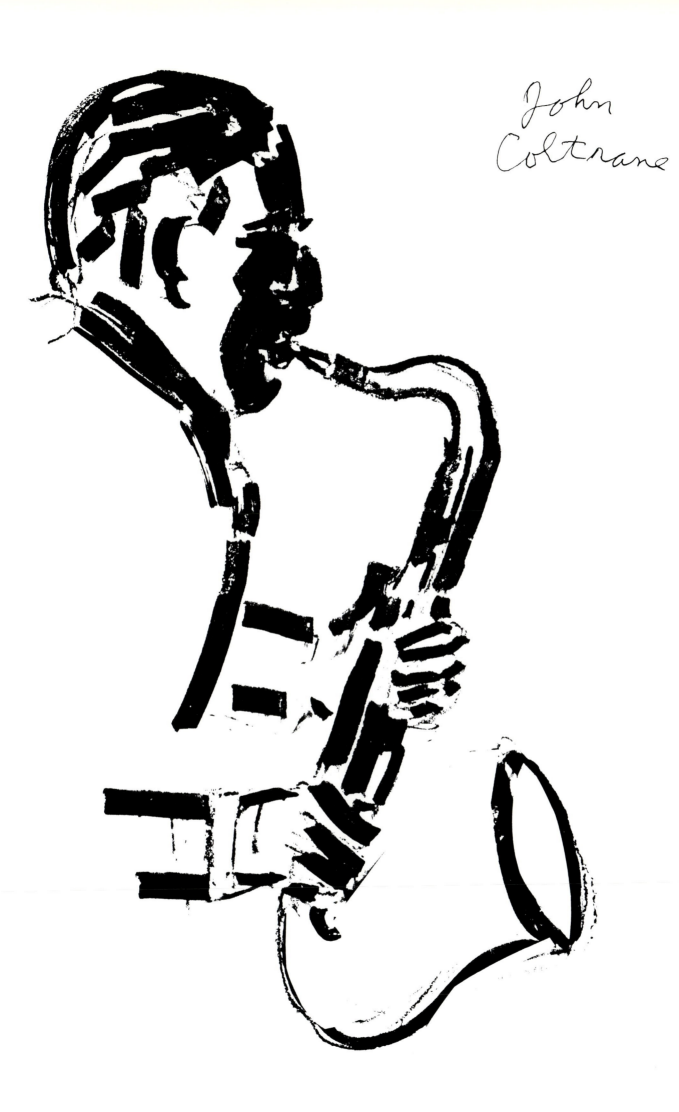

John
Coltrane

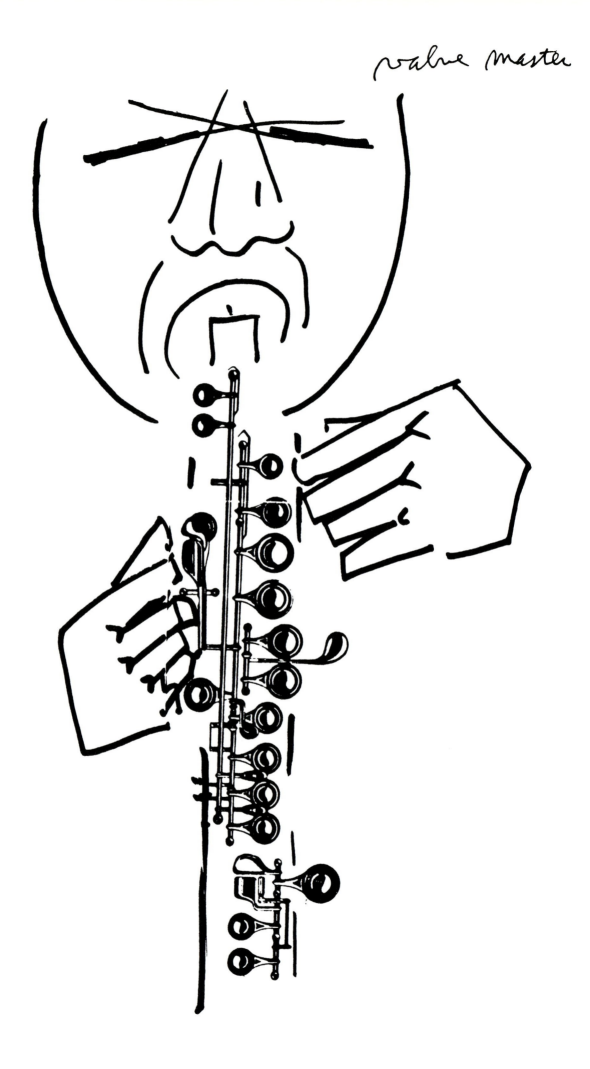

The Thinkers

ohn Coltrane was a great reader of exotic texts. Some said he was hunting a direct wire between God and Jazz. Billie Holiday told him, "God, he ain't answering the phone these days."

I remember one night when John asked me if I had ever heard of Jorge Luis Borges. I said I had. John said he felt the man was on his wavelength, they got the same electric charge full of magic. I remember he quoted Borges in some detail, but I only recall very little: "Without enchantment, the rest is useless." That is perhaps why the later Coltrane, some thought, went beyond music. Another line impressed John: "Any man must believe that whatever happens to him is an instrument; everything has been given for an end." He repeated the word instrument several times. I cheered John by saying that Borges had also written, "We are made for art."

Duke Ellington, casual, easy to the eye and ear, liked to appear as a lover of a good time behind a shield of facile humor. But I once saw him, when asked how he composed, rub the bridge of his nose and say, "You have to invent it in your head before you wind it up and run it down the track."

187

vocalist

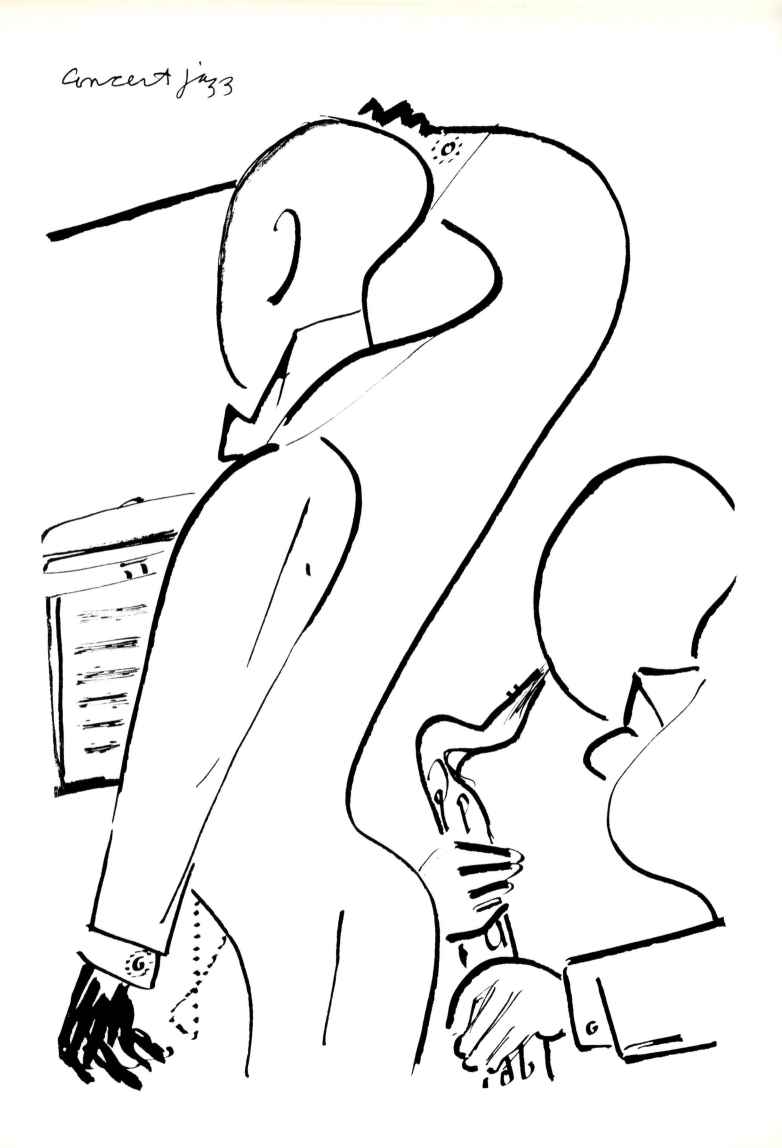

Jazz in Festival

f course the jazz musicians and the jazz fans had been gathering for some time in groups, rapping of what was jazz, and what was it becoming: the new sounds. Duke Ellington had been a star in 1956 at the Newport Jazz Festival. Louie Armstrong had been honored there in a festival that featured him. When asked about his playing at Newport, he did the "aw shucks" bit, toe in the dust. "I'm the audience myself . . . yeah, I don't like to hear myself play bad . . . it ain't no good for you."

NEWPORT

After things got uptight at Newport, there was, in 1973, "Newport in New York." To me it didn't have the flavor of older shindigs—the group effort feeling. I liked the way they did the "togethering" at the Monterey Jazz Festival out in California. Charlie Mingus was good there in 1964. I talked with Don Ellis in 1967 about his new band singer, Janis Joplin. She was certainly something you didn't expect. I enjoyed Dizzy with his upshot horn having a ball. You couldn't forget him up there, filling the air with his sound.

Monterey was a grand place for a laid back festival. Out in the open, the big brooding pines as a background. You'd sleep late and start with some Jack Daniels and an egg and bacon breakfast before you went out to the festival. Wandering among the long-haired fans, listening to the pitch made by the record company peddlers; the music was usually good and you felt everyone was in the groove and sold on jazz.

Thinking it Over

You could always pick up a group of musicians if some protest was gathering to face the cops and the hard hat goons. Blows and the blues mixed, and jazz and jabbing of your kidneys by company fuzz batons was part of protesting. Take Vietnam, the drafting of so many blacks, while white boys got college deferments. Then there were civil rights workers showing sheriffs' dog bites, black school kids being bombed by the Klan. You had to pick sides, even if all the sounds you made were not musical. Meanwhile the Birch Society was producing a lot of bumper stickers and sound and fury but not one note of music.

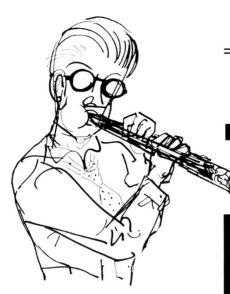

Protest with Jazz

was from the city that the buses were loaded to go down for the march on the Pentagon in Washington. Marchers from Harlem, from the loft studio and the Third Avenue bars entered political folkart and when the November Moratorium was giving all a high, the protesters marched to "When the Saints Go Marchin' In." Then came mass illegal arrests and a makeshift concentration camp: already the powder train was laid for Watergate. Louie Armstrong said, "Something is shaking."

In the opinion of some, New York City was under siege from then on, by hippies, muggers, carriers of Viet Cong flags, and poets reading protest poems to jazz at meetings behind the New York Public Library.

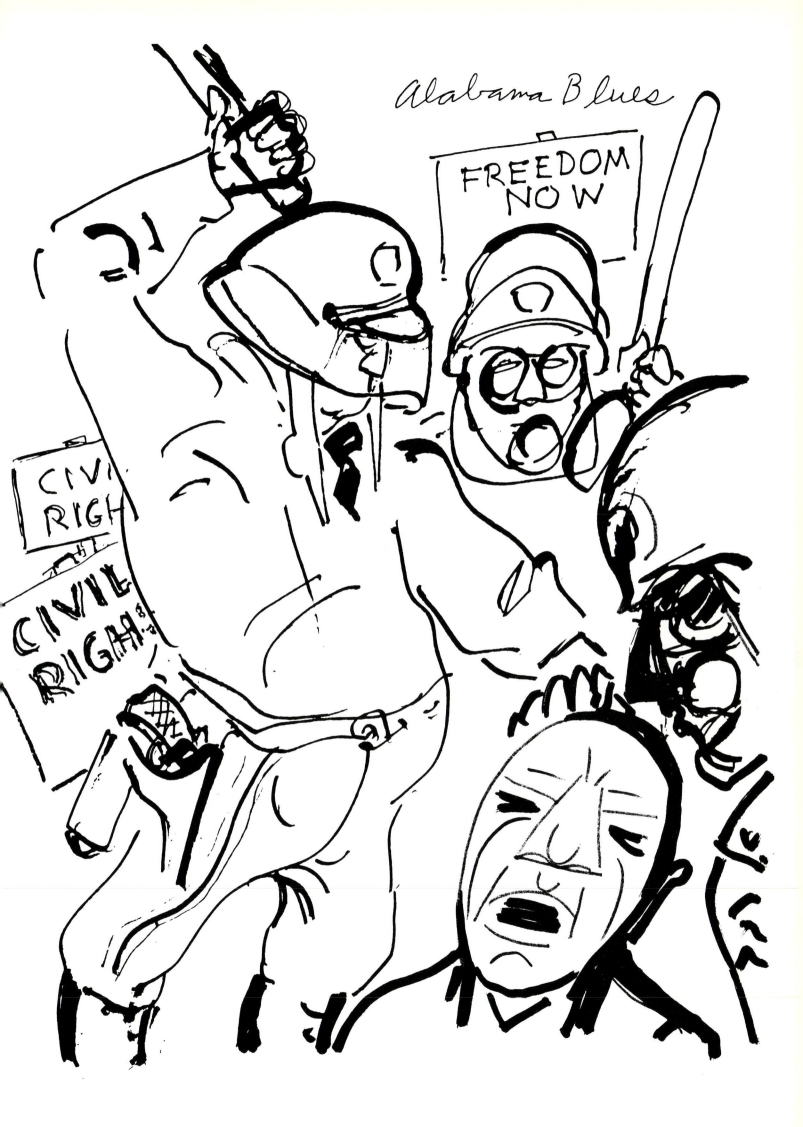

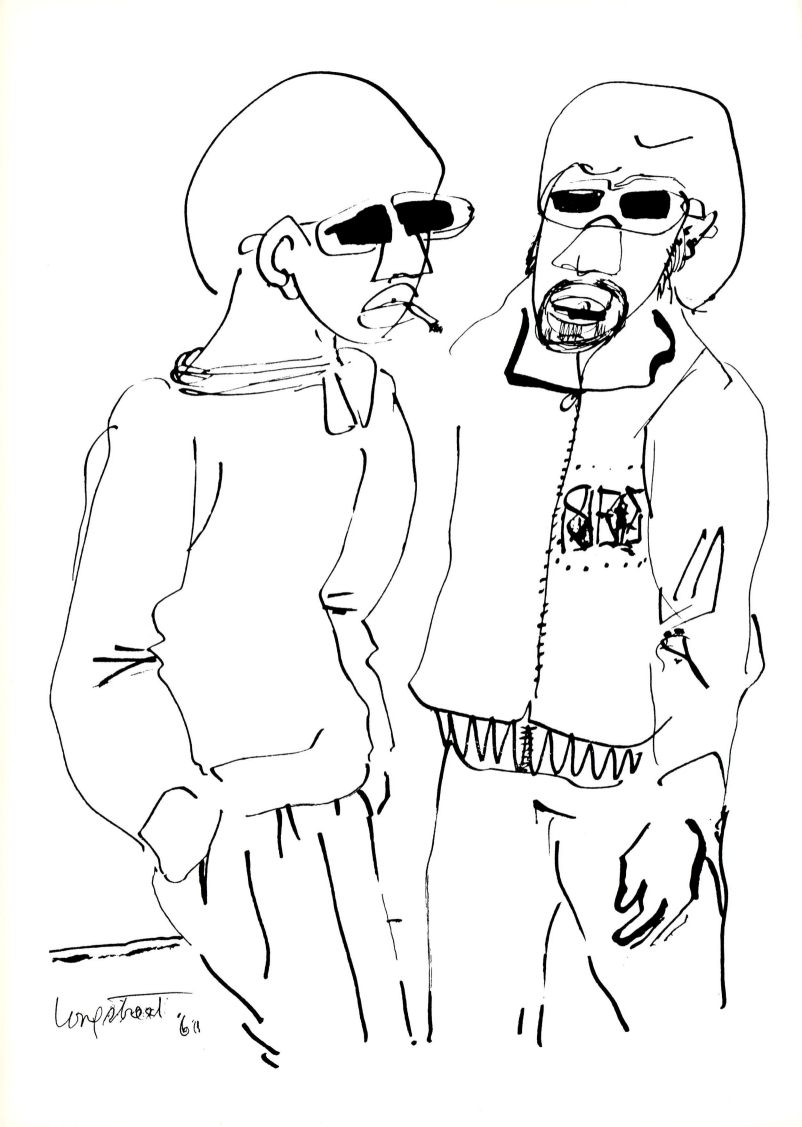

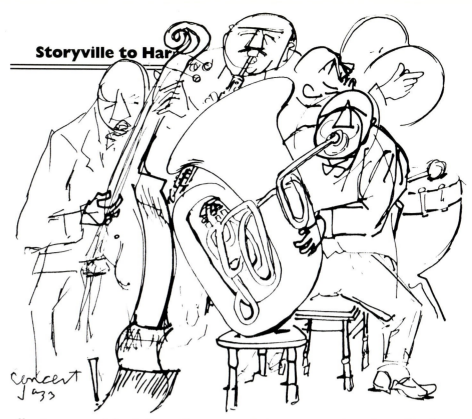

Concert Jazz

The New Black

he didn't bow or sashay, but instead grew a big ball Afro hairdo, donned mirror shades, and usually did some classroom workouts in a college. To him or her, jazz was an ethnic history, a political battering ram to bang into the cultural patterns of the American scene. The new black could be snide,

offensive, amused, ironic but well aware; one said . . . "that in two or three generations, the Hispanic-Black-Asian majority would rule the land."

Actually, the connection between jazz and the Marxist-leaning blacks—the "secret army" for black power—never was very real. But it was something, a way of tying black causes together. Raw feelings, heated emotions came into the music: like the sense of anger and outrage that can be heard in the jazz of Eric Dolphy, Albert Ayler, Archie Shepp. There were Pan-Africans

aiming at a new view of a godhead. Wrote one black critic, Leroi Jones: "Black art and culture transcends any emotional state the white man knows." Most jazzmen would consider this bigoted nonsense a barrier to the progress of jazz and civil liberties.

The Vietnam Blues

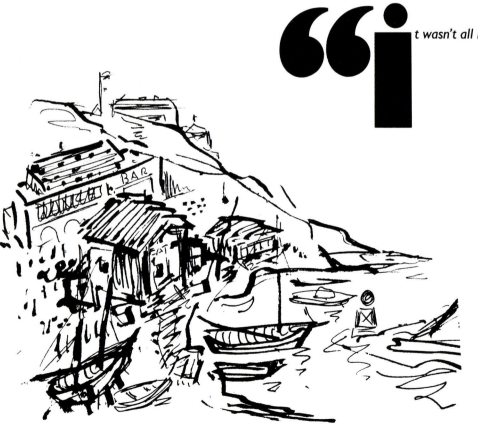

"It wasn't all Bob Hope and his glitzy reworked gags," one survivor told me. "Unlike World War II, we black soldiers were integrated with what there were of the white Joes. Saigon was full of the best yellow quiff, and if the jungle-rot and the Charlies gave you the shakes, there was the dope sold in the open; they said the CIA was behind it, bringing it in as a way of getting in-formation. . . . But the jazz players and singers from the states did tour the R&R, and jived in the field. You just had to stay alive in your bandages long enough to hear the old blue sounds."

Jazz man in Vietnam

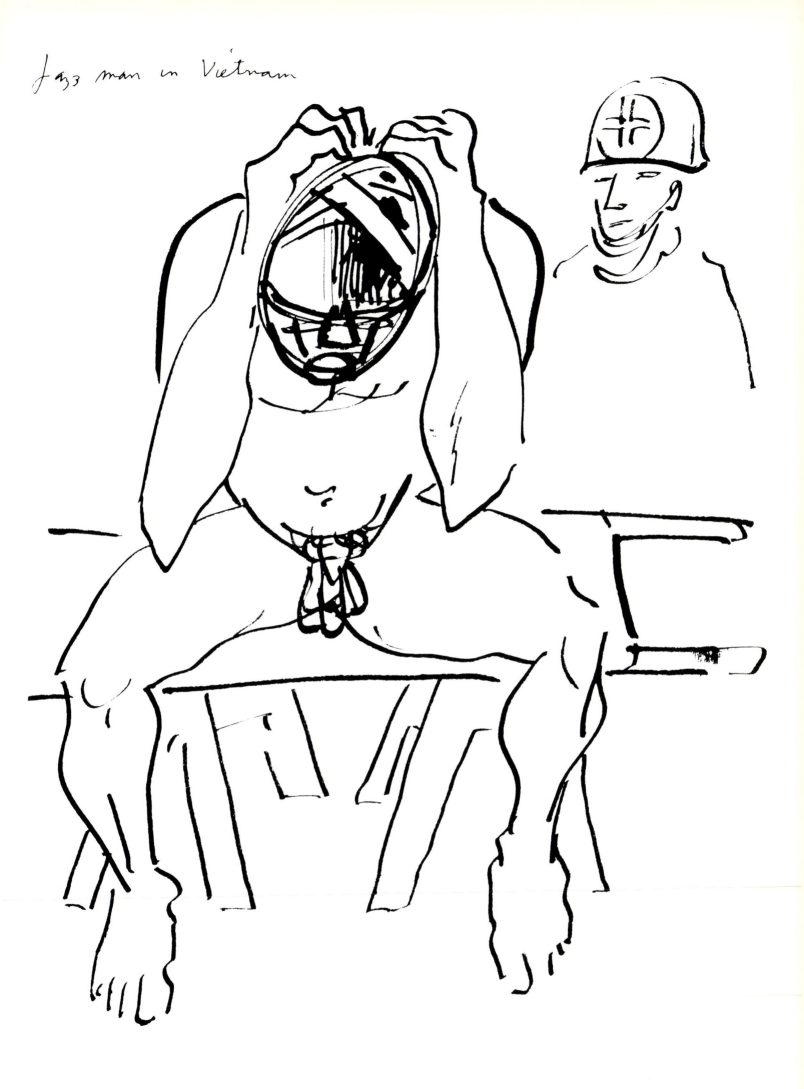

return to Harlem

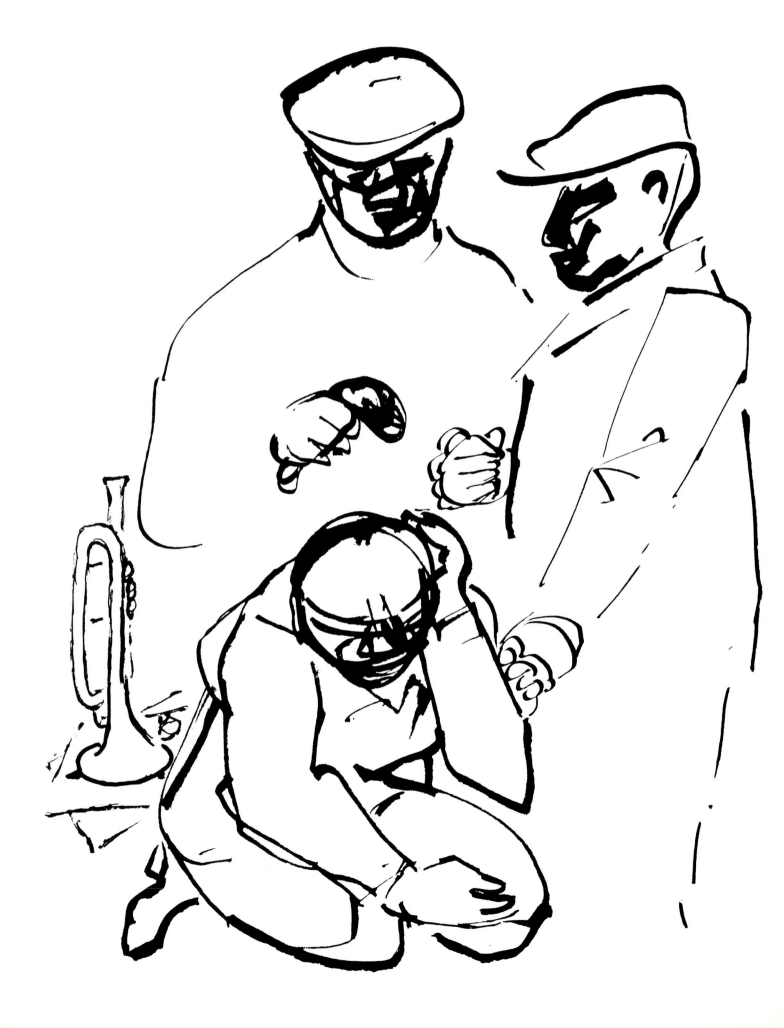

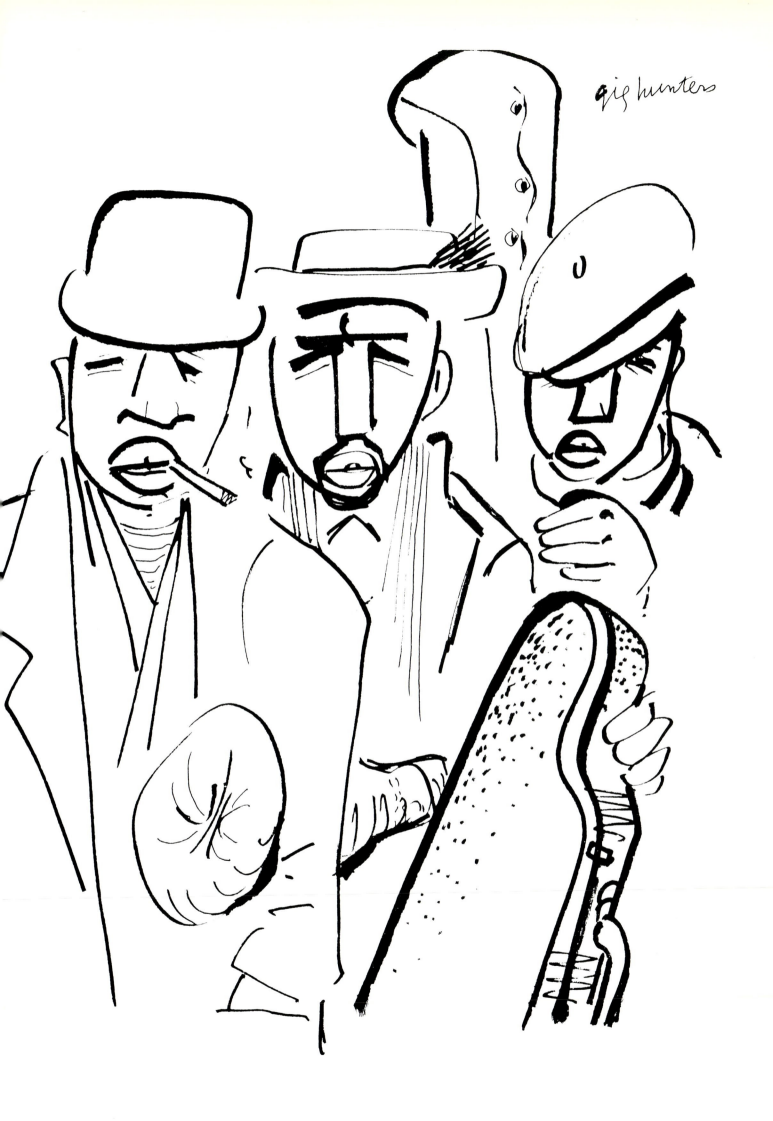

in the cold

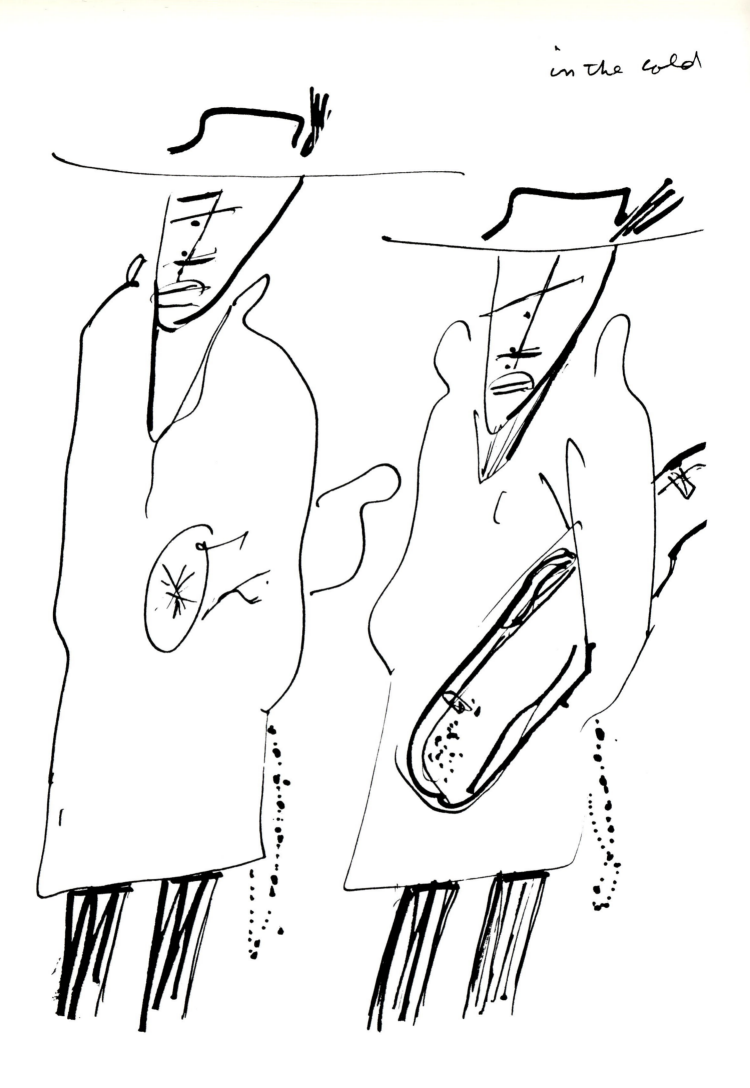

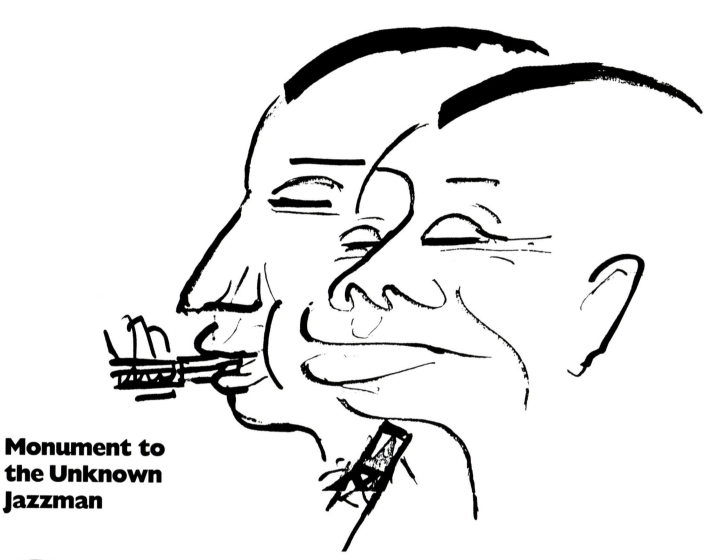

Monument to the Unknown Jazzman

omeone with little to do once figured out for me there have been 140,000 professional jazz musicians since 1900. Most of them died unknown to fame or out of the money, unable to make a living at their music. They might be going fast, and not in full repair; hazy and mumbling through their gums. Catch one in that moment of clarity and you'll hear more lies but more of the right feeling for the music than a genre historian can fully digest. Slipping them a fin is one way, just for a moment, to connect with the just-gone past. Each of the forgotten is a story that will never become a novel, never be composed into opera.

All Alone

When you came to know some of the jazz
people, there was the tragedy that not
all the good ones made it. They trickled
away in some funky room, sank into
despair, and the blues were in the shad-
ows. The street traffic mumbling
beyond the drawn window shades, and
not much left in the bottle of tiger

the trouble I've seen "

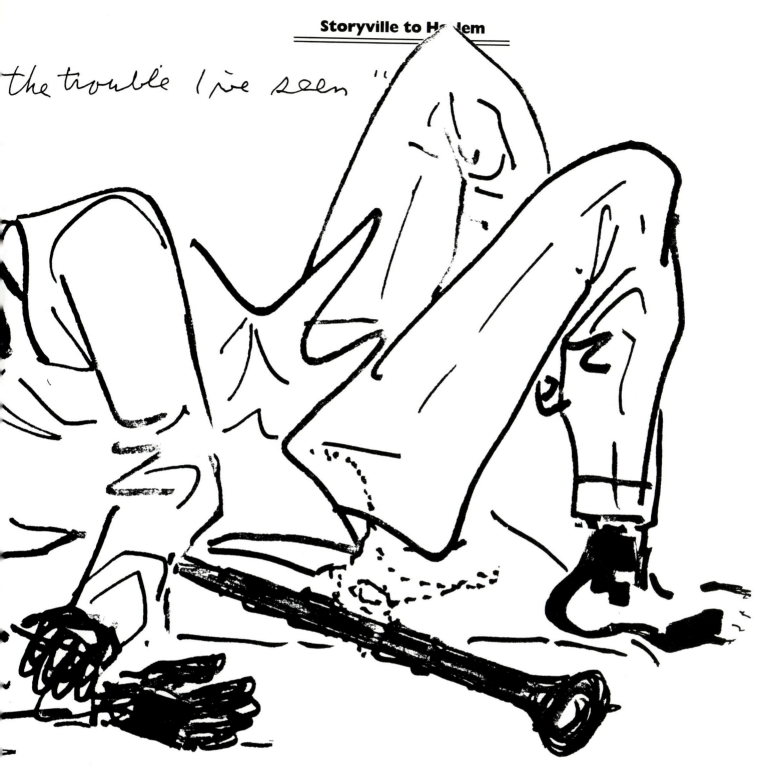

sweat. No smoke—the last handroll of pot in a part of a page from Downbeat is no longer even a roach you could take on the end of a toothpick.

Hardly worth leaving the room: the hopes of making it lost in your head, drained from your body. The horn (or saxophone?) if you hadn't hocked it, could use a shine. The pawn shop Shylocks don't take any more of the drum set with the Chinese blocks and drummer's gear, not during a hard winter.

205

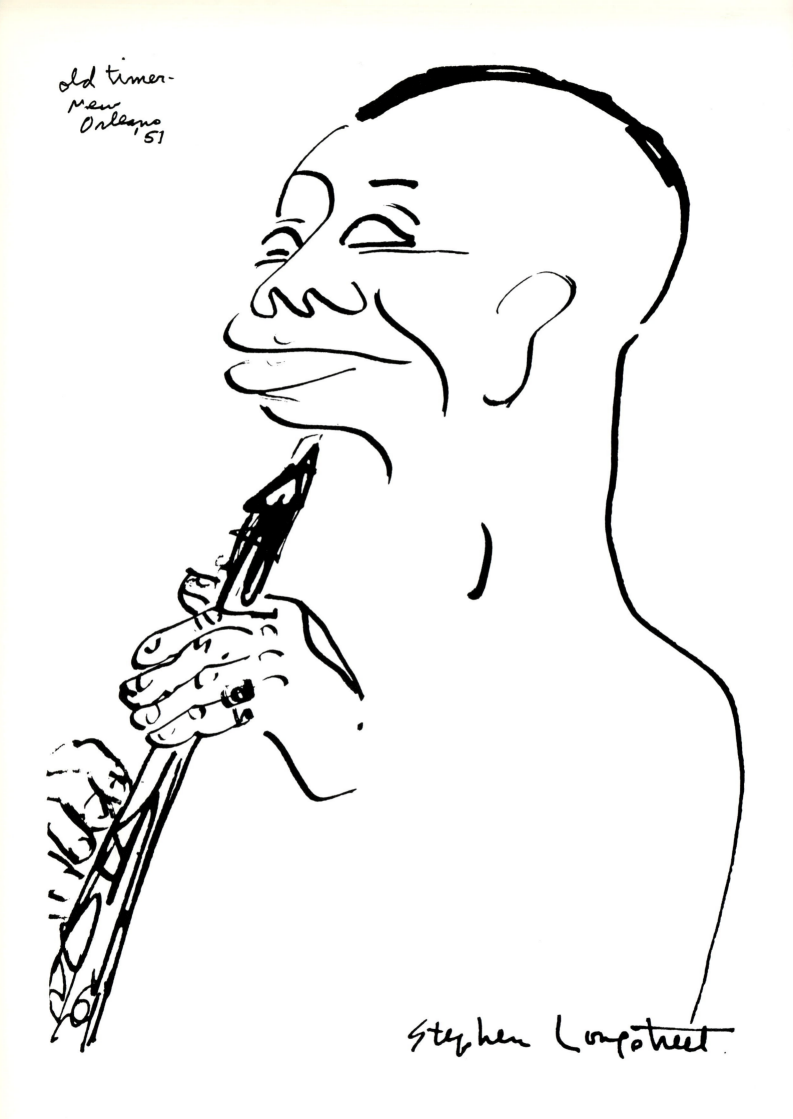

old timer–
New
Orleans
'51

Stephen Longstreet

A Short Life

here are old jazzmen. I knew two getting near to one hundred years. But too many died young, worn down by disaster, gin or drugs and by what the media called "social diseases." But most from bad, hungry, childhood living, slum horrors, bigotries. No matter, you tried to live up to the wisecrack:

"Die young and leave a beautiful body." If they remember you at all, they'll play "Shreveport Blues," "Harry Brown Blues," or the one for which you always got the big hand, "Manhattan Stomp."

207

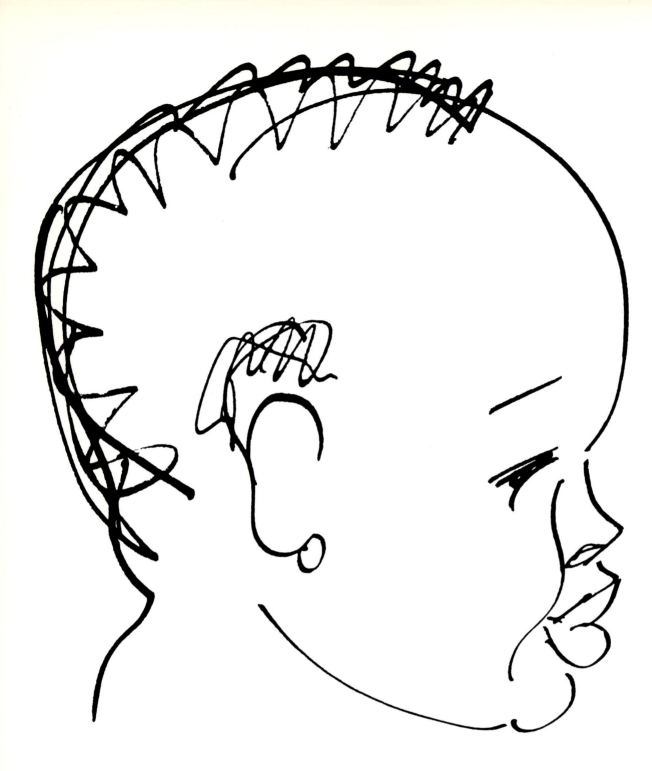

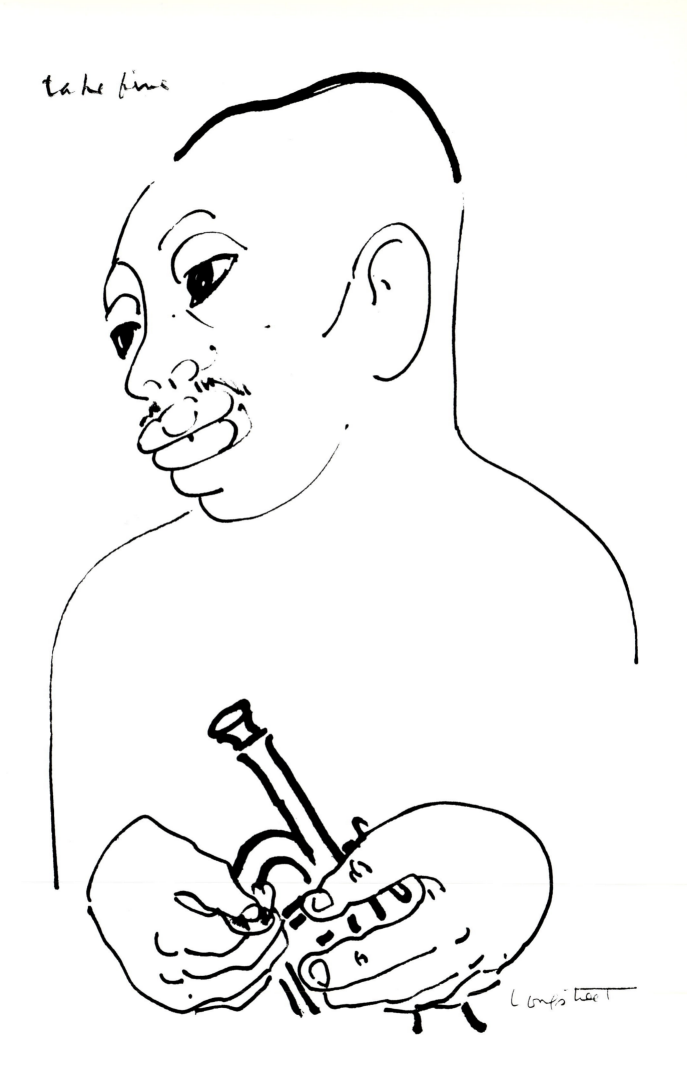

"We last as a strain of music lasts, and we go when it goes."
—George Santayanna, quoted by John Coltrane.

I n all the time, the long time, men and women have been making jazz, and playing and singing it, no real study has yet been made of the who and the why that goes deeper than skin color or surface readings. As a graphic artist and genre historian, it is a job beyond me. But I have gathered some notes that might be helpful to a psychiatrist/anthropologist, some like-minded disciple of human behavior, social patterns and the enigma of genius and talent. For a start. It seemed to me that the jazz world produced music in return for a

will to live. It was an exchange. They appeared to get their dying done as they went along, not as most of society does it—in that last terminal gasp. Perhaps because the jazzman could continue to exist without hope, he saw survival as the subtlety of timing, as in music. Survival was music. But survival was not enough for those who dueled with loneliness by living vicariously.

So many of the jazz people, players and singers, died of drugs, it became a legend that being high made better music, more original digging into the secrets of jazz. The verdict isn't in yet. The shrinks (and the white rats in the lab) are still kicking it around trying to figure out how to score it.

No, the words don't say it right . . . how you accent the off beat . . . make it up and it comes out fine . . . fights the other cat's melody . . . just

turn your face to the wall, that's not opportunity knocking at the door, it's the rent lady.

Sometimes they find you cold and gone, sometimes they come when you can't breathe easy and it's Bellevue. If in the end it's the deep six, they will come and play a little jazz music and pass the hat so they don't shovel the Potters Field dirt over a man who could have, did have it, and never made it. . . .